...INS qui se donneront à l'occasion de l'inauguration de de Flandres, à Celebrer au Marché au Vendredi a Gand Le 31. Juillet 1781.

Ordre de la Marche de l'inauguration du 27. avril 17hh.

1	un	Deputé	du pais et chatellenie de ...	1
2	un	Deputé	de la Ville de ...	1
3	deux	Deputés	de la Ville de ...	2
4	deux	Deputés	de la Ville de ...	2
5	deux	Deputés	de la Ville et franchise de ...	2
6	deux	Deputés	de la Ville et ... de ...	2
7	deux	Deputés	de la Ville ... et franchise ...	2
8	Deux	Deputé	de la Ville de ...	2
9	Deux	Deputés	de la Ville de ... Ninove	2
10	Deux	Deputé	du pais etc. ...	2
11	Deux	Deputés	de la Ville de ... termonde ...	3
12	Deux	Deputé	du Pais de ... Wael	3
13	Sept	Deputés	des Deux Villes et ...	7
14	Deux	Deputés	de la chatellenie ... Oudenarde	2
15	Deux	Deputés	de la Chatellenie de Courtrai	2
16	Deux	Deputés	du chatau ... Faubourg de gand	2
17	Deux	Deputés	de la Ville D' ... Audenarde	2
18	Deux	Deputés	de la Ville de ... Courtrai	2
19	quatre	Deputés	de la Ville de ... Bruges	4
20	quatre	Deputé	de la Ville de ... Ypres	4
21	quatre	Deputé	de la Ville de ... Bruges	4
22	...			2

Ensemble 56

Messagers de la Province et gardes externes

...ations	Qualités	No.	Noms des personnes	Destinations	
		71	...	1	
		72	Baptiste	2	
		73	Jean	3	
		74	...	4	
		75	Albert ...	5	
		76	Joseph ...	6	
		77	Joseph ...	7	
		78	...	8	
		79	... Bernard	9	
		80	...	10	
		81	...	11	
		82	Charles	12	
		83	...	13	
		84	Lucien	14	
		85	Bertrand	15	
		86	...	16	
		87	...	17	
		88	J. Bernard	18	
		89	Geoffroy	19	
		90	Henry	20	
		91	Cordier	21	
		92	Vanhecke	22	
		93	...	23	
	Domestiques servants tous habillés uniformes habit verd et veste blanche	94	...	24	
		95	Mary	25	
		96	...	26	
		97	...	27	Pour servir à Table
		98	...	28	
		99	...	29	
		100	...	30	
		101	...	31	
		102	Dunkerque	32	
		103	...	33	
		104	...	34	
		105	Leclair	35	
		106	...	36	
		107	Jean	37	
		108	Alexis	38	
		109	...	39	
		110	Louis	40	
		111	... Declercq	41	
		112	...	42	
		113	...	43	
		114	...	44	
		115	...	45	
		116	Louis de Wolf	46	
		117	...	47	
		118	...	48	
		119	...	49	
		120	...	50	
		121	...		Pour soigner les
	Messagers de la Province	122	...		toutes ... et pour
		123	...		Commissions
		124	...		
	Pour la Garde		2 Sergents		Gardes aux Portes
			4 Caporaux		
			... Appointés		
	pour porter les plats		40 ...		pour porter les plats
			50 soldats		jusqu'à la ... à manger

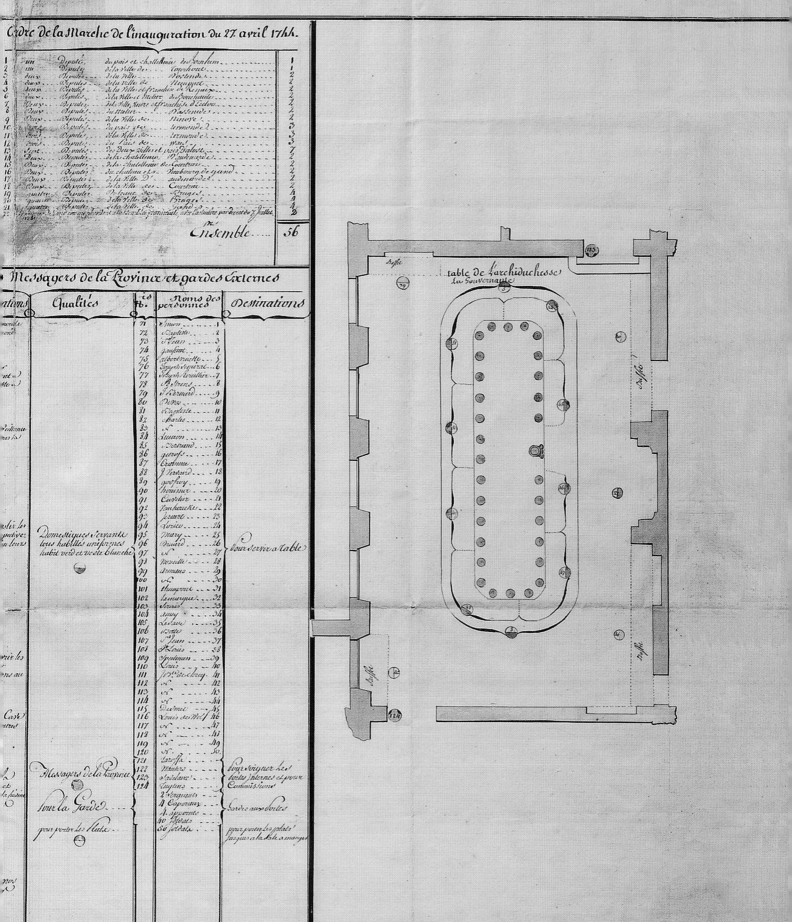

table de l'archiduchesse
la gouvernante

VIENNA CIRCA 1780

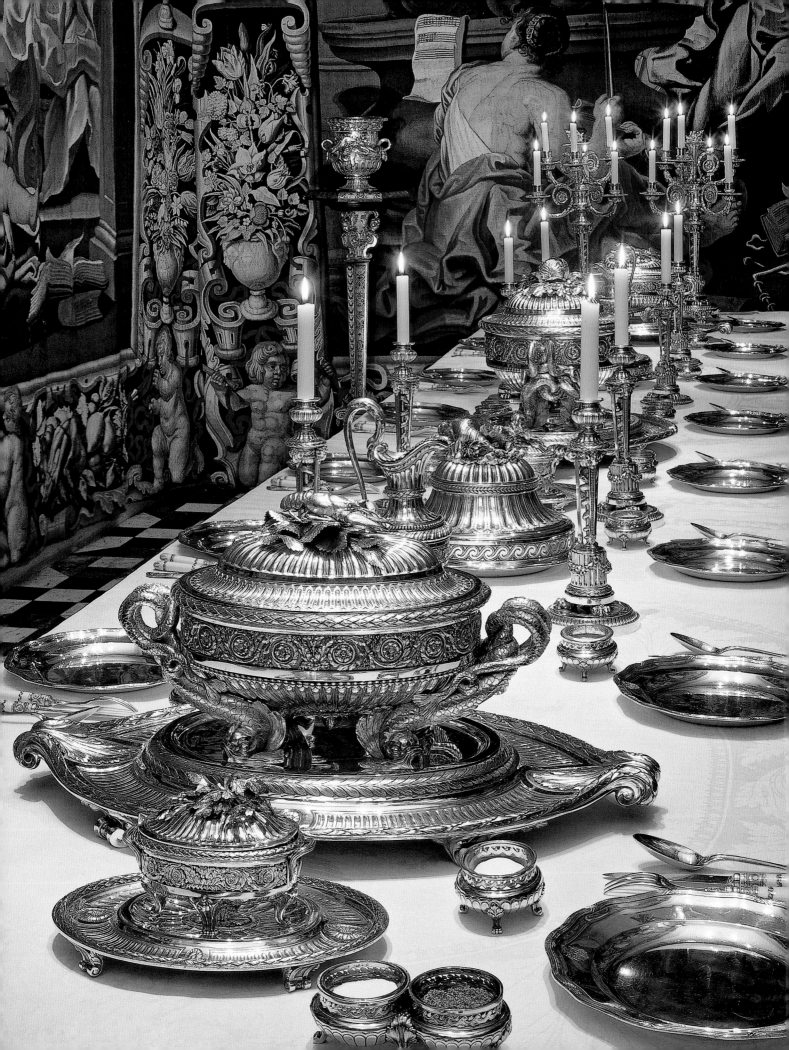

VIENNA
CIRCA 1780
An Imperial Silver Service Rediscovered

Wolfram Koeppe

The Metropolitan Museum of Art, New York

Yale University Press, New Haven and London

This catalogue is published in conjunction with the exhibition "Vienna Circa 1780: An Imperial Silver Service Rediscovered,"
on view at The Metropolitan Museum of Art, New York, April 13–November 7, 2010.
A second exhibition, based on the Museum's concept, is scheduled to be on view at the Liechtenstein Museum, Vienna,
December 2, 2010–April 26, 2011.

The exhibition and this catalogue are made possible by the Anna-Maria and Stephen Kellen Foundation.

Published by The Metropolitan Museum of Art, New York
Gwen Roginsky, General Manager of Publications
Margaret Rennolds Chace, Managing Editor
Peter Antony, Chief Production Manager
Harriet Whelchel, Editor
Bruce Campbell, Designer
Sally Van Devanter, Production Manager
Robert Weisberg, Desktop Publishing
Jayne Kuchna, Bibliographer

Separations by Professional Graphics, Inc., Rockford, Illinois
Printed and bound by Mondadori Printing S.p.A., Verona, Italy

Jacket illustration: Ignaz Joseph Würth. Round tureen with stand (detail, cat. no. 17).
Private collection, Paris

Frontispiece: Table set with a portion of the Sachsen-Teschen Service.
Private collection, Paris

Pages vi, 80: Ignaz Joseph Würth. Pair of wine coolers (detail, cat. no. 31).
The Metropolitan Museum of Art, New York.
Purchase, Anna-Maria and Stephen Kellen Foundation Gift, 2002 2002.265.1a,b.2a,b

LIBRARY OF CONGRESS CATALOGING-IN-PUBLICATION DATA

Koeppe, Wolfram, 1962–
Vienna circa 1780: an imperial silver service rediscovered / Wolfram Koeppe.
p. cm.
"This catalogue is published in conjunction with the exhibition Vienna Circa 1780: An Imperial Silver Service Rediscovered,
on view at The Metropolitan Museum of Art, New York, April 13–November 7, 2010. A second exhibition,
based on the Museum's concept, is scheduled to be on view at the Liechtenstein Museum, Vienna, December 2, 2010–April 26, 2011."
Includes bibliographical references and index.
ISBN 978-1-58839-368-5 (the metropolitan museum of art [hc])—ISBN 978-0-300-15518-1 (yale university press [hc])
1. Würth, Ignaz Joseph, d. 1792. Second Sachsen-Teschen service—Exhibitions. 2. Silverware—Austria—Vienna—Exhibitions.
3. Decoration and ornament—Austria—Vienna—Neoclassicism—Exhibitions. I. Metropolitan Museum of Art (New York, N.Y.). II. Title.
NK7198.W87A4 2010
739.2'38309436130747471—dc22
2010005895

Contents

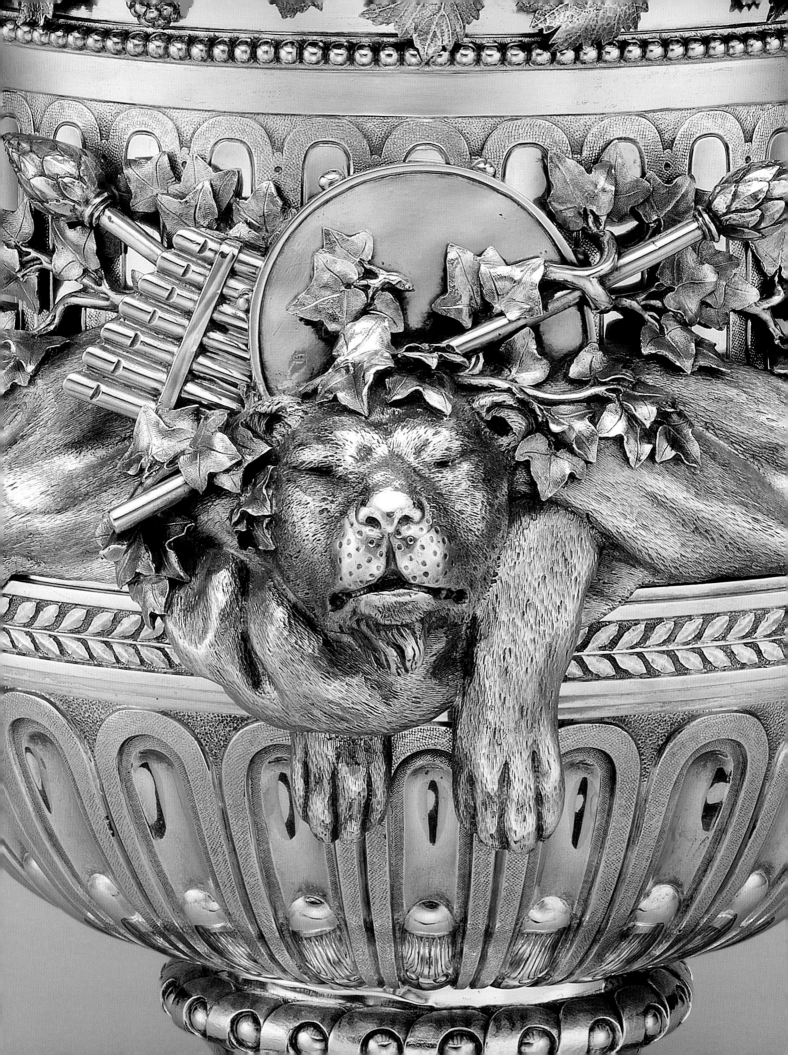

Director's Foreword

Eighteenth-century European court society was defined by its lavish banquets featuring elaborate settings and complex etiquette designed to indicate the status of both hosts and guests. Integral to these events were extravagant silver and gold dining services, many of which were displayed in palaces where decisions affecting the course of European history were made. Unfortunately, the precious metal that went into the making of these services was easily converted to coinage, then the basis of the monetary system, and most of them were subsequently melted down in times of war or hardship. What remains today is primarily an abundance of documentary evidence revealing the scope and the enormous sums of money spent by patrons on these sophisticated exercises in political and social propaganda.

The collection of gold and silver work in The Metropolitan Museum of Art's Department of European Sculpture and Decorative Arts is one of the finest in existence. It is perhaps best known for its wide range of British and French masterpieces. An opportunity to expand these already strong holdings into other areas arose in 2002, when a pair of eighteenth-century Viennese silver wine coolers of great historical significance became available. Ian Wardropper, Iris and B. Gerald Cantor Chairman of the Department of European Sculpture and Decorative Arts, and Wolfram Koeppe, Curator, Department of European Sculpture and Decorative Arts, lost no time in proposing this highly desirable acquisition to the Museum, whose wonderful long-time friends Anna-Maria Kellen and the late Stephen M. Kellen generously provided the necessary funds. We are extremely grateful for the visionary support of these caring donors.

Made between 1779 and 1782 by Ignaz Josef Würth, Imperial goldsmith to the Habsburgs, the Museum's wine coolers were once part of a magnificent Neoclassical dining ensemble—now called the Second Sachsen-Teschen Service—commissioned by Duke Albert Casimir of Sachsen-Teschen, the founder of the Albertina Collection in Vienna, and his consort, Archduchess Marie Christine of Austria. Shortly after the wine coolers went on display in our galleries, the core of the service, believed lost, came to light in a private collection in France, and the idea for this exhibition, "Vienna Circa 1780: An Imperial Silver Service Rediscovered," was conceived. We give our profound thanks to the service's owner, who was willing to part with this magnificent treasure—last seen publicly more than a century ago—in order to share it with our visitors. We are also grateful to the director and staff of the Musée national des châteaux de Versailles et de Trianon for the loan of exceptional artworks. After the Metropolitan Museum exhibition closes, the Liechtenstein Museum in Vienna plans to mount an exhibition based on the Metropolitan's concept.

Inspired by the continued generosity of the Kellens, and in honor of this exhibition, an anonymous donor presented to the museum two major works of eighteenth-century silver by the Viennese master Ignaz Krautauer. Both of these gifts are viewed in connection with the service, as are numerous objects from the Museum's collections.

At the Metropolitan, we are especially well positioned to draw from our own repositories, and an exhibition such as this one confirms the enormous breadth of the holdings gathered within our walls. By collaborating among departments and taking advantage of the extensive curatorial expertise that is a major asset of this institution, we have been able to provide an in-depth visual and documentary context for the service. This inclusiveness is reflected in the catalogue by exhibition curator Wolfram Koeppe, which not only documents the exhibition but also contributes significantly to the research on the importance of eighteenth-century Austrian silver, about which little has been published.

The Museum's educational mission is greatly enhanced by this important exhibition and accompanying volume. We extend our sincere gratitude to Anna-Maria Kellen and the Anna-Maria and Stephen Kellen Foundation for providing the crucial financial assistance that made both the exhibition and this publication possible.

Thomas P. Campbell
Director,
The Metropolitan Museum of Art

Preface and Acknowledgments

Works of art created from silver and gold have been cherished for centuries. Since ancient times, gold has been associated with the radiant light and comforting warmth of the sun, whereas silver has been compared with the cool shimmer of the moon on a clear night. The value of these precious metals, combined with their lush, reflective sheen and their malleability, inspired artisans to fashion items for domestic use as well as ever-grander display pieces that ultimately evolved into magnificently ornamented decorative objects and elaborate dinner services incorporating plates, flatware, and multiple tureens, dishes, and serving implements. The seemingly endless decorative capabilities inherent in silver, especially, continue to challenge and fascinate both makers and patrons even today.

Perhaps the finest achievements in gold and silver objects for the table occurred in eighteenth-century Europe, during the ancien régime, a time when the presentation of ostentatiously splendid silver dining ensembles at important events underlined the might of the sovereigns, aristocrats, and affluent patricians who accumulated them in dynastic treasuries. A flamboyant silver service not only decorated the banqueting table but also was used to serve the equally artistic cuisine created during the highly stylized ritual of dining in public. Ironically, the intrinsic worth of the precious metals from which the services were made often competed with, and triumphed over, the social, historical, or commemorative worth of the objects themselves. Regardless of their potential artistic importance, most gold and silver items of the period were unable to escape the melting pot, victim to either changing fashion or the need for currency.

After The Metropolitan Museum of Art acquired two wine coolers made in Vienna about 1780, my colleagues and I began to research their history. It was clear that these pieces represented rare decorative survivors of their period—a great achievement in itself given their combined silver weight of nearly twenty-five pounds—and that their sophisticated design and execution obviously reflected the hand of an extremely talented artist. The marks on the coolers identified him as the Viennese master Ignaz Joseph Würth, one of the best goldsmiths of the eighteenth century and a member of a dynasty of highly skilled artisans. Equally illustrious were the patrons who commissioned the service, members of the Imperial Habsburg family: Duke Albert of Sachsen-Teschen and his consort, Marie Christine, an archduchess of Austria. Würth's workshop began the extensive project in 1779 and did not finish before 1782. The Museum's wine coolers were part of this ambitious undertaking, now called the Second Sachsen-Teschen Service, which embodies a level of aesthetic and technical achievement as remarkable as the epoch in which it was created, a decade of extravagant and demonstrative consumption of luxury goods, before the French Revolution would change the course of Europe forever.

In the intervening years, however, this splendid service was gradually forgotten. A mere handful of items turned up in public collections, and the majority was believed to have met the fate of so many other great silver works. The ensemble's original extent was until now documented only through a rare portfolio by Edmund W. Braun, published in 1910, one hundred years ago. Thus, when a large portion of the service, with multiple parts for different purposes, was located a few years ago, our fascination with the original assemblage in its entirety grew progressively. An exhibition of this core segment of the ensemble would not only showcase its abundance but would also reveal how each item was designed to enhance the grandeur of the whole. I would like to express my profound gratitude to the owner of the service, who also believed in the importance of sharing this virtually unknown treasure with a wider public and who offered with extraordinary generosity to send this majestic ensemble across the ocean.

The display of the service also allowed us to re-create the panorama of royal banqueting in eighteenth-century court society, complete with carefully conceived table-seating plans and napkins folded in elaborate shapes intended to reflect the status of the various guests. This further provided the opportunity to celebrate a unique embodiment of Viennese Neoclassicism in the context of contemporary silver from Austria and France, especially as the latter was the preeminent cultural influence

Plaques depicting Albert of Sachsen-Teschen and his wife, Marie Christine of Austria, Vienna, ca. 1775. Hard-paste porcelain, each 5⅝ × 4¾ × 1⅛ in. (14.3 × 12.1 × 2.9 cm). The Metropolitan Museum of Art, New York. The Charles E. Sampson Memorial Fund, 2009 2009.427.1,.2

in eighteenth-century Europe. Béatrix Saule, General Director, and Bernard Rondot, Chief Curator, both of the Musée national des châteaux de Versailles et de Trianon, agreed to lend two extraordinary objects that had not left France since they arrived in 1781 from Vienna.

Many have contributed to the realization of this exhibition and catalogue. Foremost are those who have steadfastly supported the project: Thomas P. Campbell, Director, and Philippe de Montebello, Director Emeritus, The Metropolitan Museum of Art, enthusiastically endorsed the project from its inception. Ian Wardropper, Iris and B. Gerald Cantor Chairman of the Department of European Sculpture and Decorative Arts, never ceased his advice and encouragement. Among the many other Metropolitan staff members who have contributed to this endeavor, I thank Museum President Emily K. Rafferty for her enthusiastic support, as well as Martha Deese, Senior Administrator for Exhibitions and International Affairs; Nina McN. Diefenbach, Vice President for Development and Membership;

Sharon H. Cott, Senior Vice President, Secretary, and General Counsel; Kirstie Howard, Assistant Counsel; Romy M. Vreeland, Assistant Manager for Acquisitions; and Meryl Cohen, Exhibitions Registrar. Harold Holzer, Senior Vice President for External Affairs; Elyse Topalian, Vice President for Communications; and Mary Flanagan, Senior Press Officer, were instrumental in providing information to the visitors and media worldwide. Peggy Fogelman, Frederick P. and Sandra P. Rose Chairman of Education, and Joseph Loh, Associate Museum Educator, initiated and coordinated public events.

Heartfelt gratitude is extended to the exhibition team of Linda Sylling, Manager for Special Exhibitions, Gallery Installations, and Design; Patricia A. Gilkison, Assistant Manager for Special Exhibitions and Gallery Installations; and Exhibition Design Manager Daniel Bradley Kershaw, who realized the outstanding installation with the coordination of Associate Building Manager Taylor Miller and Lighting Design Managers Clint Ross Coller and

Richard Lichte. Graphics were provided by Emil Micha, and Pamela T. Barr edited the labels.

Also to be thanked are former Publisher and Editor in Chief the late John P. O'Neill, General Manager of Publications Gwen Roginsky, and Managing Editor Margaret Rennolds Chace for supervising all aspects of the catalogue's preparation and production. Chief Production Manager Peter Antony handled the correction of color proofs and printing, and Production Manager Sally Van Devanter oversaw the design process—with the desktop support of Assistant Managing Editor Robert Weisberg— and the preparation of images and layouts for printing. Jane S. Tai aided in gathering photographs and arranging for new photography. Bruce Campbell is gratefully acknowledged for the catalogue's superb design. I am particularly thankful to my editor, Harriet Whelchel, for her expertise and patience as well as for coordinating many details of the manuscript. Jayne Kuchna assiduously edited the notes, provided suggestions for further references, and compiled the bibliography. Their efforts were augmented by those of Elizabeth Zechella, Denise Eardman, and Carol Liebowitz. Kenneth Soehner, Arthur K. Watson Chief Librarian, and his associates Linda Seckelson and Robyn Fleming provided access to the formidable resources of the Thomas J. Watson Library.

Our distinguished curators in the Department of Drawings and Prints, George R. Goldner, Drue Heinz Chairman; Perrin V. Stein, Curator; Stijn Alsteens, Associate Curator; Catherine Jenkins, Assistant Curator; and their colleagues Mary Zuber and David del Gaizo shared their expertise and made important objects in their care available.

In the Department of Objects Conservation, I recognize the endeavors of Lawrence Becker, Sherman Fairchild Conservator in Charge; Richard E. Stone, Conservator Emeritus; Linda Borsch, Conservator; Anne Grady, Assistant Conservator; and Conservation Preparator Frederick J. Sager, as well those of Barbara Bridgers, General Manager for Imaging and Photography, and Senior Photographer Joseph Coscia Jr., along with their associates Mark Morosse and Robert Goldman in the Photograph Studio. I am immensely grateful to my colleagues in the Department of European Sculpture and Decorative Arts, notably our Administrator Erin E. Pick and Collections Manager Denny Stone,

also to Alisa Chiles, the late Robert C. Kaufmann, Daniëlle O. Kisluk-Grosheide, Jeffrey Munger, Marina Nudel, Melissa Smith, Juan Stacey, Bedel Tiscareño, and Clare Vincent, as well as to Katrina London and Tamara Schechter.

The graciousness with which Alexis Kugel shared his expertise and his input has been of critical importance. I am deeply indebted to him and to his brother, Nicolas Kugel. I have also benefited enormously from the zeal and perspicacity of the following experts: Christian Benedik, Barbara Brown, Ute Camphausen, Benoît Constensoux, Klaus Dahl, Ivan Day, Alain Gruber, Sabine Haag, Ingrid Haslinger, Marvin Haynes, Jørgen Hein, Bernhard Heitmann, István Heller, Günter Irmscher, Franz Kirchweger, Christine Kitzlinger, Joern Lohmann, Michelangelo Lupo, Lucrezia Obolensky Mali, Christopher O. Monkhouse, Paulus Rainer, Angelika Riemann, Rainer G. Richter, Thomas Rudi, Lorenz Seelig, Michael I. Sovern, Rüdiger Störkel, Paul Sweet, Timothy Wilson, Christian Witt-Dörring, and Ghenete Zelleke. We have enjoyed fine collegial relations with the staff of the Liechtenstein Museum in Vienna, in particular with its Director, Johann Kräftner, as well as Hans Schweller and Sophie Wistavel. As a fitting salute to this wonderful silver service, after the Metropolitan Museum exhibition closes, the Liechtenstein Museum plans to display the ensemble in Vienna in an installation based on the Metropolitan's concept.

Joan Sallas contributed his in-depth knowledge of the art of napkin folding and its significance in eighteenth-century Europe. The presence of his napkins intricately folded to follow historical precedent greatly enriched the cultural and historical context of the catalogue and the splendor of the exhibition.

Undertaking the necessary analysis on this service and its history was a rewarding adventure that led to scholarly investigations in Vienna, Belgium, Dresden, Budapest, and Paris. Claudia Lehner-Jobst conducted archival research in Vienna and Budapest and uncovered some surprising finds, which are noted in the text. For their generous input I thank Trude Fischer in Lucerne, who responded kindly to all of my queries, as did Elisabeth Schmuttermeier and Rainald Franz at the Österreichisches Museum für angewandte Kunst (MAK) in Vienna and Tim Oers in Lovendegem and London.

The intent of this catalogue is to provide a contextual summary for the further exploration of the Second Sachsen-Teschen Service. It is my hope that definitive answers to open questions surrounding the commission may be revealed by documents not yet uncovered by history. Also welcome would be a long-overdue survey of the work of Viennese goldsmiths in the second half of the eighteenth century and the important role it occupies within the panoply of European decorative arts.

The presentation of the service and accompanying objects in the Wrightsman Exhibition Gallery at The Metropolitan Museum of Art has benefited enormously from the generosity of Anna-Maria Kellen and the Anna-Maria and Stephen Kellen Foundation. They also ensured that this exhibition was accompanied by the scholarly publication it deserves.

It is with great pleasure and sincere admiration that I dedicate this publication to Anna-Maria Kellen.

Wolfram Koeppe
Curator, Department of European Sculpture
and Decorative Arts
The Metropolitan Museum of Art

VIENNA CIRCA 1780

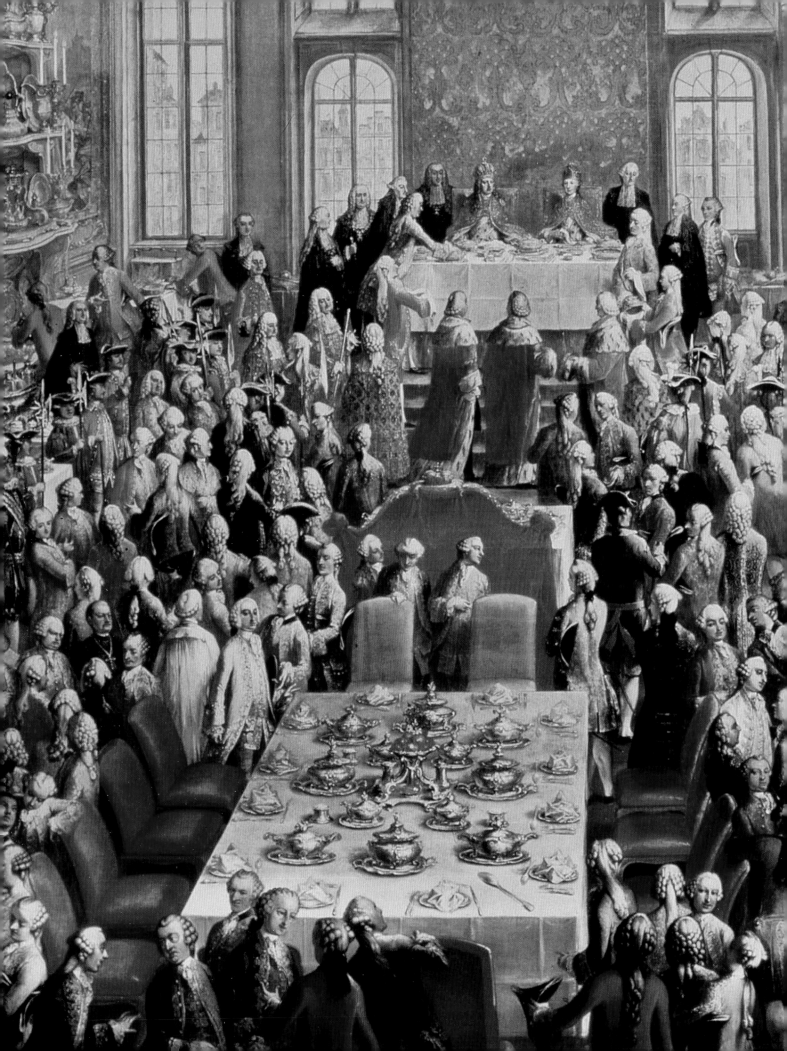

Imperial Aspirations and the Golden Age of Ceremony

Eighteenth-century Vienna was one of the liveliest and most active and inspired places in all of Europe. A look at the names of noble owners of country palaces and urban residences during this time reveals the presence of elite families from Hungary and the larger Balkans, from various Italian states, and from Bohemia, Moravia, Silesia, and regions beyond.[1] Nestled beside the Danube, Vienna's location as a crossroad between East and West and between central Europe and the Italian peninsula, made it uniquely suited to absorb and refine cultural influences from around the region. Led by France and Italy, late seventeenth-century Viennese artists had championed an academic Baroque classicism rooted in the ideals of antiquity. This classicizing tendency continued into the next century and was evident in Baroque's stylistic successor, Rococo. Reflected primarily in art and music, Viennese Rococo was a characteristic mélange that contrasted dynamism with calm and frivolity with severity.[2] Internationally regarded talents emerged from the city's Academy of Fine Arts (founded in 1692). A notable example is the painter Anton Raphael Mengs (1728–1779). The renowned art historian Johann Joachim Winckelmann (1717–1768) considered this Austrian artist the greatest Western painter after Raphael and held his theoretical writings in high esteem.[3] Composers such as Joseph Haydn (1732–1809) and, as of 1781, Wolfgang Amadeus Mozart (1756–1791) were also part of this creative community of musicians, artists, and highly skilled craftsmen.

Imprinted by the Age of Enlightenment, Austria underwent political as well as cultural transformations during this time. One of the most significant of these came in the wake of the death of Emperor Charles VI in 1740, which marked the end of the Habsburg male line and opened the door for Charles's daughter Maria Theresa (1717–1780), archduchess of Austria, to become queen of Hungary and Bohemia, empress of the Holy Roman Empire, and the only female ruler in the long history of Habsburg monarchs (1276–1918).[4] Looking back on the period in 1806, Sir Nathaniel William Wraxall noted that "never, perhaps, did any Princess ascend a Throne under circumstances of greater peril, or which demanded more fortitude, energy, and personal resolution."[5] He was referring in particular to the Habsburgs' struggles to retain their role as the leading dynasty of Europe against the fast-rising Frederick the Great of Prussia (1712–1786), the elector and short-lived emperor (1742–45) Charles Albert of Bavaria (1697–1745), and other ambitious German princes. Displaying extraordinary strength of character and a practical mind, Maria Theresa reigned for forty years, ultimately becoming an almost mystical figure to her subjects, many of whom had no direct memory of her father's rule.[6] Johann Kräftner summarized the empress's achievements during these years, which became known as the Age of Maria Theresa:

> She carried through a series of important political reforms, including the establishment of a unified penal code and the introduction of compulsory schooling as well as a number of initiatives in the fields of health and hygiene. In the arts, Maria Theresa was not a particularly generous patron. . . . [However, she] surrounded herself with important artists and, as the style changed, guided the high Baroque culture of her court into an elegant and light form of Rococo [and in her last years joined the movement toward Neoclassicism]. She sent many beautiful objects from Austria to her daughter Marie Antoinette in Paris [see fig. 13], where they measured up well against the best French luxury products.[7]

Kräftner's previous statement represents a noteworthy endorsement of Austrian goldsmiths, who worked in the shadow of the French, especially the

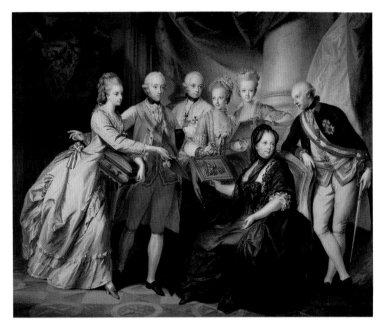

Fig. 1. Heinrich Friedrich Füger. *Maria Theresa of Austria with Her Children* [Marie Christine and Albert are on the far left; Emperor Joseph II is at far right], 1776. Tempera on parchment, 13½ × 15⅜ in. (34.2 × 39 cm). Österreichische Galerie Belvedere, Vienna

Parisian artisans of the ancien régime, who were the acknowledged leaders in the evolution of the decorative arts of the time.[8]

Maria Theresa had married Duke Francis Stephen of Lorraine (1708–1765) in 1736. Although the duke was crowned Francis I, Holy Roman Emperor, in 1745, his wife was the de facto ruler, involving herself in all the day-to-day tasks of the couple's complicated dominions. Francis appeared not to object, and the pair, who had sixteen children, continued with this arrangement for the next twenty years.[9] When Francis died suddenly in 1765, the dowager empress donned the mourning black she would wear for the rest of her life, in remembrance of her consort, and appointed her eldest son, Joseph (1741–1790), as coregent in observance of hereditary tradition (fig. 1).

The way had been prepared for Joseph's succession as Holy Roman Emperor the year before, when he was elected *Römischer König* (Roman king) and crowned in an elaborate ceremony in Frankfurt am Main. The obligatory coronation banquets had long represented the epitome of royal celebration in central Europe, drawing aristocratic spectators from all corners of the Continent.[10] A 1764 painting by Martin van Meytens (1695–1770) captured the impressive, stagelike scene of pomp and circumstance in Frankfurt's city hall (fig. 2). A closer look

at the image, however, reveals weaknesses in the Habsburgs' hegemony, which was being undermined by the political and social realities of the era.

Traditionally, a public feast like this one was intended to represent a cementing of alliances and symbolized lasting loyalty among those gathered together. Yet in his autobiograpical work *Dichtung und Wahrheit*, the German poet Johann Wolfgang von Goethe (1749–1832), who witnessed parts of the 1764 proceedings, observed otherwise:

> *At the opposite end of the hall . . . the emperor and the king, in their robes, sat under baldachins upon raised thrones. . . . The three ecclesiastical electors, with their buffets behind them, had sat down on individual daises. . . . This upper part of the hall made a worthy and gratifying sight, and prompted me to observe that the clergy likes to stand by its ruler as long as it can. On the other hand, the buffets and tables of all the secular electors, splendidly bedecked but minus their lords, reminded me that through the centuries unfriendly relations had gradually developed between these lords and the supreme head of empire. Their ambassadors had already departed to dine in a side room. And, as if it did not suffice that the greater part of the hall had acquired a spectral appearance because of the splendid preparations made for so many invisible guests, the large empty table in the center was a still drearier thing to contemplate. The numerous settings on it were unused because all the people with any right to them had stayed away out of scruple, even though they were in town, fearing to compromise their honor on this day of greatest honor.[11]*

An aspect of the ritual in the emperor's assembly room of the *Römer* (city hall) in Frankfurt was the temporary exhibition of decorative objects on shelves that were called *Credenze zur Parade*, or "parade buffets."[12] It was the customary privilege of the sovereign to display lavishly ornamented objects of gold or gilded silver; the electors were required to bring additional pieces, most of silver, from their own treasuries to be arrayed on the shelves behind their seats. Both the silver service visible on the table in the central foreground of Van Meytens's painting and the gold one set for the emperor and his son, who are seated under the throne canopy in the far background, had been shipped from Vienna for the occasion.[13] The latter had been ordered in 1759 to commemorate the marriage of Joseph to Isabella of Parma (1741–1763)

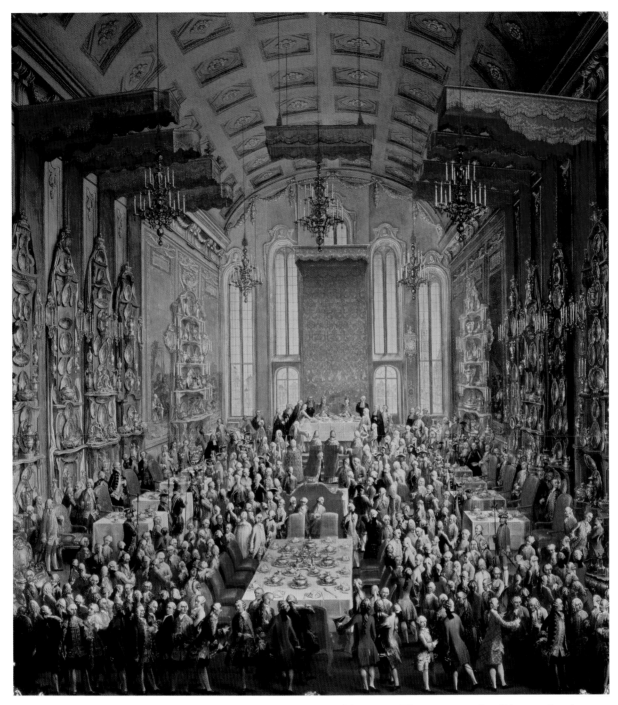

Fig. 2. Martin van Meytens. *Coronation Banquet of Joseph II in Frankfurt*, 1764. Oil on canvas, 11 ft. 9¾ in. × 10 ft. 6 in. (3.6 × 3.2 m). Silver Collection, Imperial Apartments, Hofburg Vienna. On loan from Kunsthistorisches Museum, Vienna

the following year. The maker was the talented Viennese goldsmith Franz Caspar Würth (or Wirth; master 1734, died before 1771), a member of the dynasty of outstanding goldsmiths by that name, one of whom assumes an important role in this publication.[14]

Because currencies continued to rely heavily on gold and silver well into the nineteenth century,

ornate items were often melted down and transformed into coinage.[15] Unfortunately, the tableware recorded in Van Meytens's painting met such a fate when in 1797 it was delivered to the mint to help finance the Habsburg armies during the French revolutionary wars.[16] Indeed, from Medieval times this had been the destiny of most ceremonial silver objects and table ensembles, which regularly fell

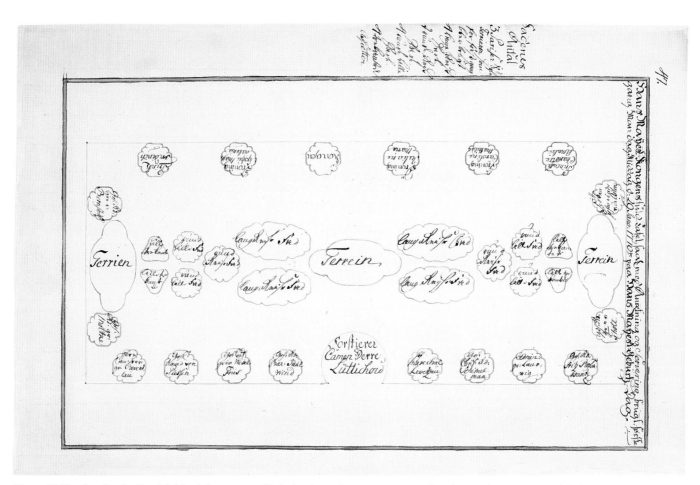

Fig. 3. Table plan for the Danish king's banquet at Christiansborg, January 29, 1770, showing various tureen and dish shapes. Pen drawing, 7½ × 12¼ in. (19.1 × 31.1 cm). National Archives, Copenhagen. Overhofmarskallatet I.O.13

victim to changing fashions or the financial needs of their owners.[17]

From the *Credenze zur Parade* to the *Service à la française*: The Silver Service in Europe during the Second Half of the Eighteenth Century

Joseph II's now-lost gold service was a magnificent example of Austrian Rococo, a variant of the late Baroque style that had swept through Europe toward the end of the reign of Louis XIV (1638–1715) of France. It was the Sun King who had established the parameters of flamboyant dining and entertaining *en public* as an expression of accomplished "etiquette."[18] His sister-in-law, Elizabeth Charlotte of the Palatinate, duchess of Orléans (1652–1722), witnessed the monarch consume during a single meal "four dishes of soup-meat, a whole pheasant, a partridge, a plate of salad, a plate of stew,

two massive pieces of ham, one plate of sweets, fruits and confitures."[19] Louis XIV's successor, Louis XV (1712–1774)—known as, among other things, a passionate gourmand—hosted an en-route "supper" of forty-one different courses for a small circle of courtiers during a voyage to the Château de Choisy, one of his royal residences, on September 16, 1745. When the king ate cherries for dessert, they were first peeled and then coated with sugar.[20] The witty salon hostess Marie de Vichy-Chamrond, marquise du Deffand (1697–1780), wrote in 1772, "In my view the stomach is the seat of the soul. Destiny is determined after him; he rules the universe, why should one not indulge [and] put one's hope in him?" This indulgence was often taken to extremes, as demonstrated in a "supper with two courses" given by the financier Joseph Bonnier de la Mosson (1702–1744) in Montpellier. The first course included 140 different meat preparations: 50 of boiled or poached meats, 50 roasts, as well as various poultry dishes

and pies. The second or dessert course consisted of 160 various dainties. The meal was served on forty-eight dozen silver plates, and, "after each toast, the glasses would be smashed."[21]

Late eighteenth-century France continued to serve as a cultural role model and its language as the lingua franca for the entire Continental elite, including all of Germany and the Russian Empire. As early as 1755, the German politician and novelist Friedrich Karl von Moser (1723–1798) had noted that "at all but the smallest courts, table services are nowadays in silver. But on high and holy days the great imperial and royal courts dine off solid gold."[22] The use of a silver service on the table arranged *à la française* became de rigueur among the aristocratic denizens of cultural centers from Stockholm to Naples, Lisbon to Saint Petersburg, and, of course, from aesthetically illustrious Vienna to commercially booming London.[23] During the eighteenth century, tables decorated in this "French manner"—characterized by a symmetrical layout of matching silver pieces on which all the various foods of a course were offered at once (fig. 3)—gradually replaced the wall-mounted or stepped parade buffet. Great attention was lavished on elaborate decor and an imaginative variety of items whose calculated aim was to astonish. The silver objects themselves reflected the owner's power, wealth, and status. Large silver services with centerpieces and tureens on stands, for example, embodied the official expression of princely splendor and the absolute power of the monarchy. The state treasury was literally on display for the admiration of those who had the privilege of seeing it.

One of the most astute patrons of such services was Catherine II of Russia, called Catherine the Great (1729–1796), who employed these ensembles as propagandistic displays of might. According to Marina Lopato, Catherine "acquired silver products with the same passion that she applied to other art works."[24] In the years immediately after 1762, when a coup d'état placed her in power, she commissioned no fewer that twenty-one silver services as special mementos of gratitude for those who had supported her claim to the throne. Lopato also noted that "Catherine II ordered at least fifty different services throughout her reign."[25]

The empress sent many of these ensembles to her newly established Russian *guberniias* (provinces) to be used by the local governors in the course of their

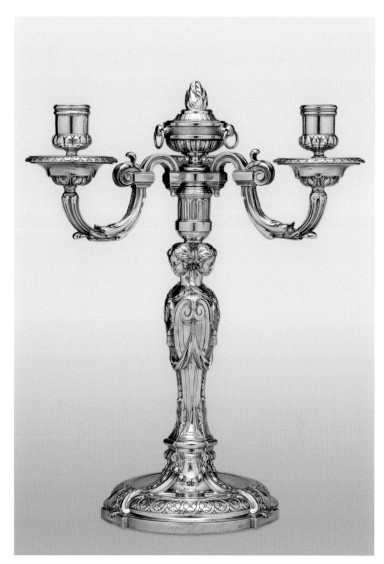

Cat. no. 1. Robert-Joseph Auguste. Three-branch candelabrum (one of a pair), Paris, 1767–68. Silver, H. 14¾ in. (37.5 cm). The Metropolitan Museum of Art, New York. Bequest of Catherine D. Wentworth, 1948 48.187.389a, b

representational duties and by the imperial entourage during its stay in those regions, thus avoiding the need to travel with a cumbersome amount of state silver. She purchased at least seventeen *guberniias* services from western European artisans—five from London, possibly six from Augsburg, and six from Paris. These works were made primarily by well-known master goldsmiths, among the most famous of whom was the Parisian Robert-Joseph Auguste (1723?–1805), acclaimed for his sophisticated and inventive ensembles. Auguste earned favor at the courts of Portugal, Denmark, Sweden, and England (see, for example, cat. no. 1 and fig. 23, p. 34) before being appointed in 1778 as goldsmith to the French court.[26]

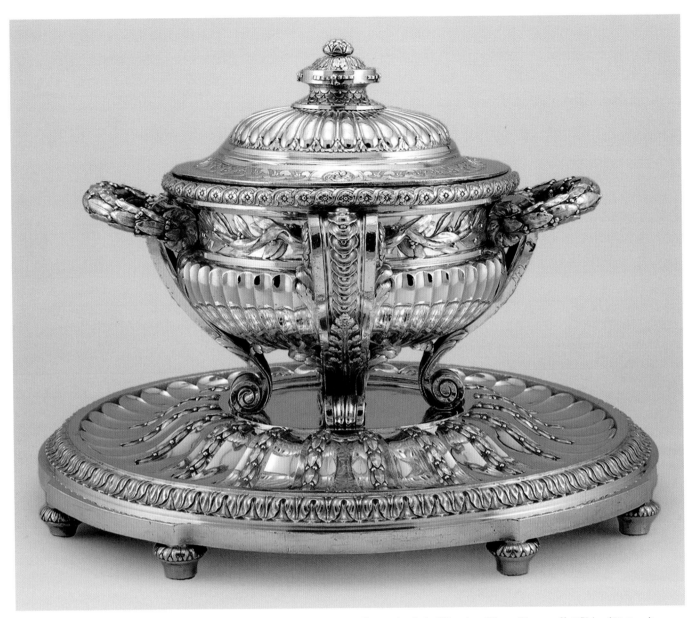

Cat. no. 2. Jacques-Nicolas Roëttiers. Tureen and stand, Paris, 1770–71. From the Orloff Service. Silver, H. overall 13⅞ in. (35.2 cm). The Metropolitan Museum of Art, New York. Rogers Fund, 1933 33.165.2a–c

As was the case among nearly all the princely households, including Catherine's, different services were used for diverse purposes. At the top of the hierarchy were ensembles reserved for exceptional state occasions. The premier state service used throughout Catherine's reign was one in the French Rococo style ordered in 1757 by her predecessor Tsarina Elizabeth Petrovna (1709–1762) and delivered in 1761 by its creator, François-Thomas Germain (1726–1791). A visionary metal artist and tastemaking designer, Germain represented the fourth generation of a continuing line of royal goldsmiths and was granted the extraordinary title

of *sculpteur et orfèvre du roi* (sculptor and goldsmith of the king).[27] The so-called Parisian Service was regularly used despite its gradual decline from fashion at the dawn of Neoclassicism. In his journals, a gentleman usher of the Russian court noted as late as February 5, 1786, that the court celebrated the birth of Grand Duchess Maria (1786–1859) with a "dinner in the Banqueting Hall for thirty guests. . . . The table was set with the silver Parisian Service."[28]

Various "simple" services were designated for daily use. An assemblage of more than five hundred items fulfilled the quotidian needs of the court at Saint Petersburg.[29] The most extensive silver

ensemble of the second half of the eighteenth century, numbering more than three thousand items and intended for sixty guests, was the Orloff Service, commissioned by Catherine to be made by Jacques-Nicolas Roëttiers de La Tour (known as Roëttiers, 1736–1788) in the latest Paris fashion (cat. no. 2).[30] Concerning herself with the smallest details of the design and production, Catherine hired the sculptor Étienne-Maurice Falconet (1716–1791), who had been instrumental in introducing the Neoclassical style to the Sèvres porcelain factory, to advise on stylistic matters. Falconet may have been responsible for some of the drawings referred to by imperial Russian agents who periodically supervised the progress at the various workshops involved in filling this large order. The Orloff Service is a rare document of the exuberant generosity Catherine showered on her favorites. A true Maecenas with "the soul of Caesar and all the seductions of Cleopatra,"[31] as the French philosopher Denis Diderot eulogized her, the empress presented the service in September 1772 to her lover Count Gregory Orloff (1734–1783), who (was) "retired" from that role shortly afterward. Following Orloff's death in 1783, the Crown reacquired the service from his heirs.[32]

Few central European royal families could compete with the virtually unlimited means of the Russian empress or the flagrantly spendthrift kings at Versailles. In hindsight it seems astounding that the conspicuous consumption of luxury products—the décor de la vie—not only by the French aristocracy but also by the new moneyed nobility, reached such a pinnacle of quality and richness of ornamentation in the ten years leading up to the French Revolution.[33] Ironically, although nearly all of France's royal silver services were melted down during the Revolution, many similar examples were preserved, largely through the survival of pieces commissioned by Catherine or other rulers that are now in either Russian museums or the Scandinavian royal collections.[34]

Amor Vincit Omnia (Love Conquers All)

Reflecting on her life, the empress Maria Theresa stated that had she not been pregnant so much of the time, she would have led the Imperial forces into battle herself.[35] This abundance of progeny

was a rare political commodity among the royal houses of Europe, where political alliances were often forged through marriage. As a proud mother, the empress also expected to have as many grandchildren as possible, and she believed in exercising her authority over her offspring regardless of their own hereditary titles and later positions. Their regal duties dominated the family's public life, and despite all personal affection, Maria Theresa did not hesitate to sacrifice her children's happiness for the welfare of the state—with one exception. Among her sixteen children, of whom thirteen survived infancy, the empress's undisputed favorite was Archduchess Marie Christine (1742–1798), who shared her mother's birthday, May 13. The archduchess's obviously privileged status initiated serious conflicts and, eventually, animosity within the family.

Marie Christine, or "Mimi," as she was called, impressed the court with her self-possession, her intelligence, her ability to have her way, and her artistic talents. When in 1760 Mimi's brother the crown prince Joseph married Isabella of Parma, a beautiful and sophisticated young princess eminently suited as an Imperial consort,[36] the lucky groom took an instant liking to his new wife. Isabella's closest relation, however, became Marie Christine. The two enchanting young princesses, both only eighteen years of age, spent as much time as they could together. When the empress and her daughter discussed Isabella, she was referred to as Mimi's "chère moitié" (beloved other half).[37]

In January 1760, two royal Saxon princes, Albert Casimir (1738–1822) and his brother Clemens (1739–1812), arrived in Vienna. After an audience with the empress, they were invited that same evening to attend a concert given by the archduchesses Maria Anna and Marie Christine in the Hofburg Imperial Palace. The latter gained the immediate admiration of Albert, who noted that her "enchanting looks, her faultless figure, and her delightful face were complemented by great liveliness of mind and vivacity—qualities that made me an admirer of hers from the very first moment onwards."[38]

Born at Moritzburg, site of a summer and hunting palace near Dresden, on November 11, 1738, Albert was the son of Frederick Augustus II (1696–1763), elector of Saxony and king of Poland (as Augustus III), and his wife, Maria Josepha of Austria (1699–1757), a first cousin of Maria Theresa's. Albert grew up in Dresden's Royal Palace, home to

the magnificent Electoral Art Chamber, the fabled Green Vault filled with jeweled treasures, as well as separate chambers for silver and gilded-silver parade buffets (displayed in a systematic order), dinner services, and silver furniture assembled by his grandfather Augustus the Strong (1670–1733).[39] Among these was the so-called Double-Gilded Service from Augsburg, which Augustus had commissioned in 1718 in preparation for the four-week-long wedding festivities of Albert's parents in August 1719. The service ultimately included more than two hundred plates and six caddinets, which marked the high status of the heads of the royal Saxon family (cat. nos. 3, 4).[40] These rectangular trays held napkins, personal cutlery, and compartments containing spices and salt. Augustus must have seen this rare example of royal etiquette in use at the court of Versailles, which he visited on his cavalier's tour in 1687.[41] A spectacle that Albert surely would have experienced firsthand was the *Doppel-Hochzeit* (double wedding) of his sister Maria Anna Sophia to the Bavarian elector Maximilian III Joseph and of Albert's brother the *Kurprinz* (heir apparent) Frederick Christian to Maximilian's sister the princess Maria Antonia in 1747. Between 1745 and 1747, the court had some of the silver of Augustus the Strong melted down in order to commission new tableware in the latest fashion for this and other occasions.[42]

During the Seven Years' War in Europe (1756–1763), Prussian forces occupied Dresden, and in 1757 Albert was held hostage in the Residenz together with his sisters and many female court members. Being a dashing prince in the prime of his youth, he complained that he felt as if he were trapped in a seraglio, isolated from the real world. His desperate wish was to join the army and to help regain the power of his family in Saxony. His opportunity to escape from "the seraglio" came during the turmoil that accompanied the capitulation of the Prussian troops in 1759.[43] As a soldier in the Austrian army, he soon experienced the harsh side of war, deprived of personal belongings and forced to sleep on the floor, softened only by straw covered with horse blankets.[44]

From his illustrious ancestors, Prince Albert had inherited the "Wettin collector's bug" but not the means to realize such a costly passion. Like Maria Theresa, Albert's mother had been blessed with many children; of her fifteen offspring, eleven lived to maturity. Although Albert held the titles of prince of Saxony and royal prince of Poland, he was the sixth male heir in line and unlikely to succeed his father. Despite his grand name and pedigree, there was no guarantee that *un pauvre cadet* (a poor cadet), as he called himself, would one day live in surroundings as splendid as those to which his family had accustomed him.[45]

Fortune smiled on Prince Albert, and he survived the war. As an officer, he visited Vienna regularly, and it soon became obvious that Maria Theresa had developed a special affection for her impoverished cousin. She observed with pleasure his "interest in everything beautiful, in the fine arts, [and] his idealistic dreams to do good."[46] Perhaps she missed such qualities in her own sons. Albert's meteoric rise within the Austrian military was propelled by the empress, who in 1763 made him a general with an annual salary of thirty thousand guilders. In November of that year, Isabella of Parma died of smallpox and Archduke Joseph and the court were devastated. Marie Christine mourned deeply as well; however, she also maintained her high regard for the Saxon prince. Although Marie Christine's father preferred to see his daughter on a European throne, Albert, under the protective guidance of the empress, had reason to hope. After the sudden death of Emperor Francis I in 1765, Albert and Marie Christine were engaged even before the official mourning period of the court had ended (fig. 4).

Maria Theresa's fondness for Albert is well documented: she mentions him in her will dated January 15, 1764, before his engagement to her daughter (but "after we [the empress] adopted the prince of Saxony as a child"),[47] and again in another will drawn up almost two years after the death of her beloved husband. The contents of the latter will stated clearly that the household of Marie Christine and Albert was to be subsidized generously until they could assume governorship of the Habsburg Lowlands, which did not occur until 1781 (see p. 71).[48] Further, not only had the marriage contract of April 6, 1766, provided a dowry appropriate for an Austrian princess—containing objects of gold and other precious materials as well as one hundred thousand guilders—but the empress had also written in an addendum that "out of affectionate love and motherly care a special provision had to be made." This special provision granted the couple an additional four million guilders, a

spectacular fortune for that time. Also included was the duchy of Teschen, north of Bohemia and next to Silesia.[49] Thus Albert became both a member of the Imperial family and duke of Teschen. Never in history had a princess of Austria received such a dowry, enabling the couple to maintain a court presence much like that of a reigning sovereign.[50] The addendum was kept secret in order to prevent further bitterness among the rest of the family. Even so, Marie Christine's influence at the Habsburg court grew stronger after her marriage (see figs. 5 and 6 for portraits of the couple during the 1770s), aided by the fact that Joseph II preferred to travel, often staying away from Vienna for months at a time.[51] Joseph's frequent traveling companion was Duke Albert, with whom he visited mines to observe metal foundries and new processing technologies, and who joined him in hunting with a small circle of very close friends. In a letter to his brother Grand Duke Leopold of Tuscany, the emperor wrote, "For myself . . . there could have been nothing more pleasing than to be insured [through Albert's marriage to Marie Christine] for the rest of my life of [his] deep affection."[52] Joseph

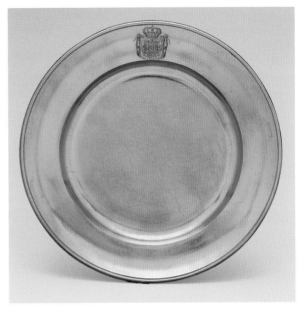

Cat. no. 3. Gottlieb Menzel. Plate (one of a pair), Augsburg, 1730. From the Double-Gilded Service. Gilded silver, Diam. 9¾ in. (24.8 cm). The Metropolitan Museum of Art, New York. Gift of Mr. and Mrs. Charles Wrightsman, 1976 1976.155.40

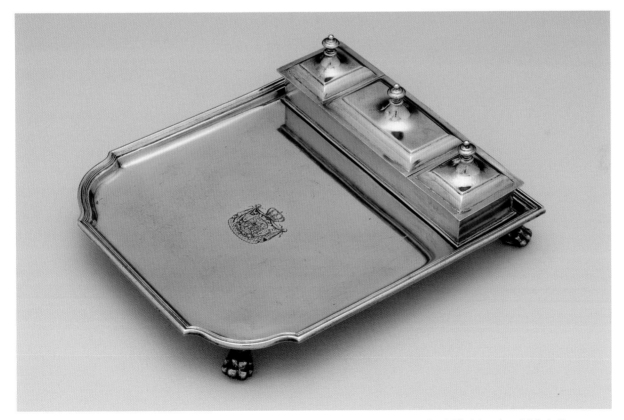

Cat. no. 4. Attributed to Gottlieb Menzel. Caddinet, Augsburg, 1718. From the Double-Gilded Service. Gilded silver, 9¾ × 8¼ in. (24.8 × 21 cm). The Metropolitan Museum of Art, New York. The Lesley and Emma Sheafer Collection, Bequest of Emma A. Sheafer, 1973 1974.356.775

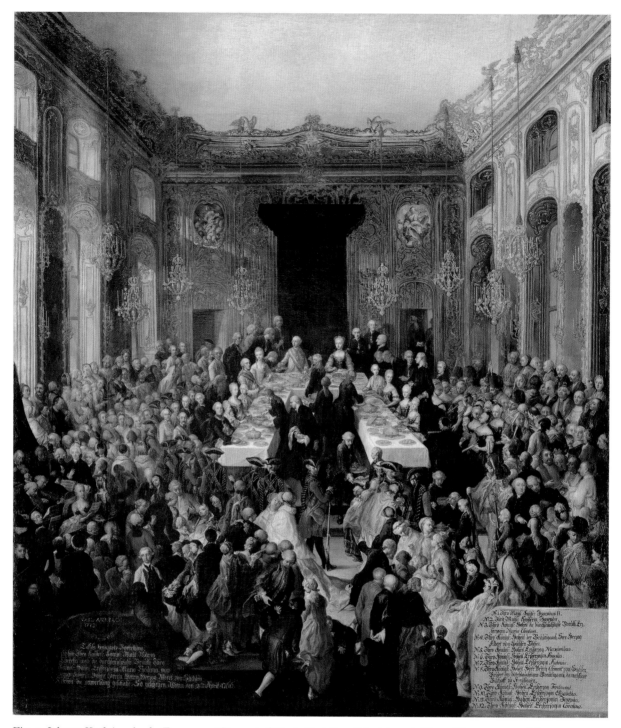

Fig. 4. Johann Karl Auerbach. *Engagement Banquet of Marie Christine of Austria and Albert of Saxony*, 1766. Oil on canvas, 88⅝ × 74¾ in. (225 × 190 cm) Kunsthistorisches Museum, Vienna GG 3150

traveled not only to see firsthand his dominions and the living conditions of his subjects but also to avoid potential tensions arising from ongoing personal and political differences with his mother. His absence was an affront to Maria Theresa, who wrote that "the [incognito and dangerous] travels of the emperor are costing me ten years of my life."[53] As a French courtier commented of the

empress's son and coregent, "He possessed a thousand fine qualities which are of no use to kings."[54]

The culmination of Maria Theresa's political ambitions was the wedding of her youngest daughter, Maria Antonia, called Marie Antoinette, to the Dauphin of France, the future Louis XVI. According to the historian Dorothy Gies McGuigan, "The wedding [in Vienna] was probably the most

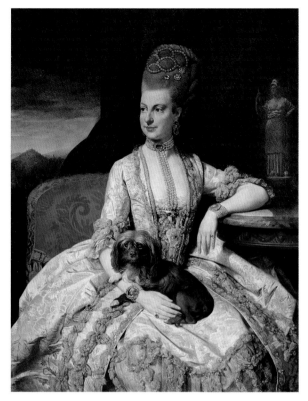

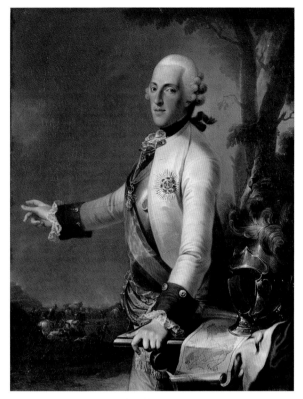

Fig. 5. Johann Zoffany. *Archduchess Marie Christine of Austria*, 1776. Oil on canvas, 51⅝ × 37 in. (131 × 94 cm). Albertina, Vienna

Fig. 6. Anonymous. *Duke Albert of Sachsen-Teschen*, 1777. Oil on canvas, 45⅝ × 36¾ in. (116 × 93.5 cm). Albertina, Vienna. On permanent loan from Kunsthistorisches Museum, Vienna GG 8871

brilliant of a brilliant century. French and Austrian officials had labored over knotty questions of mutual protocol for a solid year and finally given up in despair."[55] On April 16, 1770, at the Hofburg Imperial Palace, the French ambassador, the duc de Durfort, formally asked for the hand of Mademoiselle Antoinette. At the Belvedere Palace, a great nuptial masquerade ball was given for about six thousand guests, but the French ambassador, the official embodiment of the French monarchy, stayed away from the wedding supper because Duke Albert of Sachsen-Teschen had been given preference over him at the table. While the incident represents a great faux pas on the part of the Austrian empress and her entourage, it also provides telling evidence of how far the *pauvre cadet* had come in less than a decade.[56]

The Germains of Vienna: The Würth Dynasty of Goldsmiths

A silver service was a traditional element of a royal bride's dowry. Because there was little time

between Marie Christine's betrothal and the wedding, however, the empress gave the couple a service made in Vienna in 1748 (figs. 7, 8).[57] Large parts of the ensemble had been made by Franz Caspar Würth (master 1734, d. before 1771), who would later oversee production of the wedding service of Joseph II and Isabella of Parma.[58] Similarly, the master likely supervised work on the 1748 service in collaboration with other Viennese goldsmiths, including Johann Philipp Föbell (master 1733–51) and Georg Mathias Hochlehner (documented 1723–48), who are known to have contributed to the effort.[59] Such a division of labor was quite common, given that these services were quite extensive yet had to be completed quickly. Silver agents delegated the orders, and masters with specialized skills often worked together to create huge customized requests in a timely manner.[60]

Now called the First Sachsen-Teschen Service, Marie Christine and Albert's wedding ensemble features stylized shell forms on the plates and dishes as well as pronounced horizontal concave and convex curves on the dish covers. The influence of official architecture that was so present in Vienna's

Fig. 7. Franz Caspar Würth. Round dish, Vienna, 1748. From the First Sachsen-Teschen Service. Silver, Diam. 12½ in. (31.7 cm). Museum Huelsmann, Bielefeld

many ecclesiastical buildings and aristocratic palaces and gardens is evident in this distinctly Viennese design, which merges elegant Italianate Baroque classicism with ornamental details popular at the French court, including the acanthus buds and overlapping acanthus-leaf motifs that decorate the dish covers and finials. The architectural connotations and other aspects of this idiosyncratic, "purified" version of the Rococo style were completely independent of works by contemporary goldsmiths from Augsburg or the wider German-speaking region. No example of a tureen from this service has come to light so far, but a drawing of a Baroque tureen design published by Edmund Braun may provide a clue to its shape.[61]

An isolated surviving example of a totally divergent style during the period of Francis I is a fanciful Rococo centerpiece that features porcelain embellishments over a delicate rocaille-framed structure made of gold and gilded silver. This possibly Viennese work is said to have been made

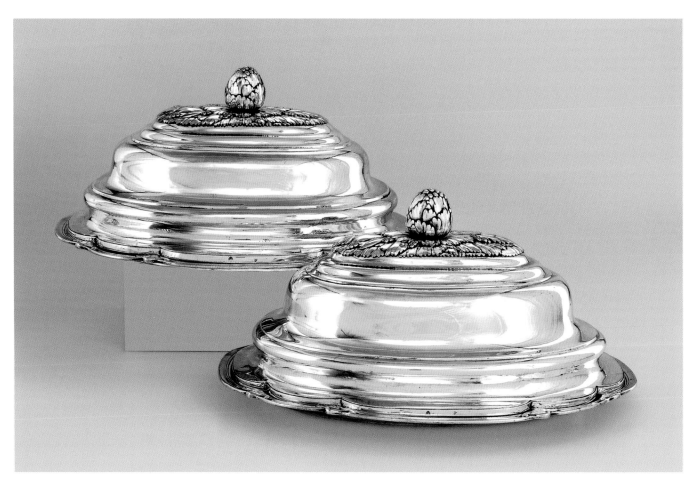

Fig. 8. Franz Caspar Würth. Oval dish with cover, Vienna, 1748. Franz Anton Denner. Oval dish, Vienna, 1774. Johann Philipp Föllbel. Cover, Vienna, 1748. From the First Sachsen-Teschen Service. Silver, H. 9 in. (23 cm). Private collection, Europe

for the emperor about 1760 by Christoph Würth (birth and death dates unknown).[62] The composition was likely influenced by major Viennese and Franco-Flemish works in silver, gold, and porcelain from the collection of Charles Alexander, duke of Lorraine (1712–1780)—the emperor's younger brother and an Austrian military commander— acquired during his time as governor-general of the Austrian Netherlands in Brussels (1744–80).[63] Many of these pieces were financed by Charles's sister-in-law, Maria Theresa, who in 1743 generously allocated fifty thousand thalers for silver tableware to be used in the governor-general's Brussels residence.[64]

Maria Theresa's youngest daughter, Marie Antoinette, also received an example of the Würths' work—representing a more contemporary style than the aforementioned objects—upon the occasion of her marriage. In addition to her trousseau and the famous *réglements* (instructions) given to her by her mother, the Dauphine took with her a precious gilded-silver hanging votive lamp on her historic voyage to France (fig. 9). The Viennese assay mark of 1770 is accompanied by the maker's mark—IS/W in an oval—for Ignaz Sebastian Würth (called Sebastian, 1746–1834 [active 1769– 1815]), the son of Franz Caspar Würth. For such a prestigious commission, he also added his signature, SEB. WÜRTH FE[CIT] 1770.[65] This devotional object not only commemorated Marie Antoinette's trip but also honored her family name with the inclusion of oval Habsburg portraits bearing the designers' monograms of Sebastian's brothers, Johann Nepomuk Würth (1753–1811) and Franz Xaver Würth (1749–1813), both gifted medalists and die cutters. Because the journey excited attention all over Europe, events along the way were meticulously planned to celebrate the glory of the Habsburgs. The composition is crowned by two joined eternally flaming hearts engraved with the abbreviated Latin names of the donors: LUD[OVICUS]: AUG[USTUS]:DAUPH[INUS]: (Ludovicus is Latin for "Louis") and M[ARIA]:ANT[ONIETTA]:ARCH[IDUCISSA]: AUST[RIAE]: (for Marie Antoinette). The consecration asks for the Lord's blessing of the royal union and the promise of the devotees to commit their prayers to Jesus and the Virgin Mary. It seems that the short stay of the young bride in Burgau, a Habsburg-held town nearly halfway between Vienna and Paris, had symbolic meaning for her:

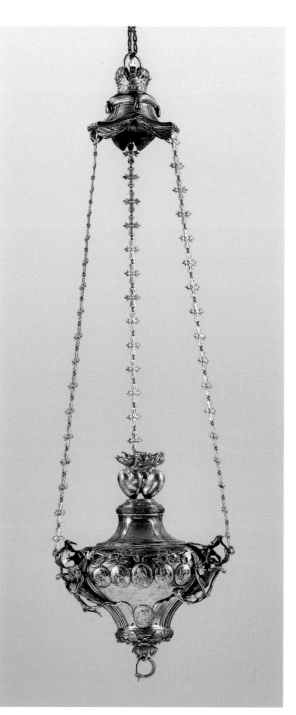

Fig. 9. Ignaz Sebastian Würth. Hanging votive lamp, Vienna, ca. 1770. Silver, partially gilded, H. with chain 44½ in. (113 cm). Münster, Freiburg im Breisgau

she dedicated the lamp to the pilgrim chapel there not long before crossing the border into France.[66]

The ostentatious object was designed in a surprisingly "modern," fully developed Neoclassical style. Sebastian Würth's avant-garde approach immediately influenced other masters, including Joseph Moser (1715–1801),[67] who assisted his teacher Johann Joseph Würth (active 1726–67) in creating the monumental

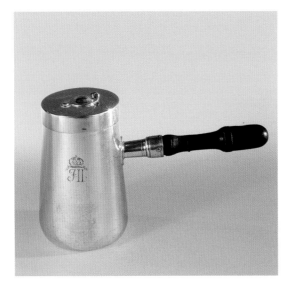

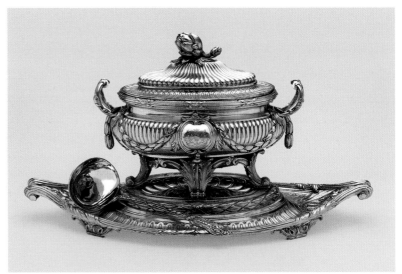

Fig. 10. Ignaz Sebastian Würth. Chocolate pot, Vienna, ca. 1780. Made for Emperor Joseph II. Silver, ebony, H. 5⅞ in. (15 cm). Bundesmobilienverwaltung. Silberkammer, Hofburg Vienna MD 180368/003–004

Fig. 11. Thomas Powell. Tureen with stand and ladle, London, 1769. Silver, H. of tureen 14⅛ in. (36 cm), L. of stand 26 in. (66 cm). Grassi Museum für Angewandte Kunst, Leipzig Inv. 1913.1 a–d.

silver mausoleum of Saint Johannes von Nepomuk (ca. 1345–1393) for the Cathedral of Saint Vitus in Prague, after designs by the architect Joseph Emanuel Fischer von Erlach (1693–1742) and the sculptor Antonio Corradini (1668–1752).[68] In 1768 Moser made a silver votive lamp for the Romanian pilgrimage church Maria Radna in what was basically still a curved Rococo formation but that incorporated some transitional Neoclassical elements. Comparison of this lamp with several *vasa sacra* (sacred vessels), dated 1772 and 1773, that reflect the fully adapted Neoclassicism (or *Josephinischer Zopfstil*, as it was called in Austria), demonstrates how quickly Sebastian Würth's progressive creations were adopted.[69]

It is interesting to note that Neoclassical laurel swags (hence the name *Zopfstil*, or "plait style," a colloquial term that was applied uniformly to all objects made in the old [specifically, ancient] or retrospective fashion) were already present in the silver antependium (altar frontal) for the main altar of the pilgrimage basilica in Mariazell (Styria). Designed by the sculptor Balthasar Ferdinand Moll (1717–1785), the Imperial monument commissioned by Maria Theresa was produced, as noted in the Bayreuth newspaper of September 2, 1769, by the "Viennese gold- and silver worker Mr. Sebastian Würth."[70] The three-sided antependium was melted down in 1793, but its innovative design survives in

prints.[71] Amazingly, it would not be until 1770 that Sebastian Würth entered the Viennese goldsmith guild as an official master; from that point, however, his reputation grew quickly and, although he continued to receive commissions from Maria Theresa and her son Joseph (see, for example, a chocolate pot made for the latter, fig. 10; the pot's simple, minimalist design reflects its function as an *egoist*, or object intended for one person, in contrast to the very ostentatious and publicly displayed silver parade objects[72]), his fame soon reached beyond the borders of the Habsburg dominions. In 1772 Anton von Maron (1733–1808), an Austrian painter living in Rome, the brother-in-law of Mengs noted for his portrait of Winckelmann, received a silver service from Würth.[73] Nothing is known about its design or extent, yet the fact that a cosmopolite living in Rome, the focus of any grand tour, would commission contemporary silverware from a Viennese goldsmith is remarkable. Maron may have acted as an agent for an affluent patron and not on his own behalf, but either way he surely supplied Sebastian with drawings or prints to guide the craftsman toward the desired results at a reasonable price.

Further evidence of the Würth family's international renown can be found in a request from the court at Hanover to submit designs for a stately silver service for King George III of Great Britain

(1738–1820), who served (from London) as prince elector of Hanover in Germany until his elevation to king of that region in 1814. Responsibility for this undertaking fell to the Hanoverian palace governor Heinrich Julius, Imperial Baron of Lichtenstein (1723–1789), who was later promoted to Lord Marshal.[74] It took months to melt down enough "old silver" (certainly hundreds of items) to reach the British king's goal of raising eighty thousand *Reichsthaler* (coinage of the Holy Roman Empire) for an ensemble "to serve in the present way," in other words, a *service à la française*.[75]

The admirable research of Lorenz Seelig reveals the complicated process of fulfilling King George's order: "specifications" from 1770 call for a large service to be made using an estimated 3,500 marks (approximately 1,797 lbs. or 815 kg) of silver, including no fewer than six hundred plates, as well as centerpieces, or *surtouts de table*, tureens, and many other accessories. The original plan to employ a local goldsmith was abandoned in favor of commissioning an ensemble of indisputably high fashion from a cultural center outside of Germany; thus, not even Augsburg was considered. Instead, twenty-two drawn designs for various items were commissioned from a currently unknown Parisian workshop.[76] The unifying element of the major items shown in the drawings was the integration of exaggerated curving and figural parts, reflecting the late French Rococo fashion as exemplified by François-Thomas Germain. Despite the slightly antiquated style represented in these drawings, the monarch and especially the high court officials esteemed Paris as the leading city of taste. Why King George, who by the 1770s had already begun to contemplate a "retreat" to his Hanoverian dominions, did not favor a London goldsmith remains a mystery. That creative artisans of the English capital were able to produce outstanding and stylish silver is verified by a tureen with stand and ladle crafted in 1769 by the London goldsmith Thomas Powell (fig. 11).[77] Perhaps the king feared that an order of such ostentatious luxury would have invited negative attention in the midst of his country's economic and political difficulties. Even so, it seems strange that the king purchased this monumental silver ensemble for his Continental residence, which he never visited, while his English court continued to use much earlier silver services that were at that time considered *démodé*.[78]

The story of the Hanover service underscores the fact that, while King George and his Francophile advisers excluded German goldsmiths from their discussions, they did consider masters in Vienna and Rome. On August 3, 1772, the Parisian drawings were dispatched to Vienna, where Heinrich Julius of Lichtenstein was staying, and it is likely that he used this opportunity to show the designs to a member of the Würth family. In October 1773 (more than one year later), a "Goldschmidt Wihrt, in Wien," was allocated a small payment for four large drawings of "*Terrinen und denen darzu gehörigen Unter Schüsseln*" ("tureens with matching under dishes [stands]") and some other designs.[79] As someone with high skill and knowledge of the latest Neoclassical designs was required, the artist was probably either Ignaz Franz (Joseph) Würth or Ignaz Sebastian Würth.[80] Added to the mix in late 1772 or 1773 was a payment, for thirteen drawings, transferred from Hanover to the famous goldsmith Luigi Valadier (1726–1785) in the Eternal City.[81] The connection was possibly made through the German Neoclassical architect Friedrich Wilhelm von Erdmannsdorff (1736–1800), who traveled to Italy in 1770–71 and acquired similar types of drawings for the court in Dessau (see fig. 26). Also certainly instrumental was Johann Ludwig von Wallmoden-Gimborn (1736–1811), an illegitimate son of King George II who served as British ambassador to the Habsburg court between 1766 and 1786. Wallmoden-Gimborn visited Rome frequently, knew Winckelmann, and—to close the circle of connections—in 1780 was portrayed with his wife, Charlotte Christiane, by Anton von Maron.

In the end, however, it was the Parisian Robert-Joseph Auguste who received the contract for a silver service in the early Neoclassical style. Begun in 1776, the service would not be completed until 1787. In light of the brief consultation with a "Wihrt" (Würth) in 1772, it is interesting to note that, between 1790 and 1801, the Hanover set was enlarged with, among other items, a mirrored tray and a number of other pieces marked 1799 by none other than Ignaz Sebastian Würth.[82] By that time, the Würths had come to be regarded as the best European goldsmiths of their era. As Edmund Braun would remark more than a century later: "Was die Germains für Paris, waren die Würths für ihre Heimatstadt" (What the Germains were to Paris, the Würths were to their native town).[83]

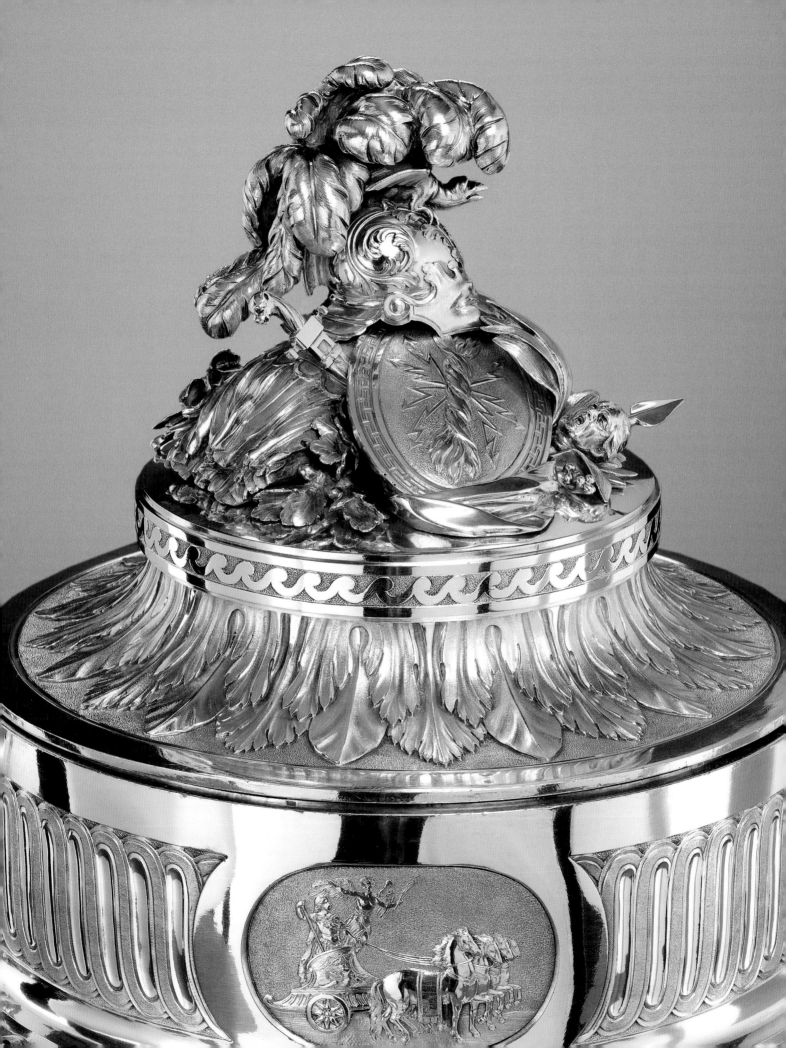

The Rise of Vienna as a Cultural Center

Establishing a Viennese School of Decorative Arts

Artisans and patrons alike traveled frequently throughout Europe, albeit under often very different circumstances. The resulting close connections among artistic communities, bright courtiers, fast-acting agents, and learned clients (as well as spoiled aristocrats in search of "only the best") came as no surprise. That these various communities and players engaged in spirited competition for cultural hegemony was also no surprise.

After serving as ambassador to the French court from 1750 to 1752, Count Wenzel Anton von Kaunitz-Rietberg (1711–1794), one of Austria's leading politicians, was charged with raising the level of workmanship among local entrepreneurs, manufacturers, and artists in order to achieve cultural and economic independence from European centers such as London and Paris. Kaunitz encouraged a foundation of theoretical learning and the study—mainly through prints—of ancient monuments and foreign works of art.[84] A Schule für Fabrikanten (School for Manufacturers) was established in 1758 by Florian Zeiss, who had studied in Paris.[85] In 1772 the school was united with the Graveurakademie (Academy of Engravers), which had existed since 1767 under the direction of the well-traveled goldsmith Anton Mathias Domanöck (1713–1779).[86] The following year, Empress Maria Theresa merged the various schools of teaching for all artistic professions, including painting, sculpture, and applied arts, into the Kaiserliche königliche vereinigte Akademie der bildenden Künste (Imperial [and] Royal United Academy of Fine Arts).[87] The academy's newly assembled library and collection of prints and plaster casts after ancient sculptures and monuments, as well as access to the Imperial painting collection, served to inspire and instruct its students. Great emphasis was placed on drawing objects in the studio and figures from life so as to capture reality as closely as possible.

Not only was Mathias Domanöck an important teacher at the academy, he had also been a Viennese goldsmith master since 1737. His notable early works include a chandelier with rock crystal and branches of polished steel made in 1750 as a gift from the empress to the Danish king. The chandelier's metalwork surface is so finely detailed and finished that it was described in an inventory of Rosenborg Castle in Copenhagen "as made of silver."[88] Today the chandelier resides in the royal collection at Christiansborg Palace, Copenhagen. Domanöck's best-known works are the gold garniture (breakfast service) of Maria Theresa and the matching toilet set of Francis I, made about 1750, both preserved in the Kunstkammer of the Kunsthistorisches Museum in Vienna.[89] These celebrated gold ensembles were designed in the same period that Franz Caspar Würth conceived the First Sachsen-Teschen Service, as evidenced by their strongly Italianate, late Baroque shapes.

Also closely involved with the Academy of Engravers was the multitalented Johann Baptist Hagenauer (1732–1810), a sculptor and decorative artist who had worked and taught in Vienna since 1774. After Domanöck's death in 1779, Hagenauer took over as the academy's director. He was a protégé of Prince Kaunitz, who recognized that the artist's strong attachment to Italian studies and his working discipline developed in Salzburg could contribute enormously to the Viennese artistic environment. As a sculptor, Hagenauer was involved in the decoration and design of fountains in the gardens of Schönbrunn Palace (ca. 1773–80). As a teacher, he focused on advancing the decorative arts. Hagenauer's influence would be of crucial importance for the rise of Neoclassicism in Vienna

and for the synthesis of a specifically Viennese ornamental vocabulary.[90]

Domanöck counted among his students at the academy several members of the Würth family, including the medalist Franz Xaver Würth, who was inspired to visit Rome several times from 1777 to 1779.[91] Rainald Franz pointed out that "principally gold- and silversmiths were among the students of the 'Graveurschule' of Johann Hagenauer. The designs of the Würth family . . . and those of [the goldsmith] Josef Moser (1715–1801) occupy in quality the first rank. The Würths were already the leading [dynasty] in the goldsmith's art during the eighteenth century. Ignaz Joseph Würth was the creator of the most important artistic silver objects of Viennese classicism."[92]

Ignaz Joseph Würth, the artisan who may have supplied drawings for the Hanover silver service in 1772–73, was born in 1742 and became master in 1770 (fig. 12). Ignaz Joseph was the son of Johann Joseph Würth (active 1726–67), who in 1736 signed his name on the monumental silver mausoleum of Saint Johannes von Nepomuk in Prague. When Johann Joseph died in 1767, his widow Anna carried on the workshop for at least two years until their son took over in 1769.[93] It was standard practice in most European guilds that a master's widow could run the business for a specified length of time, or until she remarried or one of her children was ready to assume the responsibility,[94] and in fact, after Ignaz Joseph's death in 1792, his widow, Theresa, continued his workshop.[95] Her name is mentioned in the records of the local guild until 1803 and in the commercial tax registers until 1804.[96]

Ignaz Joseph Würth grew up during the Age of Enlightenment blessed with a vast family network and an extraordinary talent. Several silver objects document that he used his father's maker's mark until about 1780–81 (see fig. 25) before taking on one of his own. The young goldsmith worked tirelessly to forge divergent family tendencies into a

Fig. 12. Signature of Ignaz Joseph Würth. From *Wiener Silber: Punzierung, 1524–1780* (Viennese Silver: Hallmarks, 1524–1780 by Waltraud Neuwirth (Vienna, 2004), p. 327

"Würth Style," whose sophistication and cultural impact led contemporaries to call Vienna of about 1780 one of the most visionary places in Europe.

The Goldsmith as Sculptor in Bronze

Most eighteenth-century artisan guilds were divided strictly among different professions in order to restrict the market and guarantee a certain income for each member. Thus it was unusual—at least in the German-speaking areas—for a goldsmith and master of a guild to work in metals other than gold and silver. Yet the tradition among the Habsburg dominions was to allow court craftsmen to work in gold and silver, bronze, and other metals outside the ordinary restrictions of their respective guilds.[97] Only a few similar workshop structures could be found among the outstanding European ateliers: Parisian examples included studios operated by Thomas Germain (1673–1748) and his son, François-Thomas Germain, and by Robert-Joseph Auguste and his son, Henri Auguste (1759–1816);[98] in Rome, Luigi Valadier managed the most renowned of these manufacturers.[99]

In 1770 Franz Anton Domanöck (1746–1821), son of Mathias Domanöck, delivered to Marie Antoinette in Versailles a small pedestal table, or gueridon, made by his father at the request of Marie Christine and Albert (fig. 13).[100] The top of petrified wood was an extremely rare curiosity; once owned by King Charles I of England, it had been sold in 1649 before ultimately entering the Habsburg collections. The metal artist likely supplied the archduchess and duke with various designs for mounting the precious material, which was considered a wondrous natural work of art (*naturalia*) in itself. The intention was to enhance the polished slab's beauty with an equally refined support. The Metropolitan Museum of Art owns several related drawings, all nearly lifesize; one is a proposed design for the top, and four others suggest ideas for the stand (cat. no. 5). They are part of a wide range of designs and inventory drawings for other decorative objects that once belonged to Duke Albert.[101] Their presence, and the fact that the table was a gift from Marie Christine and the duke, indicate the patrons' intense involvement with the order. The boldly Neoclassical designs for the stand incorporate strong citations from the ornamental vocabulary of the

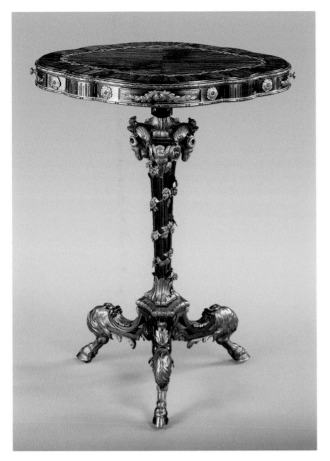

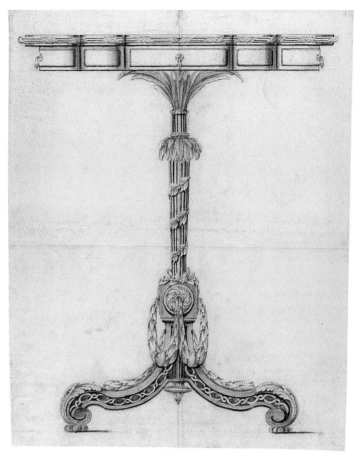

Fig. 13. Anton Mathias Domanöck. Pedestal table with inlaid top, Vienna, 1770. Petrified wood, steel, gilded bronze, H. 33⅝ in. (85.5 cm). Musée national des châteaux de Versailles et de Trianon Inv. 78-000933

Cat. no. 5. Design for elevation of a table, Austria, ca. 1770. Pen and brown and black ink, black and red chalk, and graphite, 34¼ × 26⅛ in. (87 × 66.5 cm). The Metropolitan Museum of Art, New York. Gift of Raphael Esmerian, 1963 63.547.14.4

architect and ornamental designer Jean-Charles Delafosse (1734–1789), whose patterns were engraved and widely published in the late 1760s. In comparison to the pattern shown here, the other three plans are even more ornate, with heavy gilded moldings around the stone panel. One sheet even displays urns in the Greek manner resting on each scroll foot as well as substantial gilded laurel swags hanging from the underside of the tabletop and crossing with *soleil* rosettes as they twine around the tapering shaft, all reflecting a Parisian influence.[102] The executed table still differs considerably from all the designs. Its stand is embellished with feet in the form of curved hooves and, toward the top of the shaft, ram's heads inspired by ancient Roman tripods like those excavated in Herculaneum. The object is further enriched with naturalistic rose blossoms, embracing garlands, and other whimsical flower and leaf motifs that represent a retrospective Rococo approach and a more feminine

touch. The table is signed and dated An: Domanöck Inv[enit] et Fe[cit] [1]770 Viennae Aust[ria].[103] The master noticeably states that he invented (*invenit*) the design and made (*fecit*) the object. The gueridon attests that Domanöck was an artist working in precious metals and other materials, and his graceful creations bridge with ease the threshold between craftsman and sculptor.

Like Domanöck and other of his colleagues, Ignaz Joseph Würth worked in bronze as well as gold and silver. In this medium he has hitherto been known only through a pair of vases made of petrified wood and embellished with intricate gilded bronze mounts (cat. no. 6). The wondrous material originated from deposits in Hungary, where Albert had been governor and captain-general since 1765.[104] The bronze bases are inscribed Jos[eph].Würth Fec[it].Vienna 1780. As Maria Theresa must have received these magnificent Neoclassical vases shortly before her death on November 29 of that year (they were

Cat. no. 6. Ignaz Joseph Würth. Pair of vases, Vienna, 1780. Petrified wood (Hungary), gilded bronze, H. 15¾ in. (40 cm). Petit Trianon, Musée national des châteaux de Versailles et de Trianon Inv. T 517 C

mentioned in her will), it is likely that Marie Christine and Albert, by then leading arbiters of taste in Vienna, were involved in their commission.

After fifteen long years as coregent, Joseph II finally became sole ruler of the Holy Roman Empire upon the death of his mother. On February 17, 1781, the emperor sent a message to France that a shipment with objects (including the vases) bequeathed by Maria Theresa to the French royal family was en route. The recipient of the vases was not, however, Marie Antoinette, as is often stated. Thanks to the research of Christian Baulez, it is now known that the items were expressly intended for King Louis XVI as personal mementos from his mother-in-law.[105] As such, the vases ultimately would be counted among the official French royal furnishings

and thus considered property of the Crown. The Viennese masterworks received prominent placement in the royal household: the king kept them in the dining room of his *appartement intérieur* at Versailles. Later they were installed at the gallery of the Grand Trianon and, in the nineteenth century, moved to the Petit Trianon, where they became associated with Marie Antoinette's private collection. Indeed, the queen was so enchanted by the vases that in 1783 she ordered a pair with mounts of similar quality to be made by the famous *bronzier* François Rémond (ca. 1747–1812) in Paris (today at the Musée Nissim de Camondo, Paris).[106]

The Würth vases, Mathias Domanöck's table as well as a cut-steel vase also by him, together with some earlier works in bronze allow one to assume the

Cat. no. 7. Design for an urn (potpourri), Austria?, ca. 1770–85. Pen and brown ink, graphite, 14¾ × 9⅜ in. (37.3 × 23.7 cm). The Metropolitan Museum of Art, New York. Gift of Raphael Esmerian, 1963 63.547.9

Fig. 14. Covered vase (one of two), Japan, Arita, Edo period, 1603–68; mount, Vienna, ca. 1775–85. Porcelain, gilded bronze, H. 19¼ in. (49 cm), Diam. 11⅞ in. (30 cm). Sammlungen des Fürsten von und zu Liechtenstein, Vaduz–Wien PO 1822a

presence of a relevant local industry.[107] Comparison of some of the Metropolitan Museum's drawings from the Sachsen-Teschen collection (cat. nos. 7, 8) with the overall appearance and stylistic details of the documented Versailles vases, and close visual examination of the metal's surface finish, provide solid evidence for this assumption and establish a framework for attributing to the Würth workshop a variety of gilded bronze ornaments, candelabra, and mounts for porcelain. Given the family members' ability to adapt successful shapes in new combinations without intrusive repetitions, as well as the close ties of the cousins Ignaz Joseph and Ignaz Sebastian, the following discussion of works attributed to Ignaz Joseph should be viewed as an initial concept meriting further research.

In 1782 a "Joseph W." received payment for a bronze table delivered to Emperor Joseph II. It is likely that Ignaz Joseph Würth was its creator.[108] Imperial commissions of an unusually high volume and/or with a tight time frame were shared to keep the order within the family. In 1783–84, for example, the workshops of both Ignaz Joseph and Ignaz Sebastian Würth cooperated to "make new court silver out of old inventory [of the silver chamber]" for Joseph II.[109] Nothing is known about the appearance or quantity of these newly fashioned items because only a decade later, in 1793, all silver tableware was sent to the mint on the order of Emperor Francis II, who wanted to provide a public example of thrift during the French revolutionary wars. One year later the emperor went to the extreme of ordering a service for two hundred made out of sheet metal for a trip to the Lowlands.[110]

As with gold- and silverware, the majority of Imperial court objects in other metals were also vulnerable to being melted down in times of war or changing fashions, so that almost nothing from eighteenth-century Vienna has been preserved.[111] Yet in initial studies published in the Metropolitan Museum exhibition catalogue *Liechtenstein: The Princely Collections* (1985), Clare Le Corbeiller suggested a Viennese source for a group of gilded cast-bronze mounts for exotic porcelains. She further

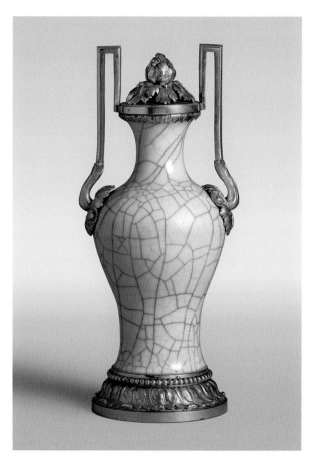

Cat. no. 8. Design for an urn (potpourri), Austria?, ca. 1770–85. Pen and brown ink, graphite, 14⅝ × 9⅝ in. (37.1 × 24.3 cm). The Metropolitan Museum of Art, New York. Gift of Raphael Esmerian, 1963 63.547.10

Fig. 15. Vase (one of a pair), China, 18th century; mounts, Vienna, ca. 1775–85. Celadon porcelain, gilded bronze, H. 11⅜ in. (29 cm). Sammlungen des Fürsten von und zu Liechtenstein, Vaduz–Wien PO 1854

proposed that the porcelains had traveled from the Far East to Vienna via Prague during the reign of Emperor Charles VI (d. 1740), probably sometime between 1722 and 1731, when the monarch owned the Ostend (Dutch East India) Trading Company.[112] Le Corbeiller's theory is plausible given Vienna's location and the fact that the Southern Lowlands were part of the Habsburgs' realm for most of the eighteenth century; however, Austria's proximity to Italian ports and international trade routes may inspire further exploration of the porcelain's origin.

The bronze-mounted porcelains illustrated here, likely acquired by Prince Franz Joseph I of Liechtenstein (1726–1781), represent a range of decorative styles in vogue during the last quarter of the eighteenth century. Among the most magnificent is a pair of Arita porcelain jars from Japan's Edo period (1603–68) embellished with gilded-bronze bases to raise the height of the jars (fig. 14). Gilded friezes of laurel festoons are attached to

rosettes that adorn bands pierced in interwoven patterns, allowing the scent of the potpourri inside to emerge. The swags' ends hang down unevenly, forming a rhythm that harmonizes with the rocky landscapes painted on the porcelain jars. A design for a potpourri urn, originally in Duke Albert's collection (cat. no. 7), confirms the contemporary preference for heavy finial compositions.

In the same Viennese workshop, a Chinese celadon vase was adorned with extravagantly high rectangular bronze handles and a pearl-string motif at the base (fig. 15). These representations of the Neoclassical style are reminiscent of similar motifs in a drawing for a potpourri urn; there, however, an asymmetrical bow tie adds a whimsical detail (cat. no. 8). Four small porcelain vases made during China's Kangxi period (1662–1723) were beautifully transformed as stems for a group of three-branch candelabra (fig. 16).[113] Similar urn-shaped finials with an eternal-flame motif, as well as nozzles supported

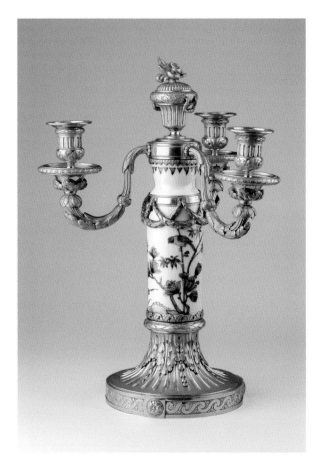

Fig. 16. Three-branch candelabrum (one of four), China, Jingdezhen, Kangxi period (1662–1723); mount, Vienna, ca. 1775–85. Porcelain with underglaze of cobalt blue painting, gilded bronze. H. approx. 18½ in. (47 cm). Sammlungen des Fürsten von und zu Liechtenstein, Vaduz–Wien PO 2012

by acanthus-covered branches, can be found on a set of four gilded-bronze three-branch candelabra that were supposedly sent to Prince Karl Hieronymus Pálffy von Erdöd (1735–1816) for his palace at the Josephsplatz in Vienna.[114] A slightly more eccentric Viennese example is a pair of bronze candelabra formerly in the Stroganoff Collection in Saint Petersburg and originally attributed to Jean Louis Prieur (ca. 1732/36–1795). Datable to about 1775, the candelabra feature heavy pedestal stands and shafts that divide into tripod shapes, forming three massive branches for candles.[115]

The most extraordinary of these bronze-mounted porcelains is a monumental candelabrum made with eighteenth-century blue and white Chinese porcelain (fig. 17), likely commissioned by the Liechtenstein family for a very specific chinoiserie cabinet or room. Kneeling Tritons of gilded calcite stone shoulder a high round pedestal, and a gilded rosette frieze behind their heads supports the large

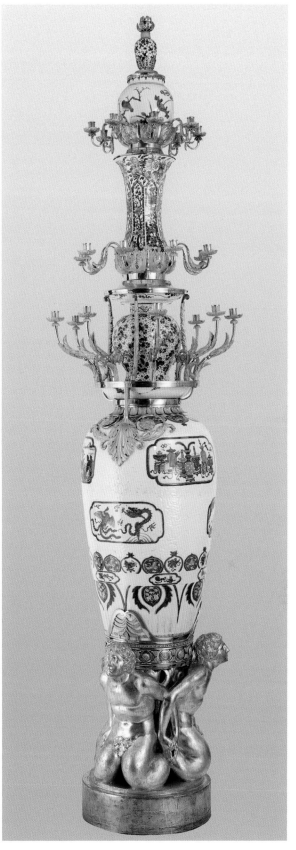

Fig. 17. Candelabrum (one of four). Vases, bowl, and plates, China, early 18th century; mounts, Vienna, ca. 1775–85. Porcelain, gilded calcite, H. 10 ft. (3.06 m). Sammlungen des Fürsten von und zu Liechtenstein, Vaduz–Wien PO 2571

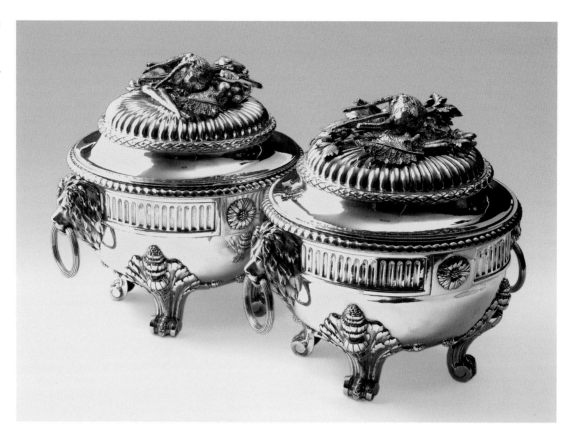

Fig. 18. Ignaz Sebastian Würth. Two tureens, Vienna, 1781. Silver, H. of each approx. 12 in. (30.4 cm). Winterthur Museum & Country Estate, Delaware

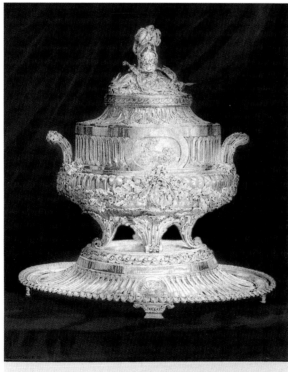

SOUPIÈRE EN ARGENT REPOUSSÉ ET CISELÉ

Exécutée par François-Thomas Germain, pour l'Impératrice Catherine II de Russie.

Fig. 19. Tureen (fig. 20), as published in Henry Havard, *Histoire l'orfèvrerie française* (Paris, 1896) and attributed to François-Thomas Germain

bottom vase. The sculptural style of the figures points to the inventions of Johann Hagenauer, but the ornamental design of the scrollwork frieze relates closely to the *frises des rinceaux* on the Second Sachsen-Teschen tureens (see. cat. no. 17, for example). The higher sections consist of porcelain vases surmounted by porcelain dishes whose rims are decorated with polished bands, three of which hold elaborately worked ormolu branches and nozzles that relate to the smaller candelabra just mentioned.[116]

The Development of Viennese Neoclassicism

A Viennese court document of 1770 specifies a silver service for "archduchess Marie Christine."[117] More than two-thirds of the 15,242.15 florins (guilders) paid for the service went to the "Imp[erial] Roy[al] Court-Goldsmith" Domenicus Sutorell (or Sudurell, 1713/14–1788); the balance was received by the silversmiths Johann Georg Sutter, Joseph Stadler, and one "Johann Christian Bahn, *Jubelier* (jeweler)."[118] Little is known about this order, except that its cost suggests a relatively small service. In 1774 the First Sachsen-Teschen Service was repaired

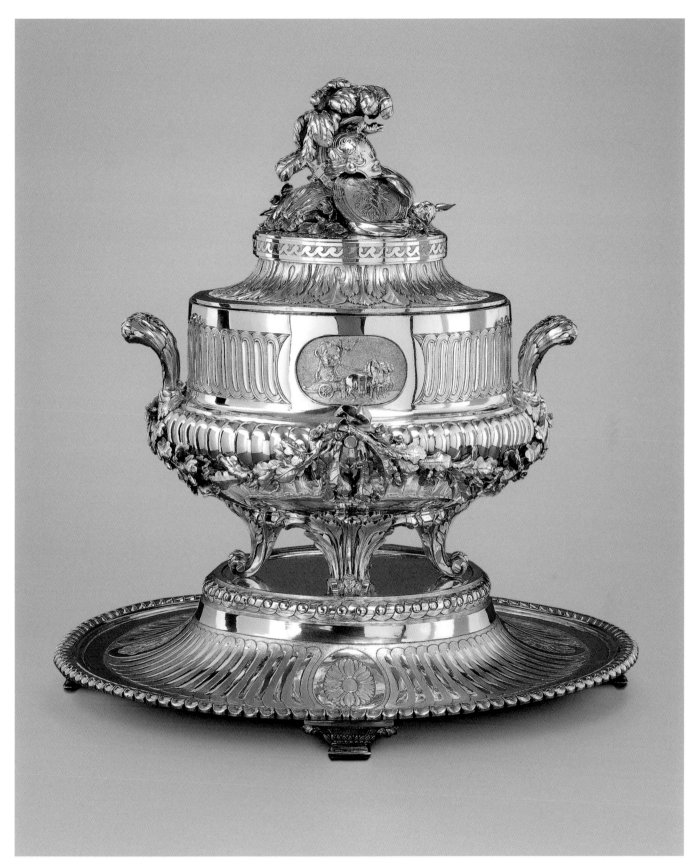

Fig. 20. Ignaz Joseph Würth. Tureen with cover, Vienna, 1775. Ignaz Krautauer, stand, Vienna, 1781. Made for Emperor Joseph II. Silver, H. of tureen 15¾ in. (40 cm), Diam. of lip 10¼ in. (26 cm); H. of stand 4 in. (10 cm), Diam. of stand 18⅞ in. (48 cm). Private collection, France

and extended (see fig. 8).[119] Edmund W. Braun has associated this ensemble with a set of six tureens, four of oval shape and two round examples (fig. 18),[120] which also passed into the silver chamber of the dukes of Sachsen-Altenburg. In 1966 the Campbell Museum (Camden, N.J.) aquired the two round tureens from Jacques Kugel; they are now at the Winterthur Museum in Delaware. The tureens' design is fully Neoclassical and they are marked by Ignaz Sebastian Würth and the date 1781. Their solid craftsmanship, size, and high-volute feet indicate that all of the tureens in this group were once supported by stands, or *présentoirs*. Braun documents a single oval example with stand.[121]

Stylistically, these objects relate to a lidded tureen and stand published in 1896 in Henry Havard's *Histoire de l'orfèvrerie française* as "made by François-Thomas Germain for Empress Catherine II of Russia" (fig. 19). This bold ex cathedra judgment was underlined by an accompanying color illustration in a volume that is considered one of the first great surveys of the best French gold and silver work.[122] The tureen's perfect craftsmanship and exuberant design, which transforms a domestic object into a sculptural monument *en miniature* guaranteed to dominate a princely dining table arranged *à la française*, were reason enough for Havard to identify it as French and its maker as the famous Germain. Yet through the aid of another great connoisseur of European gold and silver work, Alexis Kugel in Paris, the author was able to examine further this extraordinary object, which today is preserved in a private collection (fig. 20).[123] The "Roman" conqueror driving the quadriga in the oval panel of the tureen (fig. 21) has a distinguished profile that can be connected to a wax relief formerly in the Kaiser Franz Josef Museum in Troppau (today the Slezské Zemské Muzeum in Opava, Czech Republic). Edmund Braun identified the wax modello as the likeness of the young Joseph II in the manner of a "Roman king" and its signature, J. Würth F[ecit], as that of Johann Joseph Würth, the father of Ignaz Joseph Würth.[124]

In making his attribution, Havard was surely influenced by the tureen's imposing lid, crowned by a sculpted trophy with weapons and the head of an enemy warrior, as well as an ancient shield and stylized helmet of Minerva. It is true that portraits of Catherine the Great document that the empress loved to be depicted as the Roman goddess of war,

wisdom, and commerce; in fact, she was continuing an iconography that extended back to images of Roman commanders and even to Alexander the Great.[125] Further, the finial's design also reflects a standard motif used in sculptural elements of Baroque architecture. Johann Baptist Hagenauer carved similar armorial motifs in stone for the *Gloriette* (little glory) in the garden of the Schönbrunn Palace in Vienna. The ensemble's triumphal architecture, called *Monument to Just War*, glorified the Habsburg rulers; a central tablet is inscribed with the date of 1775 below the names of Joseph II and Maria Theresa.[126] Bringing the Viennese connection full circle are the tureen's hallmarks: on the lid are those of Ignaz Joseph Würth and the Vienna town mark of 1775; on the stand are the mark JK in ligature, representing another famous Viennese goldsmith, Ignaz Krautauer (master 1771, d. 1787), and the Vienna town mark dated 1781.[127] The tureen appears to be the rare survival of an Imperial court silver service that was made over a period of some years for Joseph II. It is otherwise known only through an image of a matching dish and cover whose current whereabouts are unknown.[128]

In 1775 Ignaz Krautauer made a monumental ewer (cat. no. 10). In emulation of the best French masters (fig. 23, cat. no. 9) and some of his local colleagues (see fig. 9), Krautauer added a highly visible signature at the base of the ewer: GEMACHT DURCH IGNATZ[sic] KRAUTAUER ZU WIENN[sic] IN DEM JAHR 1775 (Made by Ignaz Krautauer in Vienna in the Year 1775). Such an aggrandizing practice was tolerated by patrons only for objects of exceptional quality created by the most famous artisans of their time.[129] The ewer's handle (fig. 22), reminiscent of dolphin-shaped motifs, as well as the spout and, especially, the domed lid with stylized shell ornaments are strongly influenced by the late French Rococo (cat. no. 12), whereas the lower body reflects the recently adopted heavy version of Neoclassicism.[130] These elements, and the waisted neck with classicizing channels, document an important transitional step in the stylistic development of eighteenth-century Austrian silver. During the 1889 "Goldschmiedekunst-Ausstellung im Palais Schwarzenberg" (Goldsmith Exhibition at the Palais Schwarzenberg) in Vienna, one of the most important exhibitions of its kind, the ewer was part of an ensemble that included a

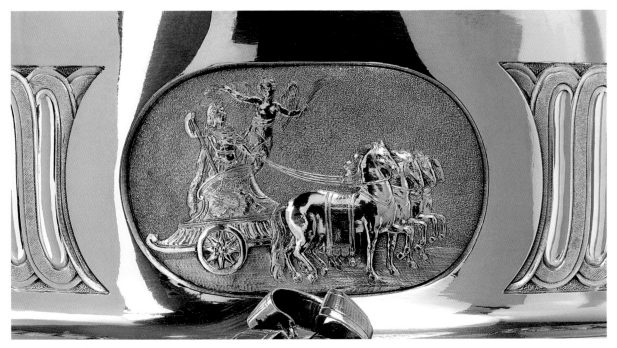

Fig. 21. Detail, fig. 20

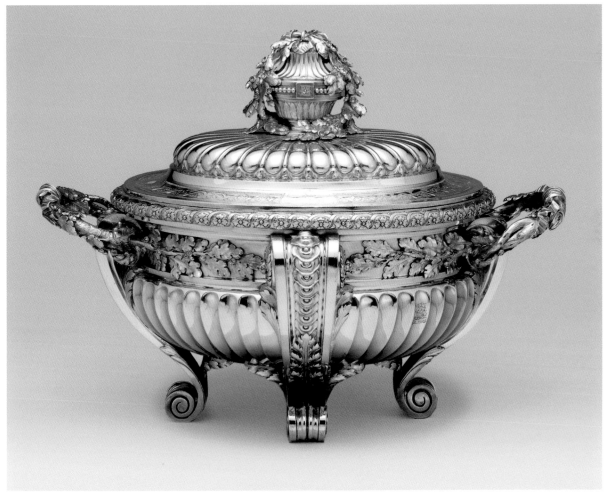

Cat. no. 9. Jacques-Nicolas Roëttiers. Tureen with cover, Paris, 1775–76. Silver, H. 11¾ in. (29.8 cm), L. 16 in. (40.6 cm).
The Metropolitan Museum of Art, New York. Gift of Mrs. Reginald McVitty and Estate of Janet C. Livingston, 1976
1976.357.1a–e

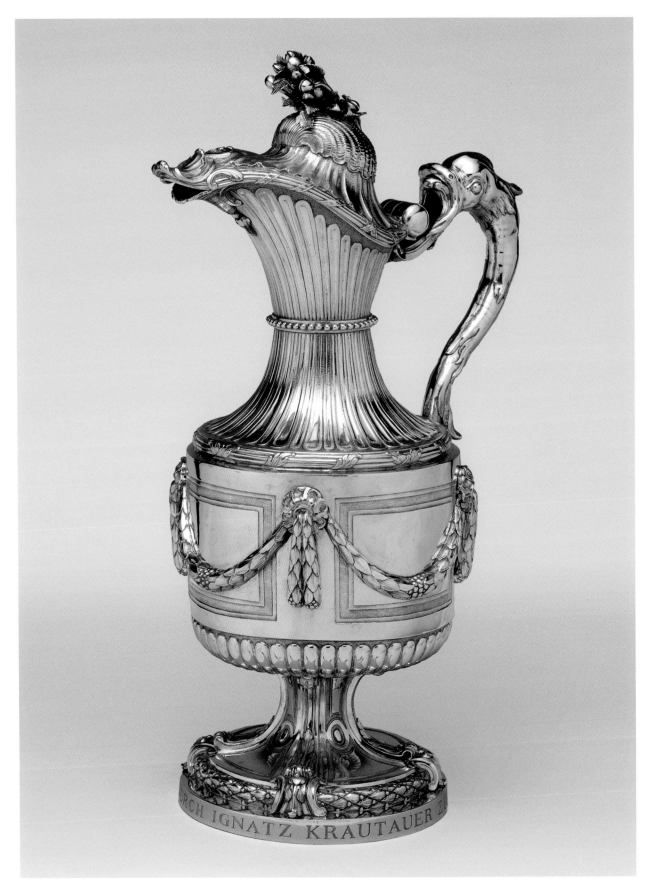

Cat. no. 10. Ignaz Krautauer. Ewer, Vienna, 1775. Silver, H. 18⅞ in. (48.1 cm). The Metropolitan Museum of Art, New York. Anonymous Gift, 2009 2009.414.1

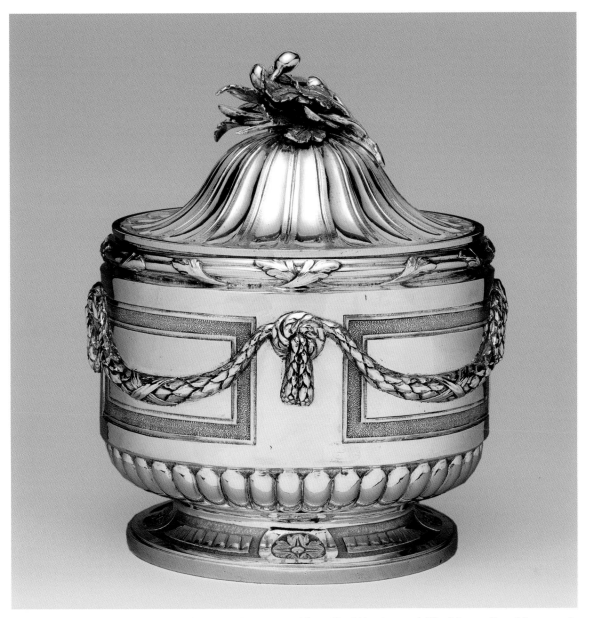

Cat. no. 11. Ignaz Krautauer. Box with cover, Vienna, 1777. Silver, H. 7⅞ in. (20.1 cm). The Metropolitan Museum of Art, New York. Anonymous Gift, 2009 2009.414.2a, b

"large oval tray [cat. no. 13], a large ewer, two small ewers [or pots] and two sugar boxes."[131] The original purpose of the set, with its extremely heavy tray and ewer, was probably for ostentatious display. The master borrowed the shape of the ewer's body, with its swags reminiscent of those on the Mariazell antependium (see p. 16), in order to create a second object, a lidded box (cat. no. 11); both were recently given to the Metropolitan Museum. The box, made in 1777 and likely one of the exhibited sugar boxes, shows a nearly full-fledged Neoclassical style. Only its naturalistic finial signals the influence of an earlier epoch.

This struggle to integrate various forms and meld them into a fashionable unit characterizes European gold and silver work in the period between 1765 and 1775. Even Auguste in Paris was known to have simultaneously made tureens in totally different styles. One variant was lavishly embellished with sculptural features;[132] another, created in 1770–72 for Count Otto von Blome, the Danish envoy to the court of France, was designed largely in the heavy *goût grec* type of classicism popular in France at the time (fig. 23); sculptural ram's heads serve as handles.[133] A third tureen, made in Berlin in about 1770 (fig. 24), features a

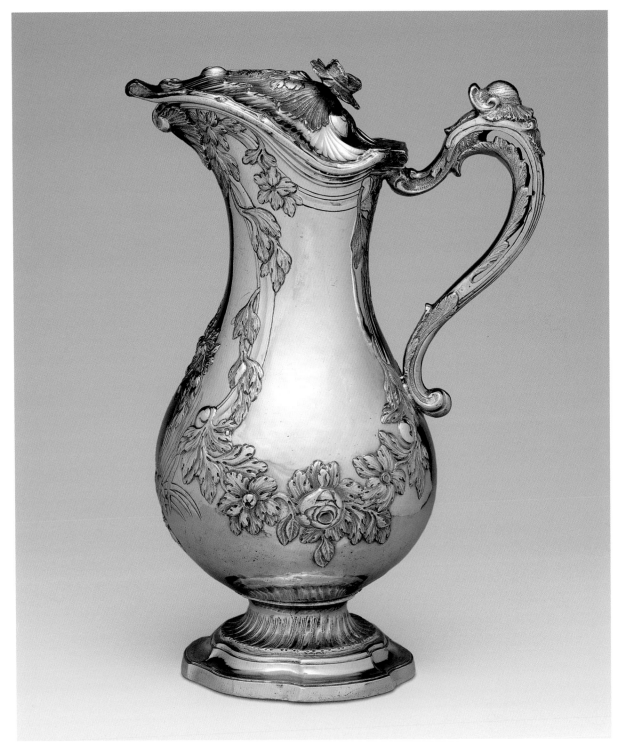

Cat. no. 12. Barthélemy Samson. Ewer, Toulouse, 1771. Silver, H. 10¾ in. (27.3 cm). The Metropolitan Museum of Art, New York. Bequest of William Mitchell, 1921 22.32.2

classical urn-shaped body adorned with festoons, ripple-curved handles, and an acanthus finial— the latter offset by two putti, one reclining lazily on either side of the lid—demonstrating the stylistic progression of silver work in another area of the Holy Roman Empire.[134]

Ignaz Joseph Würth's growing reputation and his position as *Hofsilberjewelier* (silversmith to the Imperial court) did not go unnoticed by others. In 1776 the master's workshop made two wine coolers (cat. no. 14) that took the creation of domestic objects as Neoclassical sculpture in silver to new

Fig. 22. Detail, cat. no. 10

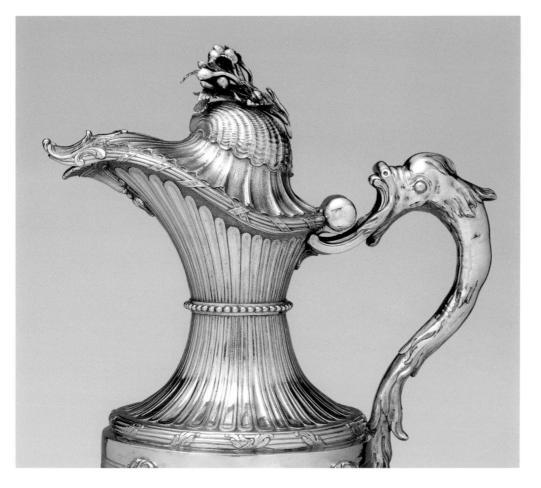

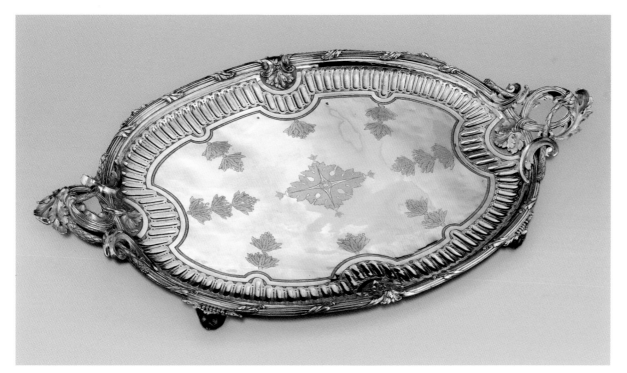

Cat. no. 13. Ignaz Krautauer. Monumental oval tray, Vienna, 1777. Silver, 38⅝ × 21⅝ in. (98 × 55 cm). Private collection, France

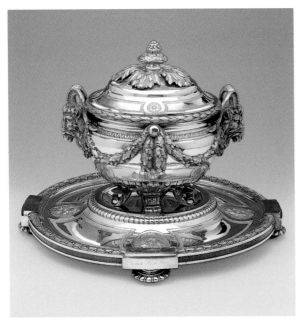

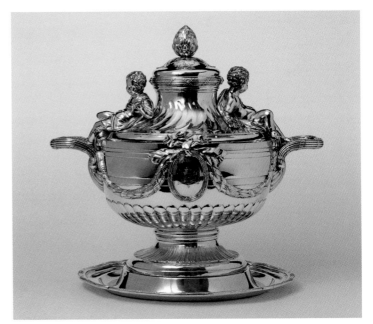

Fig. 23. Robert-Joseph Auguste. Tureen with stand, Paris, 1770–72. Silver, H. 14¼ in. (36.3 cm), Diam. of stand 19⅝ in. (50 cm). Museum für Kunst und Gewerbe, Hamburg Inv. 1911.27

Fig. 24. Johann Bernhard Müller and Georg Wilhelm Marggraff. Tureen with stand, Berlin, ca. 1770. Gilded silver, H. 19¼ in. (49 cm). Kungliga Husgerådskammaren, Stockholm Palace

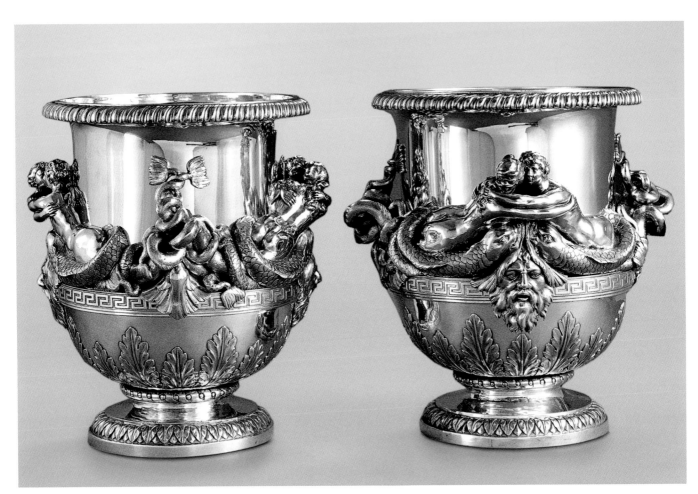

Cat. no. 14. Ignaz Joseph Würth. Two wine coolers, Vienna, 1776. Silver, H. of each approx. 10⅝ in. (27.1 cm), Diam. of openings approx. 8⅝ in. (21.8 cm), Diam. of bases approx. 5¾ in. (14.6 cm). Private collection, Paris

Fig. 25. Maker's mark from cat. no. 14

Fig. 26. Luigi Valadier. Design for a tureen, Rome, ca. 1770. For the Borghese Service. Gray pen and ink and gray wash over black chalk and pencil, 11⅛ × 14⅞ in. (28.4 × 37.7 cm). Anhaltische Gemäldegalerie Dessau/Graphische Sammlung Inv. no. Z 2763

heights. The Greek krater form was ideal for adaptation as a wine cooler, offering enough space to hold one bottle and enough ice to keep Bacchus's favorite beverage at the desired temperature. The 1776 wine coolers, so playfully and expressively embellished, follow closely an Italian design published in 1764 in a *Series of Vases* (fig. 27) by the gifted Ennemond Alexandre Petitot (1727–1801).[135] Instead of splashing about in the ocean's waves as described in ancient mythology, a Nereid enthusiastically embraces Triton, messenger of the sea. Their coiling and teasingly intertwined fish tails connect to the sides of the krater as handles. They rest on stylized dolphins and "kiss" intimately above a mask that may represent the outraged Poseidon, Triton's father. The intertwined sculptural details recall the way in which another great Italian designer, Luigi Valadier in Rome, sculpted tureen finials and handles (fig. 26).[136]

These two coolers were probably miraculous survivors of what would have been a comprehensive service commissioned by a discerning patron in either Austria or the Italian peninsula, as suggested by the printed designs of Petitot. By the end of the decade, however, Würth would again be in the service of the Imperial family and about to embark on what would come to be considered his masterpiece, the magnificent silver ensemble today known as the Second Sachsen-Teschen Service.

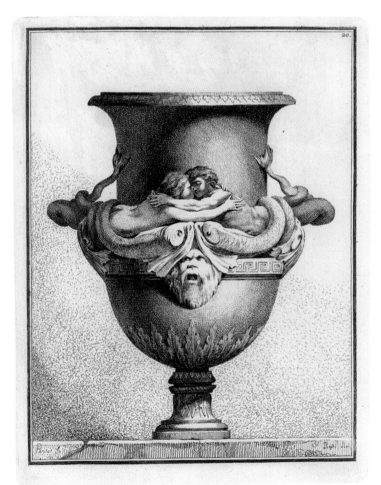

Fig. 27. Ennemond Alexandre Petitot. Design for a vase. From *Series of Vases*, etched and published by Benigno Bossi (Parma, 1764). Etching, 12⅞ × 9⅛ in. (32.7 x 23.2 cm). The Metropolitan Museum of Art, New York. Rogers Fund, 1944, transferred from the Library 1985.1024

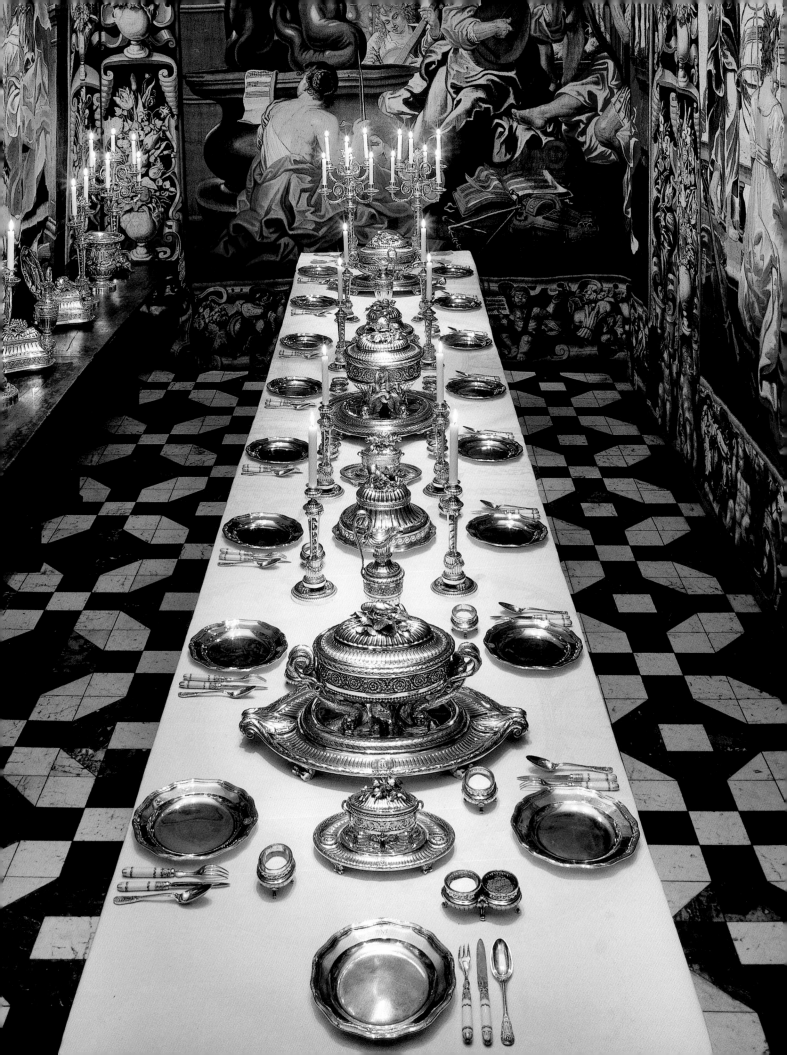

The Second Sachsen-Teschen Service Rediscovered

In 1904 Edmund W. Braun acclaimed enthusiastically, "The second most important work of the old-Viennese art of gold- and silver work [after the golden breakfast garniture and toilet set of Maria Theresa and Francis I] is the magnificent table silver of the art-loving duke Albert of Sachsen-Teschen, the son-in-law of the empress and founder of the print collection [now in the] Albertina."[137] In 1985, writing in the catalogue of an exhibition celebrating gold and silver work in the royal treasury of Copenhagen and the former Imperial Schatzkammer in Vienna, Barbara Wild concurred but added a somber note: "[Ignaz Joseph Würth's] chef d'oeuvre was . . . the table silver of Duke Albert of Sachsen-Teschen . . . made between 1779 and 1782 and now unfortunately lost."[138]

In 1779, the same year he began work on the Second Sachsen-Teschen Service, Würth also created tableware and four equally splendid tureens, two round and two oval (fig. 28), now owned by the queen of Denmark. Barbara Wild noted that "early depictions of the lost table service of the duke show great similarities with the pieces in the [Danish] royal silver chamber. Only the elegantly curved, wave-decorated bands [that support the Danish tureens] . . . distinguish these from [Würth's tureens for Albert shown in early] photographs."[139] The Danish service may have been ordered from Würth by a member of a northern European court or a high aristocrat. It is first documented in the private silver chamber of King Christian VIII (reigned 1839–48), whose grandmother Queen Juliane Marie of Denmark was a cousin of Maria Theresa's.[140] In November 1881, following the death of the dowager queen Caroline Amalie of Denmark, who used the service in her residences, much of the ensemble, including wine and glass coolers, cutlery, dishes, and plates, were sold at auction and dispersed.

That Viennese artisans traveled to France to study and improve their skills is well established, but masters from other European centers also made the journey to Vienna. In 1774, for example, Ignaz Joseph Würth and his family undoubtedly had contact with François-Thomas Germain when the brilliant artisan traveled to Vienna desperately seeking help for his terrible financial problems. In a letter written in 1774 (now in the National Archives, Paris), Germain informed his Parisian creditors that he had gone to London to start a business and that in the spring of 1774, having been cheated by his potential British partners, he went on to Vienna to explore business arrangements with people he knew there.[141] Germain had the rather eccentric idea that he would not invest any capital, which he did not have anyway, but instead would offer his know-how and skill. Although his efforts in Vienna were also unsuccessful, he must have brought with him a

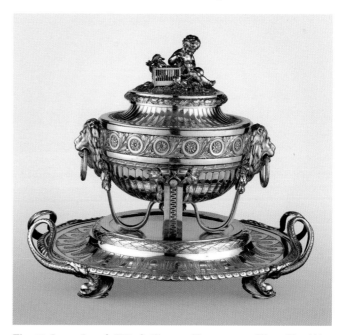

Fig. 28. Ignaz Joseph Würth. Tureen, Vienna, 1779. Silver, H. 17⅛ in. (43.4 cm), Diam. of stand 20⅞ in. (53.1 cm). Royal Silver Vault, Copenhagen

Opposite: Table set with a portion of the Second Sachsen-Teschen Service. Private collection, Paris

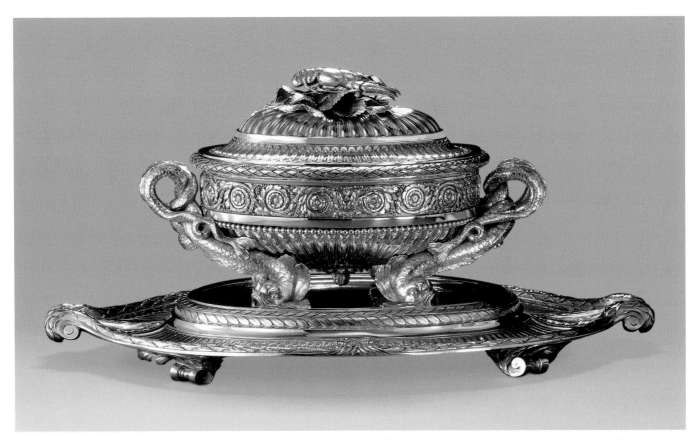

Cat. no. 15. Ignaz Joseph Würth. Oval tureen with stand, Vienna, 1780–81. Silver, H. overall 14⅝ in. (37 cm), L. of stand 26½ in. (66.8 cm). Private collection, Paris

portfolio of his flamboyant objects as well as drawings, models, and other evidence of his talent. It is highly probable, therefore, that Germain's influence on the Würth style was a result of the Würths' firsthand knowledge of the Parisian master's oeuvre.

By the late 1770s, Ignaz Joseph Würth was an accomplished master known all over Europe. For Viennese patrons, his record as goldsmith to the emperor and the availability of other Würth family workshops that could be employed if needed for larger orders were ideal recommendations. It was likely for those reasons that Duke Albert of Sachsen-Teschen assigned Würth the extraordinary commission that would occupy his workshop between 1779 and 1782.[142] A grand silver service was ordered for the use of Albert and Marie Christine in Brussels in their role as joint governors of the Austrian Netherlands (see p. 71).

Before any silver was touched, however, the artisan and patron(s) had to work out the logistics of the order, a process that involved design drawings and models for sculptural details, discussion of the extent of craftsmanship required, and above all, agreement on the amount of silver allocated to each group of objects within the service and on the terms of payment. This exercise, so crucial to the financing of the project, could have taken months or even years, as was true with George III's Hanoverian service. The large tureens with stands were first to be accomplished, as they required much of the precious-metal allotment as well as the utmost attention of the goldsmith during their casting and surface finishing. Furthermore, because they were the most prominent items on the table (see fig. 30), their completed appearance had to meet with the patron's approval before work could continue. As with parterre arrangements and carefully curated sculpture in a formal garden, these voluminous tureens and their stands marked certain focal points on the festive table. They were placed on the table before the diners arrived, and their removable silver liners containing the food were brought into the room only at the last moment. Thus, their utilitarian purpose became almost secondary to their ceremonial importance and their status as sublime works of art.

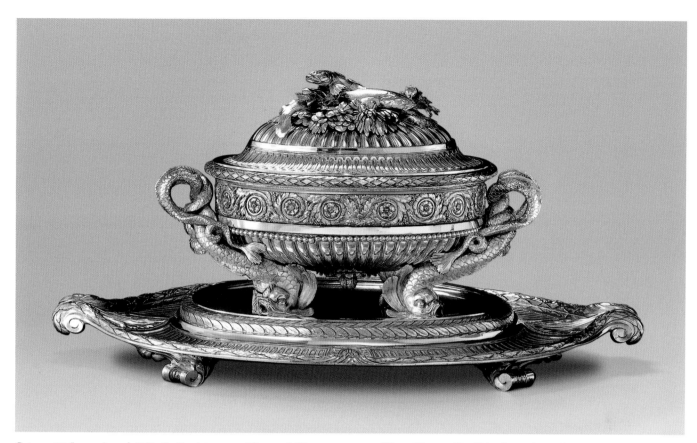

Cat. no. 16. Ignaz Joseph Würth. Oval tureen with stand, Vienna, 1780–81. Silver, H. overall 14⅝ in. (37 cm), L. of stand 27½ in. (70 cm). Private collection, Paris

Large Tureens

The lancet-shaped ovoid outline and scroll handles of the pair of oval tureen (*terrine*) stands illustrated as cat. nos. 15 and 16 represent a purified Neoclassical version of a Baroque composition that Thomas Germain (1673–1748) used about 1729–31 for a *surtout de table*, or monumental centerpiece. Thomas's son François-Thomas Germain (1726–1791) developed the idea further by adding feet and exuberant, wave-formed scrolls framing the trays of silver tureens he made in 1758–61 for the empress Elizabeth Petrovna of Russia (1709–1762).[143] François-Thomas Germain's rival Robert-Joseph Auguste interpreted the form in an expressive Baroque classicism that is characteristic of eighteenth-century court art. For a silver service made for the Danish court about 1756–57, the French artisan added small naturalistic details in a Rococo manner as well as armorial cartouches to the base.[144] Versions of this subtly symmetrical and serene form migrated as far as Great Britain (see fig. 11).

Würth ingeniously simplified Auguste's established tray (*présentoir*) form using a Neoclassical idiom of laurel moldings framing a narrowing concave frieze with grooving and small oval acanthus rosettes. The laurel motif alludes to the laurel crown, and the plant's evergreen nature was a symbol of success and princely fame. Matted acanthus leaves between polished scroll ends create the handles and feet of the large stands. The round example, the only such piece in the exhibition, features a stand with a circular center but retains protruding scroll handles similar to those of the other tureens; these handles lend the stand a slightly ovoid character (cat. no. 17). The raised center of the round tray has a completely plain but highly burnished surface that produces a mesmerizing trompe l'oeil effect by reflecting the vessel's reeded underside with its central calyx ornament (fig. 29) and the light of nearby candelabra (see p. 36). The Viennese master wished to distinguish the outlines of the tureen stands from those of the

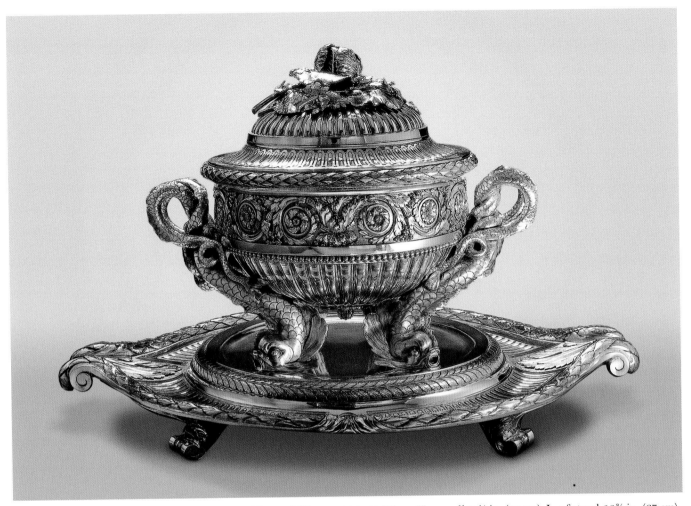

Cat. no. 17. Ignaz Joseph Würth. Round tureen with stand, Vienna, 1779–81. Silver, H. overall 16½ in. (42 cm), L. of stand 26⅜ in. (67 cm). Private collection, Paris

round, square, and triangular dishes (see cat. nos. 20–23, fig. 43) of the service; in this way, he avoided the conventional round vessel types that Roëttiers (see cat. no. 2), or Auguste (see fig. 23) applied, allowing himself instead a variety of stand shapes in order to create a rhythmic table setting *à la française* (fig. 30).[145]

An obvious difference between the Copenhagen and Second Sachsen-Teschen tureens not mentioned by Barbara Wild is that the former feature statuette finials. The putto-with-cage motif that Würth used on the Copenhagen finials (fig. 31) relates to earlier inventions of Auguste[146] and François-Thomas Germain.[147] The same composition was used again on a silver cloche (covered dish) formerly attributed to Giovanni Battista Boucheron (1742–1815) about 1785–90 in Turin, thus confirming

the international character of these cast finials incorporating putti.[148] Similarly, Würth's incorporation of sculptural handles was surely inspired by the ingenious models of the Germain family. The juvenile moray creatures with long pectoral fins carrying the tray of the Copenhagen stand (fig. 32) evolved in the Second Sachsen-Teschen Service into substantial dolphinlike sea dwellers with open mouths that seem to gasp for breath under the weight they carry (fig. 33).[149] Their coiling elongated bodies intertwine and then separate again to form two graceful handles (fig. 34) before transitioning seamlessly into vigorous tails ending in delicate fins. Reproductions of ancient sculptural groups that feature interlocking action, such as *Laocoön and His Sons* (Vatican Museums), where the subjects are depicted being strangled by sea

Opposite: Fig. 29. Detail, cat. no. 17, showing handle of stand and its reflective center

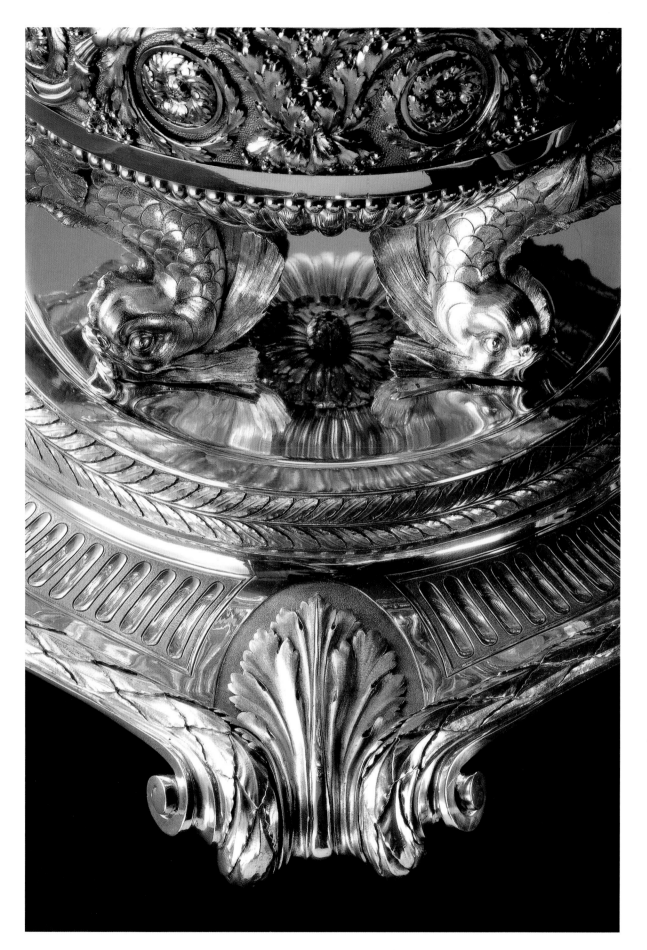

Fig. 30. Table plan for first-course setting, Augsburg, mid-18th century. Pen drawing, 11⅝ × 36 in. (29.5 × 91.4 cm). Städtische Kunstsammlungen, Augsburg. Graphische Sammlung Inv. no. Gr.24934

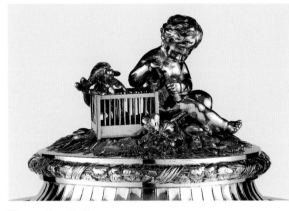

Fig. 31. Detail, fig. 28

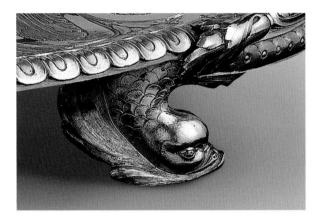

Fig. 32. Detail, fig. 28

serpents, may have inspired Würth to translate these or related vivid compositions into ornamental reminiscences of extraordinary refinement. French versions of coiling fish tails are known from naiads made by the *bronzier* Claude Galle (1759–1815), but the first of Galle's celebrated compositions are dated later, about 1785.[150]

Vertical flutes cover the lower half of the tureen bodies, above which encircling pearl strings, laurel wreaths, and polished bands bracket a frieze of turbulent acanthus-spray scrolls and seeds that alternate with embracing starlike and twisted-leaf rosettes, all against a matted ground. These detailed *frises des rinceaux* left behind the heaviness of the *goût grec* and prepared the way for the late Louis XVI style that would be practiced by the goldsmith Antoine Boullier (master 1775, last mentioned 1806), among others.[151] Comparisons with contemporary ceramics, such as those produced by Sèvres, reveal the widespread use of these fashionable patterns about 1780.[152] The condensed and precisely delineated forms give the objects a noticeably Austrian flavor, although this may be filtered through an Italian influence.[153]

Each of the tureen lids features a plain edge and concave band with framed grooves and is crowned by a reeded raised oval or burnished reeded dome (in the case of the round tureens) adorned by naturalistic cast-silver still-life compositions. The Rococo naturalism of the finials is echoed in their realistic appearance, achieved in many cases by casting from actual models.[154] One of the oval lids displays a crayfish on vegetable foliage (fig. 35). The second and more complex lid contains three different small fishes, two with gasping open mouths, lying on leaves of various herbs and vegetables (figs. 36, 37). The species identifications are speculative, as these models do not appear to be biologically accurate.

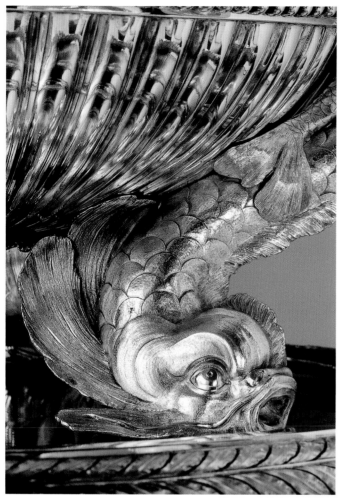

Fig. 33. Detail, cat. no. 17

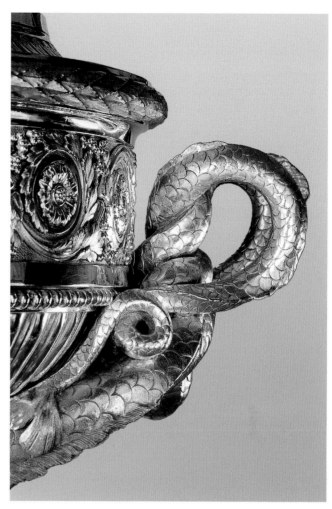

Fig. 34. Detail, cat. no. 17

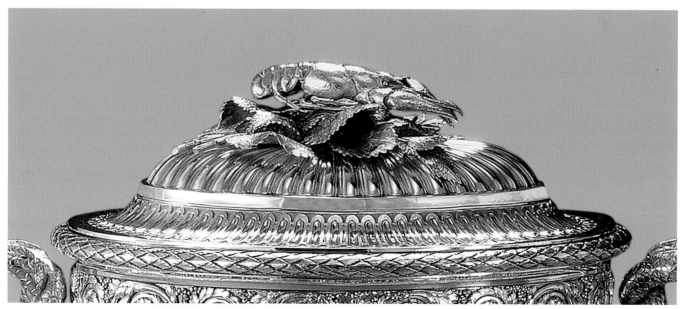

Fig. 35. Detail, cat. no. 15

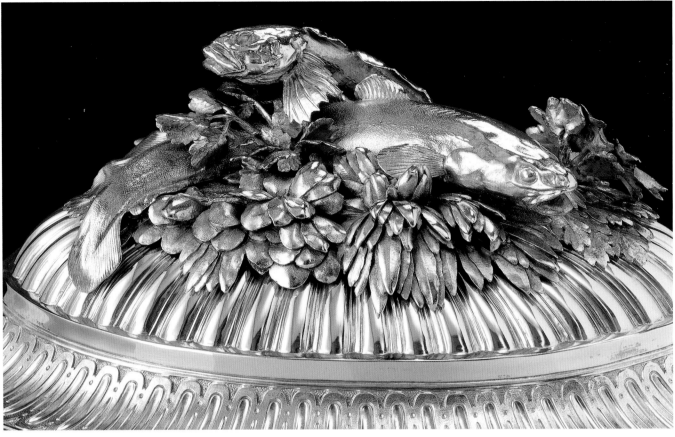

Fig. 36. Detail, cat. no. 16

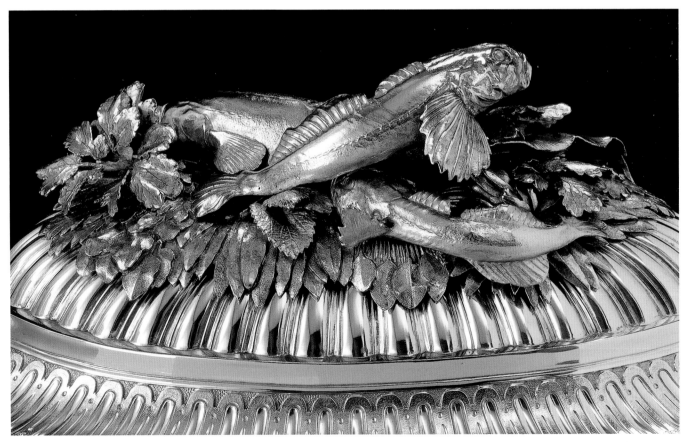

Fig. 37. Detail, cat. no. 16

Cat. no. 18. Original leather case for cat. no. 17. H. 17¼ in. (44 cm), Diam. 19 in. (48 cm). Private collection, Paris

They could be stylized cyprinids, of the family Cyprinidae, which are found in Eurasia, including Hungary, where Duke Albert was governor from 1765 to 1780. The smallest fish resembles a goby, of the family Gobiidae, or some close relative.[155] Of at least four examples of this type and size in the service, a third one is again decorated with a crayfish finial and a fourth with oysters. Both the shape of the tureens and the choice of subject for the finial adornments correspond appropriately to the food kept inside. These tureens likely held an assortment of shellfish and fish ragouts and soups.

Round tureens were primarily reserved for a special delicacy, the *pot-à-oille*, a stew (or soup) whose name derives from the *olla podrida*, a Spanish

Fig. 38. Detail, cat. no. 18

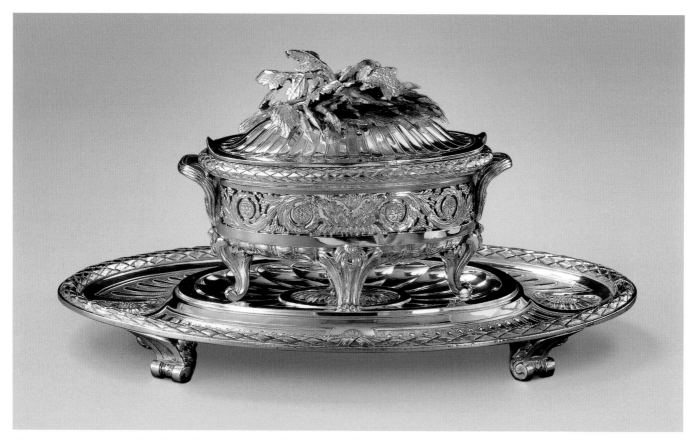

Cat. no. 19. Ignaz Joseph Würth. Small sauce tureen with stand (one of a pair), Vienna, 1781. Silver, H. 5½ in. (14 cm), L. 11¼ in. (28.5 cm). Private collection, Paris

dish consisting of a variety of meat, poultry, or fish combined with different vegetables and spices and left to cook for hours.[156] Diverse cabbage variations were especially favored, as indicated in the finial of the large round tureen (see cat. no. 17), which depicts a perfectly sculpted head of cabbage. The whereabouts of a second version, with a beet and foliage finial, is not known, but the tureen is documented through a historic photograph (see fig. 56).[157] The preservation of the original leather–covered storage case is exceptional (cat. no. 18). Such boxes, often decorated with tooling, were indispensable for the safekeeping of precious objects.[158] The octagonal design and slanted lid of this case may seem surprising at first, but the shape allows for its interior to be protected on all sides. Its solid construction and special lock confirm the value of its intended contents, which translated literally into coinage (see also cat. no. 40). Its wax seal prevented tampering with the lock en route and provided a record of when and where the case was opened (fig. 38). Würth originally made for the service at least two large oval and two large

round tureens as well as four additional oval tureens. One of the two large oval tureens, with its original leather-covered case, is in the collection of the Sterling and Francine Clark Art Institute in Williamstown, Massachusetts.[159]

Sauce Tureens

The use of containers specifically for hot or cold sauces or cream and liquid herb blends to be served separately from the meat, fish, or vegetable dishes signaled that "the preparation and service of meals had reached a new level in refinement in the eighteenth century."[160] As the expert Alain Gruber noted of the traditional open sauceboat, whose form changed little after 1720, "The most serious disadvantage of the sauce-boat is that it has no lid. To overcome the problem of loss of heat, the traditional sauce-boat was replaced [first] in England by a small version of the tureen [which usually had] a slot for the spoon or sauce-ladle."[161] That Würth and his patrons replaced sauceboats with the small

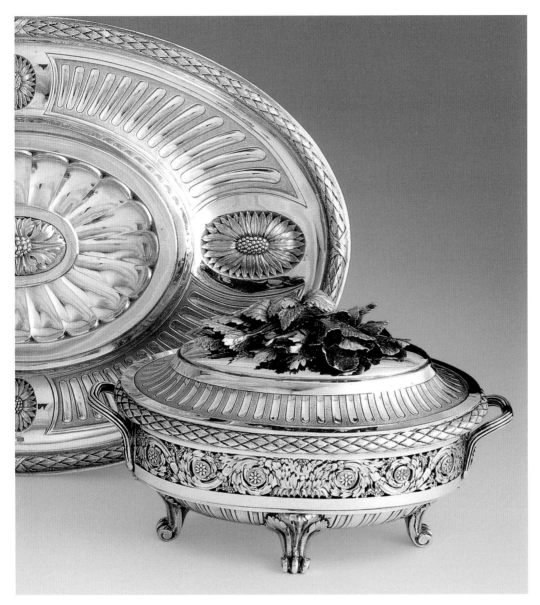

Fig. 39. Ignaz Joseph Würth. Small sauce tureen with stand, Vienna, 1782. Silver, H. overall 6¾ in. (17 cm), L. of stand 13¾ in. (35 cm). Whereabouts unknown

lidded tureens—two different types, no less—especially popular in England testifies to Vienna's cultural sophistication. The small sauce tureens (cat. no. 19) rest on oval stands without handles in order to differentiate them from the stands for the large tureens. Their elaborately ornamented trays mimic the effect created by using mirrored trays to reflect the underside decoration, as was done with the large tureens. The plants are identifiable. The partially open pods on the finials reveal the seeds and foliage of the rat-tailed radish, a variety of *Raphanus sativus*, which develop above the root system growing underground. The plant was cultivated for its seeds and pods (often pickled to complement a salad) rather than its roots.[162]

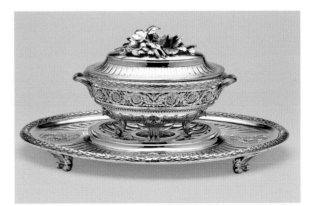

Fig. 40. Ignaz Joseph Würth. Sauce tureen with stand, Vienna, 1781–82. Silver, H. overall 6¾ in. (17 cm), L. of stand 13¾ in. (35 cm). The Art Institute of Chicago. Gift of Mrs. Rudy L. Ruggles in memory of her daughter, Jean Ruggles Romoser, through the Antiquarian Society 1998.153a–d

Fig. 41. Detail, cat. no. 19

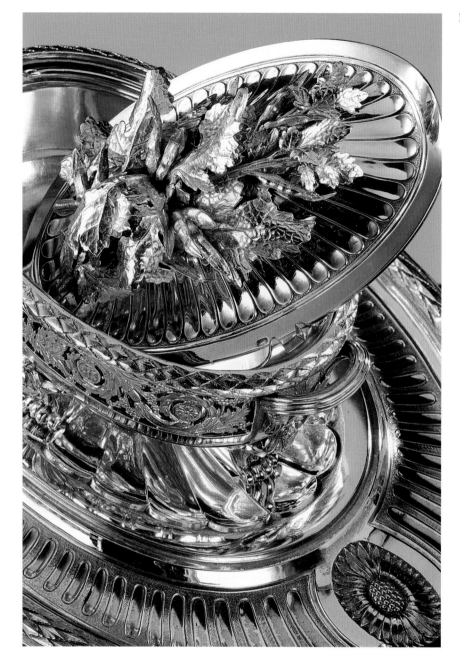

A set of six larger sauce containers from the service but with slightly altered ornamentation is documented, although only two have surfaced in recent years.[163] Both were sold at auction in 1995, one at Sotheby's in Geneva (fig. 39; present location unknown) and the other at the Galerie Fischer in Lucerne (fig. 40; now in The Art Institute of Chicago).[164] Distinctions between the two groups of sauce tureens include the increased volume and dimensions of the larger versions (lengths of stands are 13¾ inches [35 cm] versus 11¼ inches [28.5 cm]) and design variations—the larger liners do not have notches to hold spoons in place, nor do the larger lids curve up to create openings for supporting the spoons, as the small ones do (fig. 41). On the Chicago tureen, a pearl string sits below the narrow acanthus-spray scroll frieze, which curves gently upward,[165] and its stepped lid has a clearly defined raised platform that holds a finial of vegetable and foliage forms, whereas the objects seen here feature nearly horizontal scroll friezes, and their leaf-and-pod finials are mounted directly at the point where the burnished channeling meets (fig. 42). Until documentary evidence proves otherwise, there is no reason to believe that any type of oil and vinegar cruet or mustard pot ever complemented this service.[166]

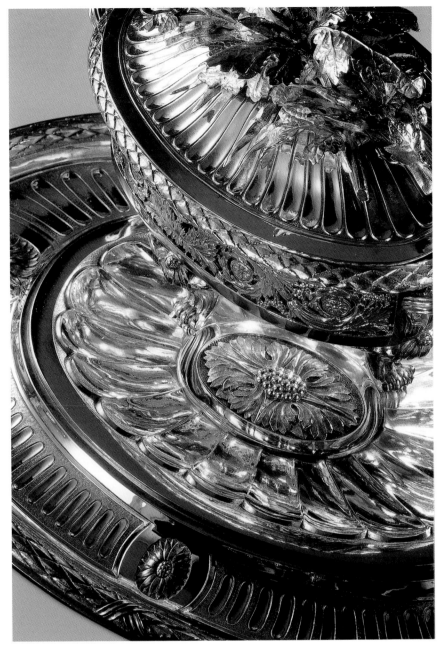

Fig. 42. Detail, cat. no. 19

Dishes with Cloches

Large tureens often appeared as monuments in miniature arrayed on the dining table; in contrast, the numerous triangular, rectangular, and round dishes (*plats*) and their matching covers, or cloches (cat. nos. 20–23, fig. 43), enabled great flexibility of arrangement for the spaces in between. Thus, they played an important role in the *service à la française*. Large dish sets were a standard part of stately services, with the round form dominating.[167] The domed covers with successions of concave and convex horizontal ornament offered numerous decorative possibilities when setting a table (see, for example, pg. 36), and their cast finials with elaborately sculpted natural delicacies inspired the imagination of every guest or onlooker. The shells, fruits, and vegetables depicted were intended to symbolize the world's rich gifts of oceans and earth and the result of human efforts to harvest them. Covered dishes were particularly useful for the *relevés* or *entremets*, smaller quantities of special creations served between the main courses. These could include vegetables or ragouts enriched with special ingredients like artichokes, rare truffles, edible cockscomb, crayfish, and freshwater telphusa

Cat. no. 20. Ignaz Joseph
Würth. Round dish with
cover, Vienna, 1781. Silver,
H. 8¼ in. (21 cm), Diam. of
cover 11¼ in. (28.5 cm).
Private collection, Paris

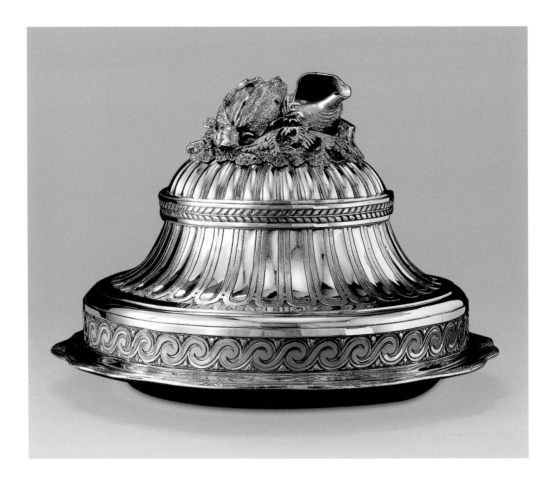

Cat. no. 21. Ignaz Joseph
Würth. Round dish with
cover, Vienna, 1781. Silver,
H. 7⅞ in. (20 cm), Diam. of
cover 11¼ in. (28.5 cm).
Private collection, Paris

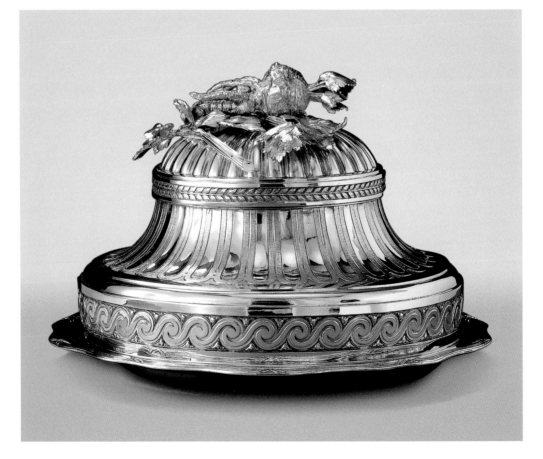

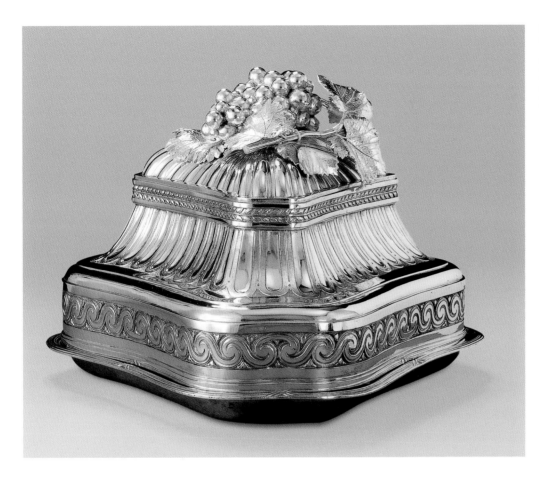

Cat. no. 22. Ignaz Joseph Würth. Triangular dish with cover, Vienna, 1781. Silver, H. 7⅞ in. (20 cm), Diam. of cover 11⅛ in. (28.4 cm). Private collection, Paris

Cat. no. 23. Ignaz Joseph Würth. Triangular dish with cover, Vienna, 1780–81. Silver, H. 7⅞ in. (20 cm), Diam. of cover 11⅛ in. (28.4 cm). Private collection, Paris

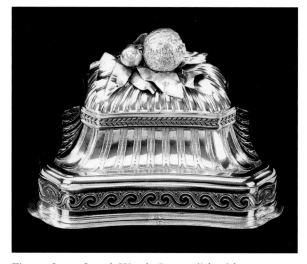

Fig. 43. Ignaz Joseph Würth. Square dish with cover, 1780–81. H. 8⅝ in. (22 cm), L. 11⅞ in. (30.2 cm). From *Silver, Gold and Fabergé*, November 18, 1996 (Sotheby's, Geneva), lot 78

Fig. 44. Giovanni Battista Piranesi. *Dessin d'un morceau d'un antique édifice*. Engraving, from *Coupes, vases, candélabres, sarcophages, trépieds, lampes & ornements divers* (Paris, 1905), plate 112

crabs (*Telphusa fluviatilis*).[168] The Vitruvian scroll (also called a wave or running-dog ornament) on the base of each cover is a prominent example of the court classicism that existed in the arts from the Renaissance to the end of the eighteenth century.[169]

These decorative covers also served an important task. Julius Bernhard von Rohr noted in his 1730 handbook of etiquette, *Einleitung zur Ceremoniel-Wissenschaft der Privat-Personen*, that the use of silver or pewter cloches not only masked steamy odors but also prevented flies, dust, candle drippings, or powder from the servants' coiffures from settling on the food.[170] This protection against taste-changing ingredients explains why even cold food was served with covers. Another factor was the long distance between the kitchen—which was often located in a basement or side wing and connected by tunnel to the main building—and the banquet hall, an arrangement designed to spare guests from strong cooking smells or the danger of open fires.

There may have been as many as twenty-four round covered dishes and four triangular ones. Four square covered dishes are recorded, one of which was offered at auction in Geneva (fig. 43).[171]

Ewers

The mixing of wine and water, a widespread fashion during the ancien régime, was also popular in Vienna. Water was also needed to rinse the mouth before changing courses or drinks and for cleaning

the hands; used for the latter was a lavabo set consisting of a basin and ewer that in some cases, as here, were not part of the formal service. The Second Sachsen-Teschen ensemble included two types of ewer (*aiguière*), of different sizes but nearly the same design. That the larger version was intended for water and the smaller (cat. no. 24) for either wine or wine and water can only be assumed from a photograph published in a Galerie Fischer sales catalogue, in which ewers of both sizes stand side by side.[172]

The ewers' design represents a radical move toward a purely Neoclassical approach that contrasts with the traditional helmet-shaped forms that had dominated most silver ewers for more than two centuries. The fluted body consists of a vase placed between a spreading foot and gadrooned shoulder, followed by a high, waisted neck, flaring spout, and tall handle. When open, the naturalistic acanthus-leaf lid complements the graceful movement of the snake handle without touching it. The acanthus leaf that partially covers the snake evokes the sloughing of the animal's skin. The *Physiologus*, an ancient bestiary that was obligatory reading for a princely education, was certainly known to the patrons. The book cites the reptile as a symbol connected to the water served in such ewers: "When [the snake] comes to the river to drink water, he does not bring with him the poison which he bears in his head, but he leaves it in his pit. Therefore, when we gather together we, too, ought to draw the living and everlasting water [cf. John 4:15].

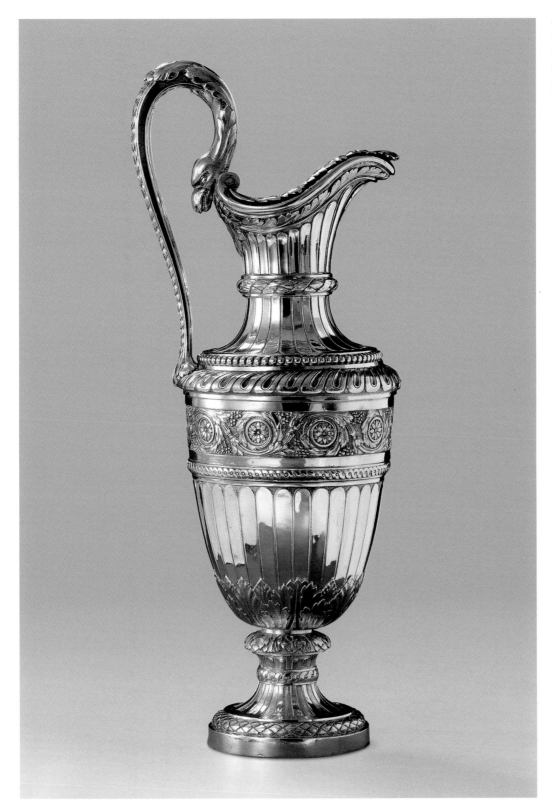

Cat. no. 24. Ignaz Joseph Würth. Small ewer, Vienna, 1782. Silver, H. approx. 13¾ in. (34.8 cm), Diam. of base approx. 3⅛ in. (8.1 cm). Private collection, Paris

And when we hear the divine and heavenly word in church, we ought not to bear poison along with us (that is, wicked earthly desires) [cf. Col. 3:5]."[173] On the ewers, the snake was prominently displayed for everybody to see and literally to "handle" (see also cat. nos. 27, 28).

The ornamental vocabulary of the ewers and the other items of the Sachsen-Teschen service discussed so far is beautifully represented in engravings by Giovanni Battista Piranesi (1720–1778), which offer both a capriccio mixture of motifs and painstakingly drawn models of actual ancient objects

and architectural compositions. Decorative details employed by Würth—specifically, rosettes with loops, pearl strings, Vitruvian scrolls, and vivid acanthus-spray volutes—are matched closely in Piranesi's engraved *Dessin d'un morceau d'un antique édifice* (fig. 44), published in Rome in 1778. If the service's designer did not encounter Piranesi's images on his travels, they were certainly available in the Viennese Academy library or in the extensive print collection of Duke Albert (see p. 20–21, 76–77).[174]

The service originally included at least two large and six small ewers; only three of the small ewers are known today (see cat. no. 24).

Salts

That salt was a highly desired and expensive commodity up to the eighteenth century is evidenced by the attention given to its containers. Not only did ornate saltcellars (*salières*) serve a ceremonial role, but they also gained a quasi-cult status. During the late Medieval period and the Renaissance, a large saltcellar customarily resided at the right of the master's place setting.[175] The Second Sachsen-Teschen salts (cat. nos. 25, 26) feature thin bands of Vitruvian scrolls and fluting on the bowls as well as acanthus volute feet similar to those that support the sauce tureens (see cat. no. 19, fig. 39). The double salt with two compartments, one for salt and one for powdered pepper or nutmeg, was favored in England and France in the second half of the eighteenth century.[176] The inside had to be gilded or, as in the case of the Sachsen-Teschen salts, protected with glass liners (see p. 36) in order to prevent the corrosion of the silver. As the price and perceived rarity of salt decreased, smaller forms of saltcellars were developed. Nevertheless, *salières* continued to be indispensable and were used in large quantities.

The eight single and six double salts in the exhibition include four later salts (out of at least ten originally). These additions to the service were made in 1852 by the Viennese maker Mayerhofer & Klinkosch, who in 1837 had succeeded the last master of the Würth dynasty as Imperial goldsmith to the Austrian court (see pp. 58, 68).[177]

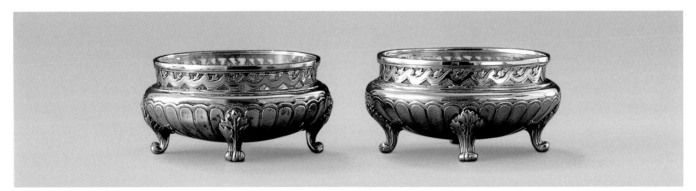

Cat. no. 25. Ignaz Joseph Würth. Pair of single salts, Vienna, 1782. Silver, H. of each 2 in. (5.2 cm), L. 4 in. (10 cm). Private collection, Paris

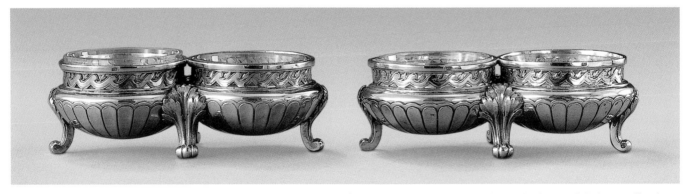

Cat. no. 26. Ignaz Joseph Würth. Pair of double salts, Vienna, 1782. Silver, H. of each 3⅛ in. (7.9 cm), L. 6 in. (15.2 cm). Private collection, Paris

Candlesticks and Candelabra

The ingeniously constructed lighting pieces of the service are a tour de force of the goldsmith's art. In the days before electricity, wax candles were the primary source of artificial light. As Alain Gruber noted, at night, "one could not live without [them]."[178] At least thirty-two single candlesticks, or *flambeaux* (cat. no. 27), can be attributed to the original service,[179] an abundance that allowed the allocation of one candlestick per place setting or—depending on the number of guests—every two seats (see p. 36). At minimum, the ensemble allowed the hosts to entertain thirty-two guests luxuriously.[180]

The single candle stands and the supports of the candelabra were inspired by the classical tripod or *athénienne* shape.[181] One stylistic predecessor is a tripod incense burner with hoof feet and ram's-head and spiral-snake details depicted by Joseph-Marie Vien (1716–1809) in a painting from 1762.[182] Related forms were fully developed by the early 1760s, as seen in a bronze candlestick of about 1775, signed "Marincourt," now in the J. Paul Getty Museum, and a drawing of about 1775 by Charles Crimpelle in the Bibliothèque Littéraire Jacques Doucet, Paris.[183] A slightly more eccentric Viennese

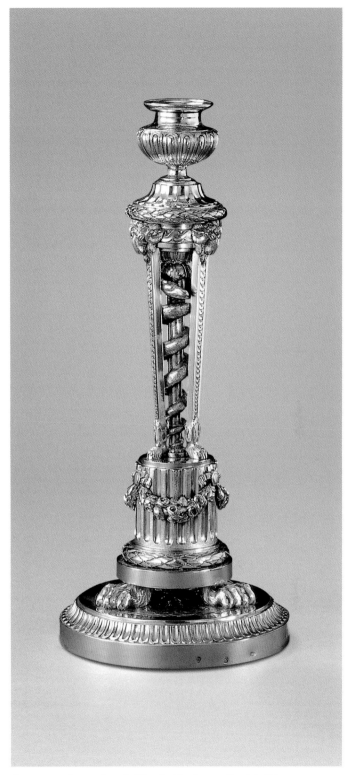

Cat. no. 27. Ignaz Joseph Würth. Single candlestick, Vienna, 1781. Silver, H. approx. 12¼ in. (31 cm). Private collection, Paris

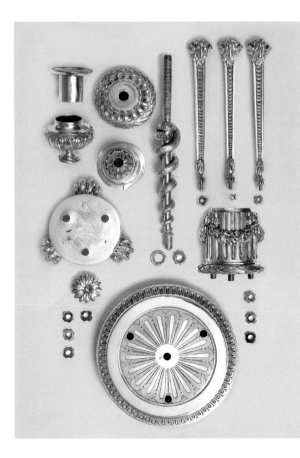

Fig. 45. Detail, cat. no. 27, component pieces of candlestick

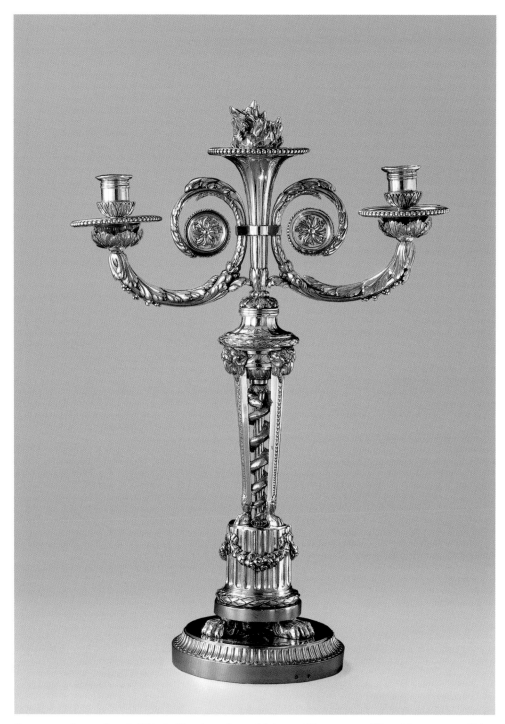

Cat. no. 28. Ignaz Joseph Würth. Two-branch candelabrum, Vienna, 1781. Silver, H. approx. 22⅞ in. (58 cm). Private collection, Paris

version resembles a pair of gilded-bronze candelabra formerly in the Stroganoff Collection in Saint Petersburg, here attributed to the Würth workshop and dated about 1775–80. Their shafts divide into a tripod structure ornamented with ram's heads and supported by a circular spreading base under a fluted column segment with laurel swags; the three

branches are very similar to the bronze mounts on porcelain candelabra in the Liechtenstein Collection (see fig. 16).[184]

The snake motif on the Second Sachsen-Teschen ewers is repeated on the candlesticks and candelabra; there, however, a snake coils around the support inside each of the pierced shafts, creating a

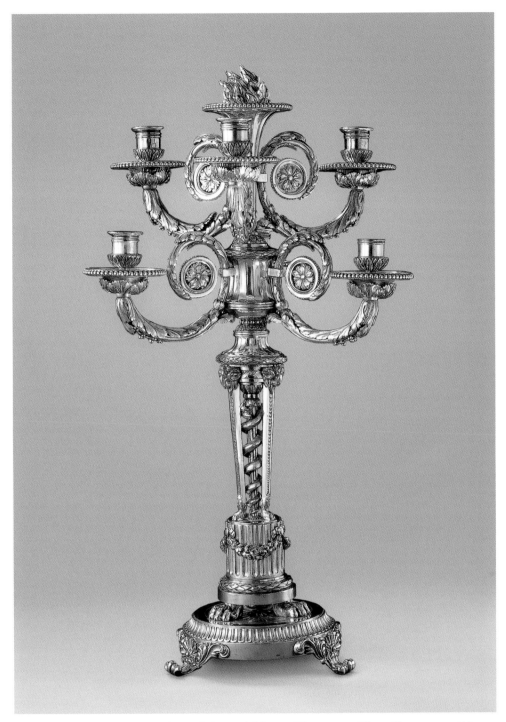

Cat. no. 29. Ignaz Joseph Würth. Six-light candelabrum, Vienna, 1781. Silver, H. approx. 27 ⅛ in. (69 cm). Private collection, Paris

very different visual effect. The result resembles the staff of Asclepius—which likewise features a snake entwined around it—a symbol of healing, renewal (through the molting of the snake), and the physician's art.[185]

More than twenty-four different elements were assembled to create one candlestick (fig. 45), an approach that allowed dismantling for thorough cleaning. This number does not include the separately cast snake, the base with three attached claw feet, or the pedestal encircled by a laurel wreath and applied floral swags. The quality and the surface finishing of each object are of a consistently high level, often surpassing the quality of

Cat. no. 30. Design for a candelabrum with eleven branches, Austrian, ca. 1770–80. Pen and black ink, graphite, 10⅝ × 16½ in. (27.1 × 41.7 cm). The Metropolitan Museum of Art, New York. Gift of Raphael Esmerian, 1963 63.547.15.9

comparable large services from Paris (see cat. nos. 2, 9). The bases of the candelabra are enlarged versions of the single candleholders surmounted by torch-shaped central elements with eternal flame finials and scroll branches with vaselike sockets and removable nozzles (cat. nos. 28, 29). The four grand candelabra with six lights have two tiers of branches (cat. no. 29). The second tier of each candelabrum is attached with a bayonet mounting to secure it firmly. This made the candelabra appear larger and, perhaps more important, gave them greater stability.

As dining habits changed during the nineteenth century, tables were ostentatiously decorated with flowers and high candelabra carrying ever-taller candles reflected in large mirrored *surtouts*. This was a matter of decoration and practicality. Because guests were seated on both sides of the table, the reflection of the candle flames had to be well above the guests' heads in order to allow for conversation or at least viewing across the table.[186] It appears

that Albert foresaw this need, as there is a candelabrum design for twelve lights among his drawings (cat. no. 30). Although the drawing was initially catalogued as "French, eighteenth century," it is marked with an inscription in German.[187] The bird's-eye view of the design imparts a strongly modernist quality. Only a similar abstract design for candelabra with four branches on a banquet table for King Louis XIV supports this interpretation.[188] The square shape seems to omit one corner nozzle with circular wax pan, an indication that the unusual device was intended for the end of a table or a side serving table. The drawing's inscription confirms this theory (see p. 96).

The bases of the candelabra with three and six lights (see cat. no. 29) are supported by three scroll feet ornamented with volutes and shell motifs. They were presumably added in 1852 as a unifying element when Archduke Albrecht (1817–1895), duke of Teschen, commissioned a substantial addition to the service. The scroll feet match those on at least five monumental vases and on a set of fruit and dessert stands (*tambours*) made in 1852 by Mayerhofer & Klinkosch.[189] Thirty-six of the stands, each with glass bowl in a silver mount, were part of a 1947 auction at the Galerie Fischer, whose sale catalogue also documents three large mirrored *surtouts* from 1853 as well as further additions dated about 1860.[190] Of the at least thirty-two original candlesticks, twenty-six are known today. Braun documented eight two-branch and four three-branch candelabra, in addition to four grand candelabra with six lights.[191]

Wine Coolers

If the tureens occupy a special position as visual anchors for the table, the wine coolers are sculptural works of art in themselves. Until the early eighteenth century, glass or metal containers filled with wine or other beverages were kept cold in large basins with ice.[192] The vase-shaped wine coolers, or *seaux à champagne*, that replaced the basins were much smaller and could therefore be moved to locations around the dining hall as needed. Two of the Second Sachsen-Teschen wine coolers entered the Metropolitan Museum's collection in 2002 (cat. no. 31);[193] a second pair exists in a private collection in Paris. The dramatically shaped

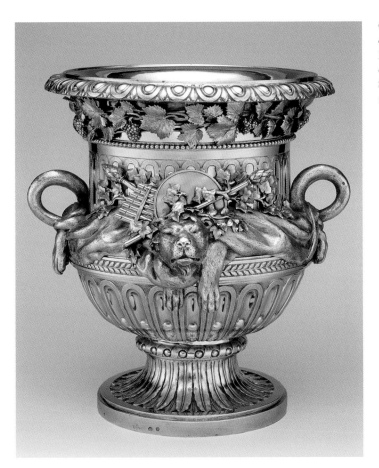

Cat. no. 31. Ignaz Joseph Würth. Pair of wine coolers (two views), Vienna, 1781. Silver, H. 11⅜ in. (28.9 cm). The Metropolitan Museum of Art, New York. Purchase, Anna-Maria and Stephen Kellen Foundation Gift, 2002 2002.265.1a,b.2a,b

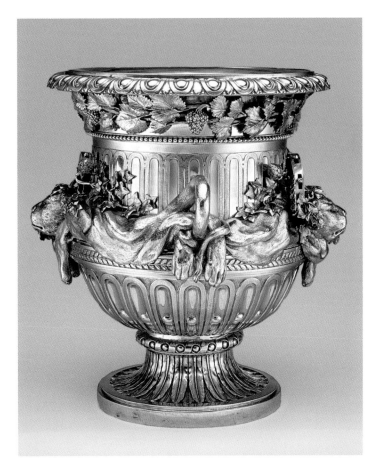

outline of these four is similar to that of Würth's wine coolers from 1776 (see cat. no. 14). While the overall ornamental style of the coolers draws inspiration from the contemporary French Neoclassical art and culture so appreciated by their owners, Würth's vigorous design, sparkling play of textures, and daring juxtaposition of classical elements with whimsical sculptural details represent the embodiment of Viennese Neoclassicism. Fully exploiting the light-reflective quality of the precious metal, Würth tested its malleability to the limit to create a technical triumph of the goldsmith's art.

In a nod to earlier Baroque imagery, lion skins drape the bodies of the wine coolers, a reference to Hercules wearing the coat of the Nemean lion as a symbol of his strength, and curled lion tails form the unusual handles. The lion skins also teasingly evoke the insulating properties of the coolers. The applied ivy, grapevines, and trophies—which include crossed thyrsi (staffs), tambourines, and reed pipes—symbolize Bacchus, god of wine and erotic ecstasy. The witty decoration of the wine coolers represents the triumph of Bacchic pleasures over the worldly Herculean power in the form of the new military commander and his consort.[194] Each of the eight documented wine coolers bears Würth's mark for 1781, the year after Albert and Marie Christine assumed their duties in Brussels.[195]

Serving Dishes and Dinner Plates

Dishes (*plats*) were required in successive sizes to serve a multitude of tasks (cat. nos. 32–35). Fish prepared in a variety of ways was a regular feature of celebratory dining (especially during the Lenten season), as were concoctions of beef, poultry, and game meat, and dozens of the silver dishes were needed to keep up with the beautifully arranged food creations coming from the kitchen. Large oval fish dishes accommodated pike or the black carp that came from the Polish region of the Habsburg monarchy; these were supplemented by round versions in various sizes.[196] Edmund Braun lists four oval and four round large dishes, twenty-four of medium and small size, as well as six deep oval dishes, among others.[197]

As with serving dishes, the service's two hundred eighty-eight plates, or *assiettes* (cat. no. 36),

feature curved outer edges and rims decorated with rippled surfaces and crossed stripes resembling fasces, a motif inspired by ancient Roman bundled rods.[198] The curving shape existed in countless nuances. The gently restrained wavelike forms seen here follow the classical archetype and recall a pattern likely to have been familiar to Duke Albert, who regularly visited his family in Saxony and was surely aware of the silver *Servis vor die hohe Herrschaft* (Service for the High Lords [or ruling House]) made in Dresden by the goldsmith firm Schrödel in the 1760s.[199]

The number of dinner plates may seem high today, but they were necessary for serving guests efficiently throughout the numerous courses specified by the ceremonial customs of the princely house (see p. 62). In July 1767 the monthly journal *Miscellanea Saxonica* reported that a Dresden court goldsmith named Ingermann had invented a machine that produced large quantities of silver blanks to be embossed and used as silver plates and dishes. The machine could also draw silver wire.[200] This invention was likely born of the ongoing need to supply multiple dishes and plates for extensive silver services. No documentary evidence has come to light so far, but Duke Albert or the Viennese goldsmiths themselves could well have played a role in introducing this technology to Austria.

At public feasts, one's rank within the social hierarchy would either guarantee a seat at a table or lead to a long night of standing and looking on while others ate. Participation in such a meal was a complicated process in which the guest's seat placement, dietary preferences, and the distribution of dishes around the table were inextricably linked. Everyone received a share of something, but the degree of choice depended on how successful the diner was in conveying his or her wishes to the right person.[201]

Perhaps one of the most obvious, and visually arresting, dining-related symbols of status was the formal napkin. Napkins artistically folded in the form of ornaments, architecture, animals, or grotesque creatures had long been an important aspect of public table decoration. A substantial number of illustrated books were published during the seventeenth and eighteenth centuries as both inspiration and instruction on how to transmit symbolic messages in such a splendid and pictorial way (cat. no. 37).[202]

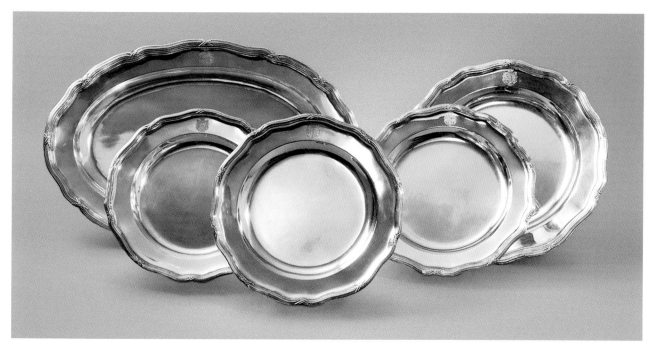

Cat. nos. 32–35 (front to back). Ignaz Joseph Würth. Silver serving dishes, Vienna, 1780–81. Medium round serving dish, 1781. Diam. 12¾ in. (32.5 cm). Two round dishes, 1780. Diam. 11⅛ in. (30.3 cm). Large oval serving platter, 1780. 23¾ × 16½ in. (60.4 × 41.8 cm). Large round serving platter, 1781. Diam. 16½ in. (41.8 cm). Private collection, Paris

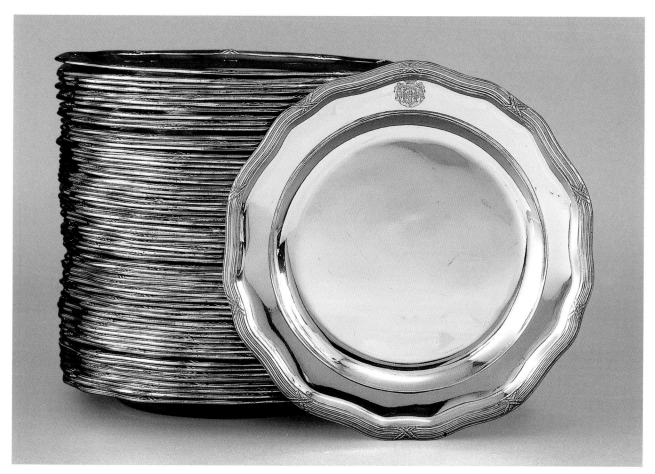

Cat. no. 36. Ignaz Joseph Würth. Sixty dinner plates, Vienna, 1781–82. Silver, Diam. of each approx. 10⅛ in. (25.6 cm). Private collection, Paris

Cat. no. 37. Napkin designs in the form of various animals, Italian, 1639. Engraving, 5¾ × 8⅛ in. (14.6 × 20.8 cm), from *Li tre trattati* (The Three Treatises) by Mattia Giegher (Padua, 1639), plate 5. The Metropolitan Museum of Art, New York. Harris Brisbane Dick Fund, 1940 40.84

Another role of the napkin managed to transcend political and social differences. According to the napkin-folding specialist and researcher Joan Sallas, "One napkin was placed under the plate for members of the royal [or princely] family and another on top of it (a tradition still practiced at the Swedish court). On special occasions, the allegorical theme of the festivity was woven into or applied to these [under] napkins, which could only be admired during the changing of the plates between courses."[203] An intricate example of this special napkin type commemorates the Peace Treaty of Teschen in 1779, one of which Sallas has identified at the Grassi Museum für Angewandte Kunst in Leipzig (fig. 46).[204] In March 1779 a congress of the four major European powers—Austria, Prussia, France, and Russia—met at Teschen to negotiate terms for ending the so-called War of the Bavarian Succession. The inscription on the napkin states that "under Russian and French mediation," the treaty was signed on May 13, 1779.[205] Emperor Joseph II and Duke Albert attended the celebratory banquet at which the special napkin was presented to the princely guests from various parts of Europe.[206]

A late eighteenth-century Austrian guidebook, *Praktischer Unterricht in der neuesten Art des*

Tafeldeckens und Trenchirens, mit Figuren erläutert, recorded the etiquette of setting a table appropriate for special occasions.

[For] the orderly arrangement of the festive board or tables . . . for their decor and necessary uses, and how they are to be set. . . . The napkins [should be] six quarters [approx. 86.4 cm (34 in.), one quarter = approx. 14.4 cm (5⅝ in.)] long and five [approx. 72 cm (28⅜ in.)] wide. . . . If the napkins can be [fancifully] folded, they will grace and fill the table; today, however, this is less often done, and even at tables for distinguished persons [the folded napkins] will be rectangular, presumably, because [elaborate napkin folding] takes much effort; the napkins are not getting better, but most [of the hosts] lack the knowledge [to follow this etiquette]. Finally the plates . . . must be warmed, and above all there have to be enough plates that clean ones can be served four times, otherwise the dishwashers cannot keep up, and nothing is more disgraceful than when dirty, wet, or crooked plates are brought to the table. Each plate shall have a spoon, a pair of knives, and two small rolls, which must be rubbed with a grater on the underside and placed under the napkins.[207]

Fig. 46. Commemorative napkin showing an allegory of the Peace Treaty of Teschen, Großschönau, ca. 1779. Silk and damask weave, 42½ × 34⅝ in. (108 × 88 cm). Grassi Museum für Angewandte Kunst, Leipzig. Purchase 1923 Inv. no. 1923.032

The guidebook further specified that the napkins should match the tablecloths, applied in several layers, all of which had to overhang equally on each side of the table. Between courses, the soiled cloths would be removed to reveal clean ones underneath, a process that culminated with the dessert cloth, which would remain until the banquet's end.[208]

Flatware and Serving Pieces

Eating utensils made of gold were commissioned on special occasions and were considered personal to members of European royalty. It is not documented whether Albert and Marie Christine used golden flatware reserved only for themselves, but it is known that Empress Maria Theresa gave Albert a golden service in memory of her late husband, Francis Stephen.[209] The term "golden service" differs from the eighteenth-century *Mundzeug* (which included spoon, knife, fork, egg and marrow spoons, spice box, and egg cup), and the exact appearance of Albert's golden service is not clear. In about 1780, Albert and Marie Christine's adopted son, Archduke Charles of Austria, duke of Teschen (1771–1847; see p. 70), had such a set made of gold in Vienna.[210]

The Second Sachsen-Teschen Service certainly included matching tableware for main courses, but to date only a few serving utensils—for example, a large serving ladle, or *louche* (cat. no. 38)—have surfaced.[211] Roëttiers employed similar decorative motifs but applied them differently in his ladle of 1775–76 (cat. no. 39). Serving items documented

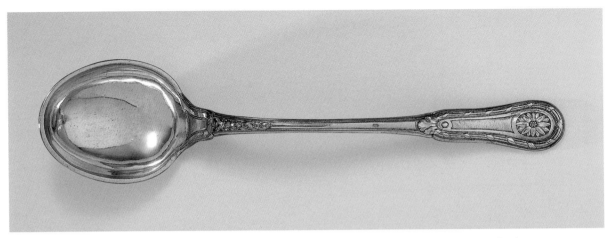

Cat. no. 38. Ignaz Joseph Würth. Ladle, Vienna, 1780. Silver, L. 14⅜ in. (36.4 cm). Private collection, Paris

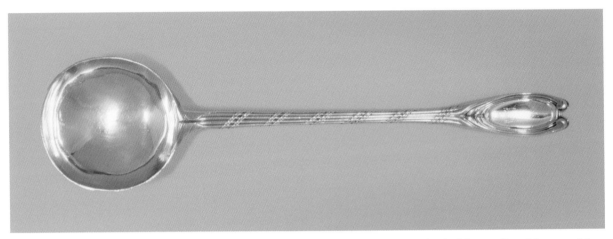

Cat. no. 39. Jacques-Nicolas Roëttiers. Ladle, Paris, 1775–76. Silver, L. 14⅞ in. (37.9 cm). The Metropolitan Museum of Art, New York. Gift of Mrs. Reginald McVitty and Estate of Janet C. Livingston, 1976 1976.357.2

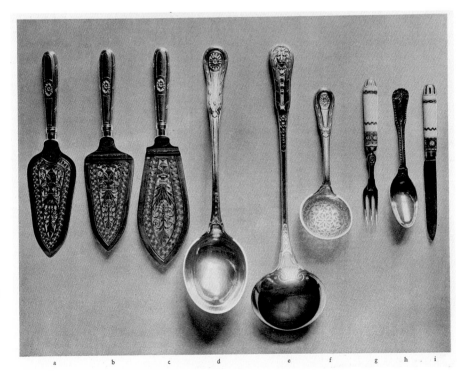

Fig. 47. Ignaz Joseph Würth. Dessert serving utensils for the Second Sachsen-Teschen Service, ca. 1779–81. From *Das Tafelsilber des Herzogs Albert von Sachsen-Teschen* (The Silver Service of Duke Albert of Sachsen-Teschen) by Edmund W. Braun (Vienna, 1910), plate IX

Cat. no. 40. Original leather cases for cat. nos. 41, 42, 43. Top to bottom: 5½ × 11½ × 11 in. (14 × 29 × 28 cm); 5 × 15 × 10½ in. (13 × 38 × 27 cm); 3½ × 22½ × 10¼ in. (9 × 57 × 26 cm). Private collection, Paris

by Edmund Braun (fig. 47) include six large ladles (see d, e), two fish slicers (c), two cake and pie slicers (a, b), and two sugar sifters (f); they give a clear indication of the original flatware's overall appearance. The matching silver knives were likely fitted with sharpened steel blades and handles similar to those of the slicers—which feature a rosette framed by two fields surrounded by rippled moldings with bands. This same design is evident in the handles of two fish slicers belonging to the Würth service of 1779 now in the Danish royal collection in Copenhagen (see also fig. 28).[212]

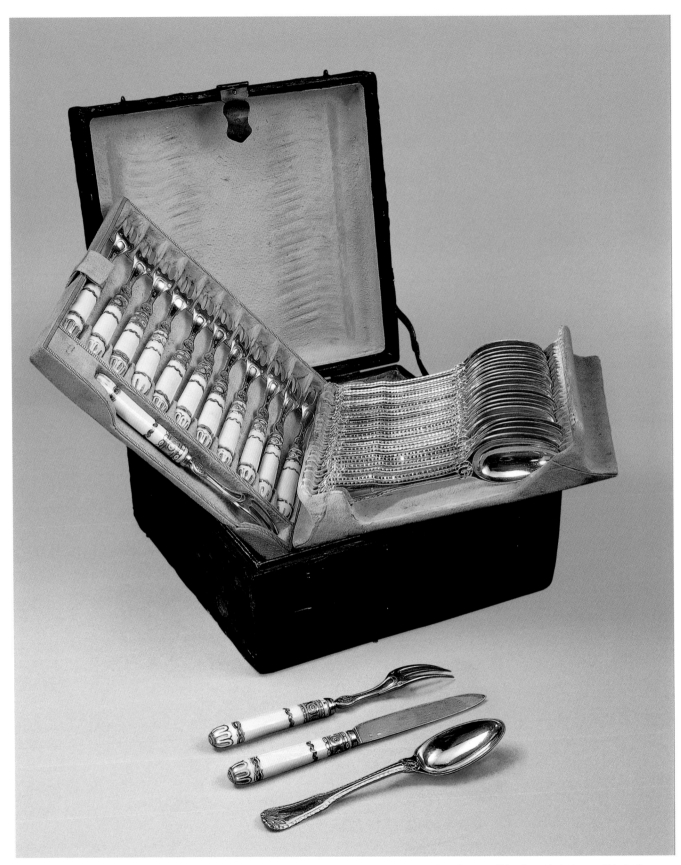

Cat. no. 41. Ignaz Joseph Würth. Flatware, Vienna, 1781. Forks: gilded silver, porcelain handle, L. 8¼ in. (21 cm); knives: gilded silver, porcelain handle, L. 8⅝–8¾ in. (22–22.2 cm); spoons: gilded silver, with undulating band decor, L. 7¾–7⅞ in. (19.7–19.9 cm). Private collection, Paris

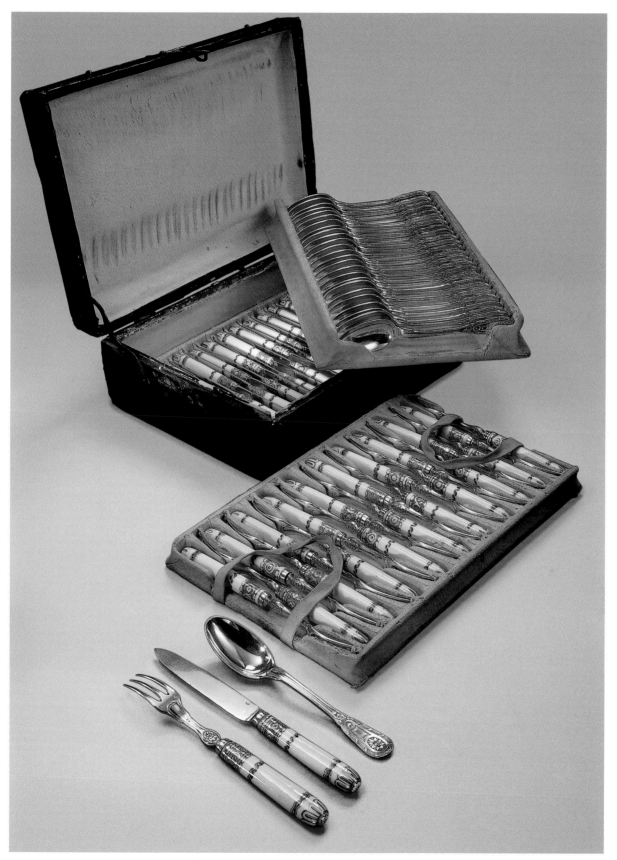

Cat. no. 42. Ignaz Joseph Würth. Flatware, Vienna, 1781. Forks: gilded silver, porcelain handle, L. 8¼ in. (21 cm); knives: gilded silver, porcelain handle, L. 8⅝–8¾ in. (22–22.2 cm); spoons: gilded silver, with rosettes, L. 7½ in. (19 cm). Private collection, Paris

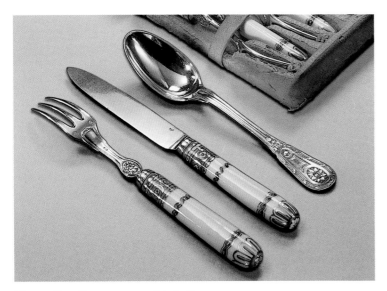

Fig. 48. Detail, cat. no. 42, gilded-silver spoon

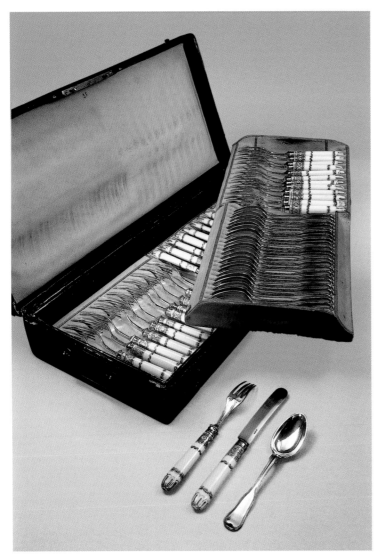

Cat. no. 43. Mayerhofer & Klinkosch. Flatware, Vienna, 1852. Forks: silver, porcelain handle, L. 8¼ in. (21 cm); knives: silver, porcelain handle, L. 8⅜ in. (21.2 cm); spoons: silver, L. 7 in. (17.7 cm). Private collection, Paris

Illustrated here is an extensive dessert set that includes gilded-silver spoons in two slightly different designs. The bowl (*Laffe*) of one type (cat. no. 41) ends in a slight point, and the handle is decorated with a leaf ornament and gently undulating edge molding. The second version (cat. no. 42, fig. 48) mirrors exactly the rosette pattern on the fork illustrated by Braun (see cat. no. 38) and the ripple and band molding of the ladle (fig. 47d). The matching fork and knife (fig. 47g,i) have porcelain handles made in Vienna's porcelain manufactory about 1780. The flatware lengths are greater than those of the average dessert set—spoon: 6¾ inches (17 cm); fork: 6¼ inches (16 cm); knife: 7⅞ inches (20 cm)—which was customarily gilded.[213] The second, similar flatware ensemble seen here (cat. no. 43) does not show any gilding; its silver parts were made in 1852 by Mayerhofer & Klinkosch in Vienna, although most of the porcelain elements are from about 1780.

Preserved in the 1779 Danish ensemble by Würth are thirty-six gilded-silver dessert spoons,

Fig. 49. Plate (see cat. no. 36) showing silver crest added after 1822 by Albert's heir, Archduke Charles of Austria

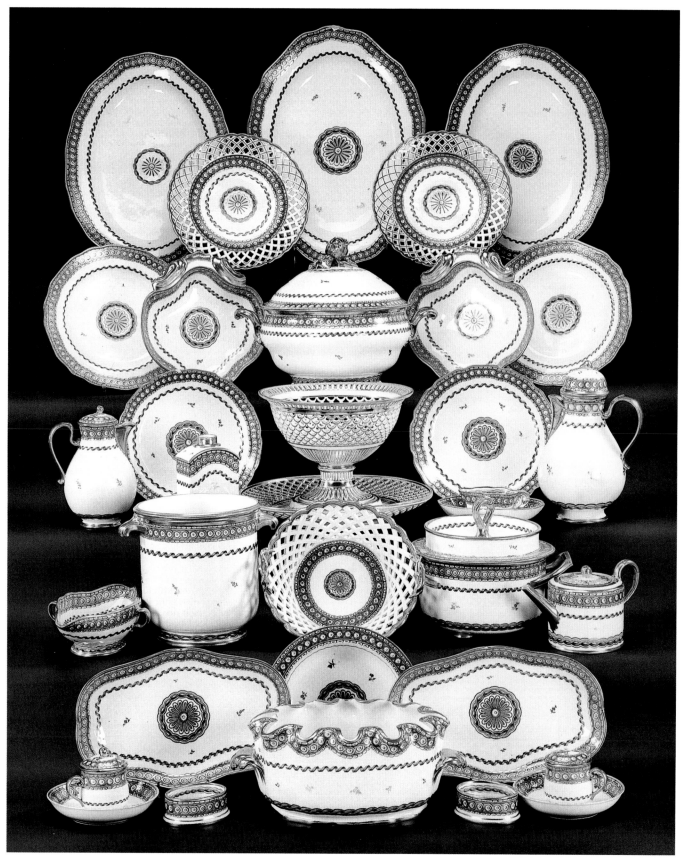

Fig. 50. Viennese Porcelain Manufactory. Porcelain service in same pattern as the porcelain handles in cat. nos. 41–43, ca. 1780. From *Die Fürstliche Sammlung Thurn und Taxis*, vol. 3, *Keramik & Glas* (The Princely Collection of Thurn and Taxis, vol. 3, Ceramic and Glass), October 16 and 18, 1993 (Sotheby's, Regensburg), plate 13

Fig. 51. Antoine Cardon.
Coat of arms of Marie
Christine of Austria and
Albert of Sachsen-Teschen
(detail), 1785. Engraving,
from *Albert Herzog von
Sachsen-Teschen, 1738–1822*,
exhibition catalogue
(Vienna, 1988)

forks, and knives, some with reeded handles. The
spoons are 7⅜ inches (18.8 cm) long and nearly
match the length of the flatware seen here. The
porcelain handles of the knives and forks shown
here feature the same motifs and Neoclassical
colors (green, gold, and gray) seen in a large porce-
lain service formerly in the Princely Collection of
Thurn und Taxis in Regensburg (fig. 50).[214] In 1910
Edmund Braun connected parts of a porcelain ser-
vice made in Vienna, presumably in the same pat-
tern, to the Second Sachsen-Teschen Service. At
that time these porcelains were owned by Archduke
Frederick Maria, duke of Teschen, and were still
preserved in the Albertina Palace (see below).[215]
Recent research by Claudia Lehner-Jobst reveals
that the First Sachsen-Teschen Service (see figs. 7,
8), given to Marie Christine in 1766 on the occasion
of her wedding, also included a dessert set for
twenty-four made of gilded silver with porcelain
handles, which perhaps reflects a private passion on
the part of the archduchess for such gilded-silver
and porcelain combinations.[216]

The Fate of the Second Sachsen-Teschen Service

The uncovered serving dishes and dinner plates in
the Second Sachsen-Teschen Service display some
wear as evidence of their use, albeit only on special
occasions (see cat. nos. 32–36). These are the only
items that bear a finely engraved coat of arms

(fig. 49). One would reasonably expect that these
arms represented the family crest of the service's
original patrons, Albert and Marie Christine (fig. 51),
but they are in fact those of the couple's adopted
son, Charles.[217] Because the archduchess bore only
one child, a daughter who died one day after her
birth on May 16, 1767, she and Albert adopted as
their heir, and successor to the ducal Teschen line,
their nephew Charles, the third-born son of Marie
Christine's brother the Holy Roman Emperor
Leopold II (1747–1792). This may explain how the
service became attached to the estates of the
Sachsen-Teschen line. In his will, Albert made gen-
eral provisions for his estate and gave more specific
instructions regarding the disposition of his collec-
tion of drawings and prints, which could not be
divided.[218] Charles's son Albrecht (1817–1895) passed
the service on to his nephew Frederick (1856–1936).
In 1919 Frederick and his son Albrecht II (1897–
1955) were banished from Austria by the leaders
of the new republic; they went into exile at their
Hungarian estate in Ungarisch-Altenburg (today
Moszonmagyaróvár, Hungary).[219] In 1933 Frederick,
once celebrated as the wealthiest aristocrat in the
Austro-Hungarian Empire, was forced to sell in
Vienna some of his paintings and furniture.[220] After
the death of Albrecht II in Argentina, the estate
passed to Albrecht's nephew Baron Paul Waldbott-
Bassenheim (1924–2008). It is not clear whether
Albrecht or his heirs sold some or most of the
Second Sachsen-Teschen Silver Service in 1947.[221]

The Silver Service in Brussels

By the time of her death on November 29, 1780, the empress Maria Theresa was presumably aware of the costly commission for Albert and Marie Christine's extraordinary silver service. Many of the pieces bear assay marks of 1779 and 1780, and those marked 1781—including many of the dishes and the thirty-two or more single candlesticks—were likely in progress by then as well. As long as Maria Theresa was alive, Mimi was able to maintain her careful balance of power, which largely allowed her to ignore her brother Joseph II and to influence the empress to an extent that still seems widely underestimated by historians today. As Leopold, another of Marie Christine's brothers and the grand duke of Tuscany, who succeeded Joseph II as Emperor Leopold II for two years (1790–92), commented: "She knows and always has known exactly how to capitalize on the Empress's weaknesses. . . . [Mimi] has her under her thumb . . . and makes great demands on her. The Empress . . . does everything [Mimi] wishes in order not to lose her [affections]. . . . [Marie Christine] also has a great hatred and dislike of the Emperor [Joseph II]."[222]

At the time of Marie Christine's marriage, Maria Theresa had stipulated that her daughter and new son-in-law would one day become joint governor-generals of the Austrian Netherlands (today roughly comprising Belgium and Luxembourg). Because of her attachment to Mimi, the empress deliberately avoided carrying out this provision during her lifetime, even after the death of the existing governor, Duke Charles Alexander of Lorraine, on July 4, 1780.[223] On August 31, 1780, Maria Theresa wrote with relief to Marie Antoinette in France that "le départ de votre soeur pour les Pays-Bas ne sera qu'au printemps prochain."[224] Despite the lack of documentation, one can infer that it was not the very wealthy couple but the empress herself who paid, out of her private purse, for much of the Second Sachsen-Teschen Service in order to endow her favorite daughter and son-in-law with stately silver for their forthcoming responsibilities.[225] This theory is supported by the contemporary tradition of Russian governors and English ambassadors being supplied with silver ensembles by their monarchs (see pp. 7–9, 16–17). Maria Theresa had also given the couple's predecessor in Brussels a handsome amount for furnishing the official residence.[226]

The passing of the exalted empress led to great change in Vienna. According to Dorothy Gies McGuigan, "The first thing Joseph did after his mother's death was to rid himself of what he called 'this feminine republic' that had ruled so long in the Hofburg. He announced briskly that . . . all the women his mother had kept about her—elderly court widows, relatives, ex-governesses—were to leave during the summer . . . of 1781."[227] Neither did Joseph II care much for any of his sisters at the time. He was finally able to dispatch Marie Christine and her husband from the castle at Pressburg (today Bratislava, Slovakia), Albert's official residence as governor of Hungary (1765–80), which Joseph considered to be too close to Vienna, to Brussels, where the couple took up their duties (1781–93).

The first years in the Habsburg Netherlands were relatively uneventful for the governors, allowing them an opportunity to get to know their new domain. An early exception was the opposition of the powerful regional gentry to changes in their privileges, which had been in place for centuries. Despite Joseph II's stated desire earlier in his reign for an enlightened monarchy, by the time of his mother's death he had embraced a more authoritarian approach and now sought to establish himself as direct ruler over the gentry. Despite local resistance, the emperor prevailed and on July 31, 1781, represented by Marie Christine, who as an archduchess of Austria always outranked her husband, the duke of Saxony, Joseph was inaugurated and formally invested as the count of Flanders in Ghent. *La Gazette Van Gend* reported that on the evenings of July 30 and 31, 15,000 lanterns (or candles) were lit and the bells of the cathedral rang in honor of the celebration, which included a banquet offered by the magistrate of Ghent at the Hôtel de Ville with 180 *couverts* (place settings). The *gouverneurs généraux* were seated separately in two halls (cat. no. 44), one furnished with a large, U-shaped structure for Albert (*table de gouverneur*) and the second installed with a smaller table for Marie Christine (*table de l'archduchesse*).[228] There is no indication whether the new governors used parts of their impressive new Viennese silver service, at least for display, on that spectacular occasion, which was also marked with triumphal arches and outdoor activities, including elaborate fireworks.

In contrast to the palace in Pressburg, which was already standing when Marie Christine and Albert arrived, the couple's future residence in Brussels was to be built according to their own requirements and personal taste. The discerning pair acquired a property called Schoonenberg on the outskirts of the city and sought the advice of the best architects in Brussels for the design and construction of their new palace.[229] The death of Mimi's mother ended any extra financial contributions to her favorite daughter; this loss, in combination with Joseph II's constant economizing, resulted in a shortage of funds. The new governors were now required to manage their finances carefully in order to continue to afford the glorious lifestyle they had enjoyed in Vienna and on their other estates. Fortunately Duke Albert was closely associated with those prosperous Habsburg dominions that were considered the "economic powerhouse of

pre-industrial Austria": income from northeastern Bohemia, the duchy of Teschen, and the vast expanses of the Hungarian plains, as well as the mines in Hungary and Bohemia, had nourished Austria for centuries.[230] Albert also developed a close rapport with Charles DeWailly (1730–1798), the renowned French architect and designer (and a friend of the famous sculptor Augustin Pajou [1730–1809]), and with the director of the Ministry of Public Buildings in the Austrian Netherlands, Louis Joseph Montoyer (ca. 1747/49–1811), whom the governor named as his court architect in 1780.[231] With the aid of these experts, Albert began construction in 1782 and completed the project in the summer of 1785.

The inauguration of Schoonenberg Palace, today the Château de Laeken and still the residence of the royal family of Belgium (fig. 52), was celebrated lavishly between July 14 and August 4, 1785.

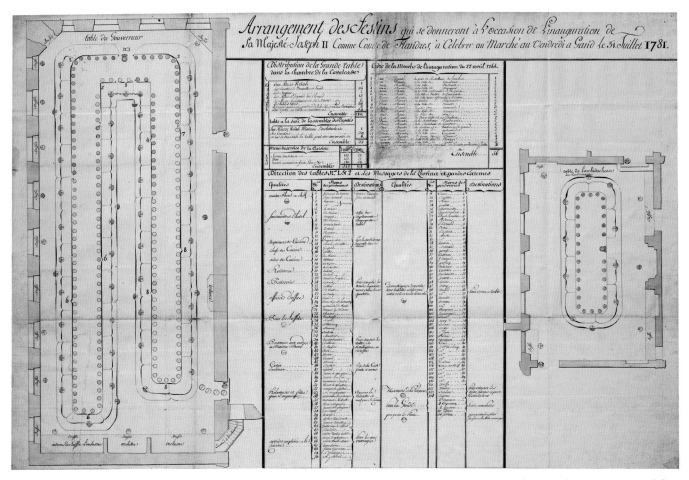

Cat. no. 44. Table setting for the inauguration of Joseph II as count of Flanders, with Marie Christine and Albert, joint governors of the Austrian Netherlands, presiding. Ghent, July 1781. Drawing, 25¼ × 36⅜ in. (64 × 93 cm). Private collection, France

Fig. 52. View of Schoonenberg Palace (Château de Laeken), ca. 1804. Painted detail from a Sèvres vase, 1809.
From *Laeken: Résidence impériale et royale* by Anne and Paul van Ypersele de Strihou (Brussels, 1970), p. 47

Because it was a major cultural event both in the region and farther afield, Marie Christine and Albert invited many of their closest friends, such as Charles Joseph Emmanuel (1759–1792), prince de Ligne, a connoisseur of garden landscaping; Freiherr Friedrich Wilhelm von Seckendorff-Aberdar (1743–1814), Albert's general-adjutant and confidant; some family members, including Albert's siblings Clemens Wenceslaus of Saxony, archbishop of Trier (1739–1812), and Maria Anna Sophia of Saxony; as well as major local dignitaries and even members of the Brussels guilds. Among the highlights of the occasion were a balloon flight from Schoonenberg to Paris, made by Monsieur de la Touche de Frourcoi on July 19, and a bascule pigeon shoot for which twenty-five valuable silver prizes were offered. By the evening of the first day of shooting, not one of the lucky pigeons had been

shot; when the shoot continued on August 2, however, sixteen birds lost their lives and sixteen massive silver trophies were given away. The nine remaining prizes were given to the participating guilds to be saved for future competitions.[232]

The Second Sachsen-Teschen Service was certainly used during these festivities and must have been greatly admired (see, for example, pp. 2, 36). To set the Brussels banquet table with a Viennese silver service of such quality, quantity, and imaginative design—which would not only match but in many ways surpass some of the best Parisian creations for the French and the European courts—was a form of Habsburg propaganda. The result of Ignaz Joseph Würth's enormous achievement, in which he looked beyond French models to incorporate other, mainly Italianate, influences, is a distinctive Viennese Neoclassical style that powerfully

Fig. 53. The interior of Schoonenberg Palace (Château de Laeken) with a view of the dome. From *Laeken: Résidence impériale et royale* by Anne and Paul van Ypersele de Strihou (Brussels, 1970), p. 23

symbolized the cultural and financial abilities of the Habsburg dynasty. Because Würth's patrons Albert and Marie Christine were well versed in the contemporary fashions in architecture, stuccowork, and the decorative arts, it was natural that their new silver service would correspond with its surroundings to make an especially strong impression on their guests.[233] Thus, the service's silver ornamental vocabulary of vivid acanthus scrolls and rosettes was echoed in stucco on the walls, culminating in the monumental decor of the palace's dome (fig. 53).[234]

Fig. 54. Dining room at Schoonenberg Palace (Château de Laeken), Brussels, where the service was used (today it is the state dining room of the king of Belgium)

Freemasonry and Eighteenth-Century European Culture

Both the Schoonenberg Palace and the English-style garden—complete with follies and pavilions—that surrounded it were designed to include symbols relating to Freemasonry. The result was a *Gesamtkunstwerk* of a cost and magnificence far beyond the standards of the day. Much attention was paid to the central rotunda, conceived as a pantheon, as well as to the adjunct rooms, including the dining room where the silver service would have been used (fig. 54).[235]

The impact of the Freemasons in the development of artistic environments and the transmission of styles through their networks has largely been forgotten today. In fact, many of Duke Albert's relatives, aristocratic friends, and artists, including Charles DeWailly and the prince de Ligne, were Freemasons, as were Haydn, Mozart, and even

Austria's enemy Frederick the Great. The Freemasonry tradition had been established earlier within Albert's family by several members of the House of Wettin. The duke himself joined the Masonic order in 1764, and his leading role in several Viennese lodges has been documented.[236] Albert was likely oriented more closely toward the rationalist and Enlightenment-inspired members, the so-called Illuminati, than to those who were absorbed with mysticism and the occult. As members of an all-male society, Masons were officially equal within the confines of a lodge regardless of their relative positions in the outside world. Thus, when Albert initiated a craftsman into a class, he "left his titles behind," and the two men could speak freely and informally with each other.[237] Conrad von Sorgenthal (active 1784–1805), a director of

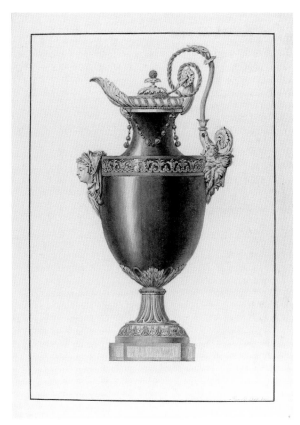

Cat. no. 45. Georg Heinrich von Kirn. Design for a porcelain gilded-bronze-mounted ewer, German, ca. 1790. Pen and black and brown ink, graphite, watercolor, framing lines in pen and black ink, 19⅞ × 14⅛ in. (50.5 × 35.9 cm). The Metropolitan Museum of Art, New York. Gift of Raphael Esmerian, 1963 63.547.3

Vienna's porcelain manufactory, was a Freemason, and it is likely that at least some members of the gifted Würth family were also.

Another prominent Freemason was Count Giacomo Durazzo (1717–1794). Originally an Italian diplomat, the count changed careers and in 1754 was appointed director of the Imperial theaters in Vienna. In Pressburg, Albert had already begun, timidly, to acquire art with the aid of the highly knowledgeable Durazzo, who acted as the duke's agent and helped to prepare the ground for what would become a world-renowned collection, systematically assembled for comprehensiveness and carefully documented.²³⁸ Albert's well-known interest in art was shared and supported by Marie Christine; in July 1776, at the end of the couple's grand cultural tour through Italy that spring and summer, Count Durazzo delivered to them in Venice a collection of thirty thousand prints, with an accompanying register and vitae for fourteen hundred artists.²³⁹

Once established in Brussels, the joint governors furnished the Schoonenberg Palace with the best that Europe had to offer, acquiring major works of art from Paris and employing influential artists/connoisseurs (and likely Freemasons) such as Johann Georg Wille (1715–1808) as agents. Even Marie Antoinette, who avoided her sister's company whenever possible during the latter's visit in 1786, knew about Albert's passion and arranged to purchase from dealers and artists' ateliers a great quantity of drawings as a commemorative gift for the governor, "so many, it is said, that one did not know how to pack them [all] away." Louis XVI gave the couple four tapestries with scenes from Cervantes's *History of Don Quixote* (today in the J. Paul Getty Museum).²⁴⁰ A drawing from about 1790 by Georg Heinrich von Kirn (1736– 1793) of a blue Sèvres porcelain ewer mounted with delicate gilded bronze (cat. no. 45) exemplifies the type of precious object procured from *marchands merciers* (merchants who worked outside the guild system to provide clients with items of great luxury).²⁴¹

Epilogue: Founding a Cultural Legacy

The Brabant and French revolutionary wars brought about irrevocable change in Europe. The collapse of the ancien régime and the encroaching enemy army forced Marie Christine and Albert to flee Brussels in November 1792. More than five hundred employees of the royal court managed to load the ducal property and their own possessions onto three large freight ships to be transported by sea to Hamburg and then by land to Vienna.²⁴² One of the ships capsized and was lost. Surviving lists of its freight, unfortunately not very detailed, document fifteen crates with *vaisselles* (dishes and crockery), forty-two with fine books, thirty-seven *meubles divers* (items of furniture), and four crates with *Porcellain du Saxon* (Meissen porcelain), among many other items.²⁴³ The lord chamberlain Joseph Ritter Girtler von Kleeborn, mentions that "a substantial part of our silver" was lost but that the missing items were either everyday tableware or silver belonging to court officials. The loss was valued at "close to one million guilders."²⁴⁴

After the French Revolution, the building minister and architect Louis Joseph Montoyer continued to work for Duke Albert in Vienna,

overseeing the reconstruction of the Palais Tarouca, the Viennese residence of the Netherlandish governors. Tragically, before work could begin on the couple's new home, the duke faced a disaster much greater than the loss of replaceable treasures: on June 24, 1798, Mimi died of typhus. Her bereaved husband commissioned Antonio Canova (1757–1822) to create a memorial. Completed in 1805, Marie Christine's cenotaph was widely considered one of the grandest and most beguiling monuments in the Austrian capital.[245]

Duke Albert outlived his wife by twenty-four long years, during which he led a solitary life ("une vie moins agitée") devoted to collecting and charity work. The duke "spent his days in these sacred rooms [of the Albertina], from early morning until late at night, granting himself only as much free time as was necessary for meals and walks. Visiting scholars and artists always found him there, constantly busy with the ordering and expansion of his art treasures."[246] Ironically, when Albert died in

1822 at the age of eighty-four, few could recall his illustrious early career because he had disappeared from the limelight so long before. Yet the palace he had renovated and enlarged after Marie Christine's death would ultimately bear his name and house his extensive art collection, which he ensured would remain largely intact (fig. 55). We should also remember, however, that it was Albert's consort, Marie Christine, who laid the foundation for this world-famous collection with her dynamic ambition, wealth, and love of art.

The Second Sachsen-Teschen Service survived under the protection of Duke Albert and his wealthy heirs. Given that nearly all the extant pieces bear various Austrian tax marks from 1806–7 and later, Albert must have paid considerable sums in duty in order to keep the service intact rather than deliver it to the mint.[247] The service brought acclaim not only to its owners but also to Ignaz Joseph Würth, one of the most sought-after and influential goldsmiths of his time, whose creations inspired both

Fig. 55. Eduard Gurk and Joseph Lutz. Albertina, Vienna, view of the state-rooms wing, ca. 1804. Engraving, from *The Albertina: The Palais and the Habsburg State Rooms* by Christian Benedik (Vienna, 2008), p. 54

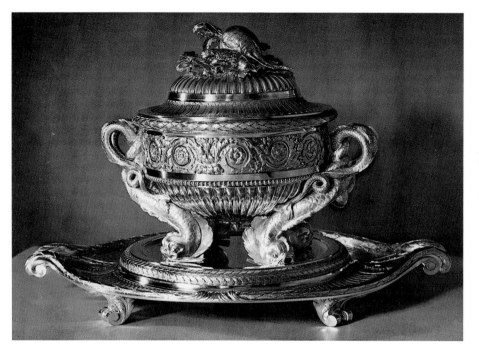

Fig. 56. Ignaz Joseph Würth. Round tureen with stand, ca. 1779–81. Part of the Second Sachsen-Teschen Service. From *Das Tafelsilber des Herzogs Albert von Sachsen-Teschen* (The Silver Service of Duke Albert of Sachsen-Teschen) by Edmund W. Braun (Vienna, 1910), plate 1. Whereabouts unknown

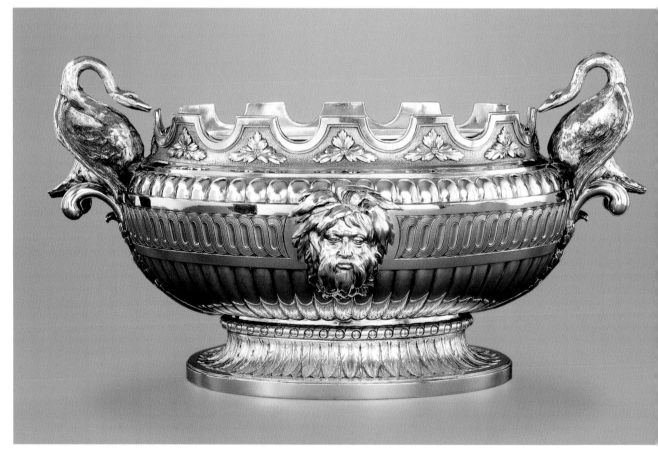

Cat. no. 46. Verrière (glass cooler), attributed to Ignaz Joseph Würth, Vienna, ca. 1780. Silver, H. 10 in. (25.3 cm), L. 18¼ in. (46.4 cm). Private collection, France

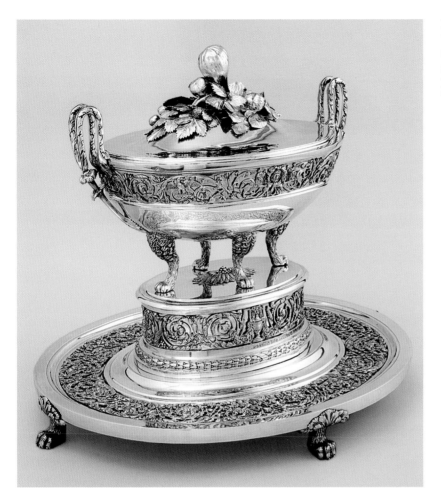

Fig. 57. Johann Georg Hann.
Tureen with stand, Vienna, 1794.
Silver, H. 20⅛ (51 cm), L. 23¼ in.
(59.2 cm). Sammlungen des
Fürsten von und zu Liechtenstein,
Vaduz–Wien

his colleagues and family members. A small number of Würth's works survive in major museums all over the world. Many grace princely collections from Brazil to Stockholm and/or are still used in some royal households.[248]

The engraved inventory numbers allow us to estimate the service's original extent. The overall weight of the silver forged into these works of art must have been nearly 1,500 pounds (680 kg), exclusive of the silver the goldsmith would have received in payment.[249] The twenty-four dozen plates alone represented a small fortune. Several important pieces, including one of the large and two of the smaller oval tureens as well as one of the round tureens (fig. 56) and various cutlery items (see fig. 47), are known only through historic photographs.[250] This publication may encourage further exploration.

The magnificent silver service allows scholars to ascribe even unmarked objects to the Würth family's workshops. An example par excellence is a large *verrière* (glass cooler) that has traditionally been attributed to Giovanni Battista Boucheron

(1742–1815) of Turin (cat. no. 46).[251] The ornamental details, however, connect it closely to Ignaz Joseph Würth's pair of wine coolers from 1776 (see cat. no. 14) and to parts of the second Sachsen-Teschen ensemble (see cat. no. 31). In addition, the verrière features an engraved weight marking that corresponds to the Viennese standard.

The years between 1775 and the early 1790s produced silver forms of extraordinary inventiveness and superb quality, and it is apparent that contemporaries, competitors, and followers of Ignaz Joseph Würth observed closely the master's style. The Liechtenstein princely collection owns a tureen that was once associated with Albert's collection and was in fact used with the Second Sachsen-Teschen Service (fig. 57).[252] Made in 1794 by Johann Georg Hann (master 1780, d. 1812) in Vienna, it survives as one of the last efforts to achieve the style of the Würth dynasty; at the same time, its oversized stand and high legs anticipate the next stylistic developments to spread throughout Europe, those of late Neoclassicism and the Empire period.

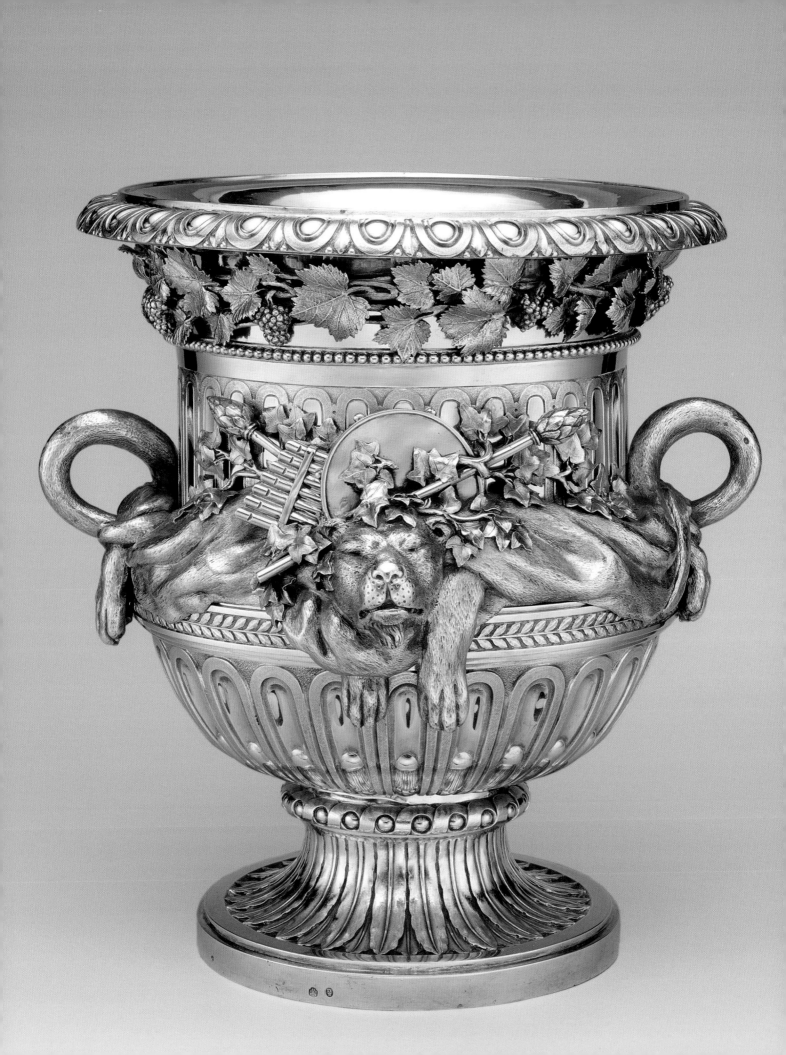

NOTES

BIBLIOGRAPHY

INDEX

PHOTOGRAPH CREDITS

Notes

Imperial Aspirations and the Golden Age of Ceremony

1. Kraus and Müller 1993.
2. For a compelling overview of Vienna during this period, see Tolley 2001; and Hagen 2002.
3. Mengs 1762/1995, p. 247; Betthausen 2002, p. 81.
4. Löffler 1910; "Maria Theresa" 1911.
5. Wraxall 1806, vol. 2, pp. 304–5, quoted in Semple 2005, p. 15.
6. The average life span in seventeenth-century Europe was twenty-six years, a number that rose to about thirty-five years in the eighteenth century. It was not until about 1876–80 that a life span of forty years was considered average in central Europe. See Rattner and Danzer 2005, p. 12.
7. Kräftner 2009, p. 54.
8. Whitehead 1992; Sargentson 1996.
9. For a view of the couple's 1736 wedding banquet, see Ottomeyer and Völkel 2002, pp. 154–55, no. 44 (entry by Hans-Jörg Czech); and Stahl 2002. They had five sons and eleven daughters; the latter were all given the first name Marie in honor of the Virgin Mary, an indication of the empress's deeply rooted devotion to the Catholic faith (see Löffler 1910; and "Maria Theresa" 1911).
10. Seelig 1994a; Stahl 2002.
11. Goethe 1811/1994, p. 160 (part 1, book 5); see also Stahl 2002, pp. 69–70.
12. For discussion of the German term, see Hoos 1991, pp. 53–54; for more on the *parade buffet*, see *Plaisirs et manières de table* 1992; and Ennès 1995.
13. Both the gold and the silver services seen in fig. 2, as well as other gilded-silver objects, were brought under military guard from Vienna to Frankfurt for the coronation. The declared value of the whole was the then-enormous sum of more than five hundred thousand guilders (Winkler 1993, pp. 89–90, 153, n. 30); see also *Versailles et les tables royales en Europe* 1993. The gold service is possibly the "Golden Service" described in 1784 by Johann Bernoulli as consisting of at least 136 various items, among them 58 plates (the average weight of a plate was approximately 22.93 to 25.7 oz. [650 to 700 g]; see cat. no. 36), 4 tureens on stands, and extra cutlery containing approximately 494 lbs. (225 kg) of gold (Hoos 1991, p. 52).
14. Haslinger 1997, p. 23. See also note 96 below.
15. In times of war or deprivation, silver or gold objects could even be cut into roughly square-shaped or canted parts and impressed with their equivalent value; these pieces were called *Klippe*, which derives from Swedish, meaning "to cut with a pair of scissors" (see Gerd Stumpf in Zischka, Ottomeyer, and Bäumler 1993, pp. 174–75, no. 6.4.1). The gold service is also depicted in a 1760 painting of Joseph II's wedding by Martin van Meytens (see Gruber 1982, p. 37, ill. no. 19; and Haslinger 2002, p. 51, fig. 23 [image reversed]).
16. Winkler 1993, p. 94 (under "1797"), and p. 156, n. 78.
17. Seelig 2002.
18. *Versailles et les tables royales en Europe* 1993.
19. Boehn 1921, p. 466.
20. Ibid., pp. 470–71, 473; regarding another voyage to Choisy, see also Marie-France Noël-Waldteufel in *Versailles et les tables royales en Europe* 1993, pp. 273–74, no. 55.
21. Boehn 1921, p. 466. Regarding Deffand's remark, see also Neidhardt Antiquitäten 1995, pp. 62–64, which mentions a "Marquis de Deffand" without any documentation.

22. Quoted in Hantschmann 2009, p. 769.
23. Mabille 1988; *Versailles et les tables royales en Europe* 1993 (with bibliography).
24. Lopato 2001, p. 307.
25. Ibid.
26. Ibid.; Munger 2003.
27. Perrin 1993. Most of the Germains were named either sculptors or goldsmiths of the king, but François-Thomas Germain, like his father before him, was accorded the double honor.
28. Quoted in Lopato 1998, p. 579.
29. Lopato 2001, p. 307. The various pieces weighed 30 *pud*, a now-obsolete Russian unit of measure equivalent to 36 lbs. (16.38 kg) per *pud*, making the total weight of the silver about 1,083 pounds (491.4 kg).
30. See Koeppe 2009, pp. 230–31.
31. Quoted in Le Corbeiller 1969, p. 289.
32. See Le Corbeiller, Kuodriaveca, and Lopato 1993; Gérard Mabille et al. in *Versailles et les tables royales en Europe* 1993, pp. 318–21, nos. 207–31; Koeppe 2003; and Munger 2003. For more on Orloff, see Helbig 1917.
33. For various aspects of this consumption, see Koeppe and Knothe 2008.
34. *En Konges Taffel* 1988; *Catherine the Great* 1998. Although Russian collections still preserve impressive pieces, when compared with historic inventories and early publications, it becomes apparent that they represent only a fraction of what existed before the Russian Revolution (see Foelkersam 1907). In the 1920s and early 1930s, the Soviets dispersed and sold great amounts of silver to Western collectors and art dealers (Koeppe 2009, pp. 230–32).
35. Mahan 1932/2007, pp. 266–71, 313.
36. Wolf 1863, vol. 1, pp. 13–27; McGuigan 1966, pp. 241–42.
37. Wolf 1863, vol. 1, p. 28; McGuigan 1966, p. 242.
38. Koschatzky and Krasa 1982, pp. 32–33; Benedik 2008, pp. 35–36.
39. Syndram 1999; Syndram and Scherner 2004; and Gaehtgens, Syndram, and Saule 2006. For a discussion of the silver, see Baumstark and Seling 1994, pp. 474–83, nos. 126–35 (entries by Ulli Arnold), pp. 483–93, nos. 136–40 (entries by Gisela Haase); and Seelig 1994b.
40. The two plates included in cat. no. 3 are from an additional order from 1730, enlarging the Double-Gilded Service; see Carl Christian Dauterman in Watson and Dauterman 1970, pp. 236–37, no. 58. For more on the service itself, see Weber 1985; and Arnold 1994.
41. When not in use, caddinets were usually locked away to prevent enemies of the royal family from adding poison, such as arsenic, to the spices. See Seelig 1995; Koeppe 1996, p. 186, fig. 8, p. 188, n. 25; and Christie's, Geneva, sale cat., May 21, 1997, no. 146 (today in the Gilbert Collection, Victoria & Albert Museum, London, marked as "No. 6"; Seelig 1995 mentions only four examples). For the cavalier's tour, see Keller 1995.
42. The king ordered, for example, thirty-six candelabra and one hundred matching candlesticks in exuberant Rococo forms from the Dresden goldsmith Christian Heinrich Ingermann (master 1732, d. 1775?); see Koeppe 1993, pp. 50–52. I am grateful to Andrea Huber of Mühltal, Germany, who shared with me (via email communication, November 3, 2004) her discovery that twelve of the girandoles from the Double-Gilded Service of 1719 were melted down in 1747 to subsidize the Ingermann order; the entry in the earliest identified inventory reads in part: "König. Pohln. Churf. Sächß. Silber-Cammer

Inventarium 1741," vol. 1, "Inventarium über das bey der König. Pohln. und Churf" (Sächsisches Hauptstaatsarchiv Dresden, Oberhofmarschallamt, T XI, nr. 29); compare Arnold 1994, p. 61. For the 1719 service type, see Koeppe 1993, p. 48, fig. 1; the model invented by Albrecht Biller before 1700 was copied by Gottlieb Menzel in Augsburg for the Dresden court in 1718–19. For the silver collections used in Dresden by the court under Augustus III, see Hanke 2006, p. 116, esp. n. 1; Cassidy-Geiger 2007a (with bibliography); and Cassidy-Geiger 2007b.

43. Koschatzky and Krasa 1982, p. 27.
44. Ibid., p. 30.
45. Ibid., p. 11.
46. Ibid., pp. 11–12.
47. Ibid., p. 59.
48. Ibid., p. 88.
49. Biermann 1894.
50. Wolf 1863, vol. 1, pp. 39–40, 49.
51. McGuigan 1966, pp. 256–59.
52. Koschatzky and Krasa 1982, p. 67.
53. Hennings 1966, pp. 28–29.
54. Quoted in McGuigan 1966, p. 253.
55. McGuigan 1966, p. 248.
56. Ibid., pp. 248–49.
57. It is very likely that it was the empress's private property or that it was acquired with her personal funds. The large *Teller* (dish) in the Museum Huelsmann (fig. 7) is incised on the back with the number IIII.R:N:5, suggesting that this dish had a matching cloche and was the fifth example of the size NO. IIII within the various models of the service; see Heitmann 1986, ill. p. 148. For a *Spielleuchter* (candlestick for a gaming table) of 1765 by the same master, see Overzier 1987, p. 137, fig. 219 (where the goldsmith is wrongly identified as "Friedrich Caspar Würth").
58. See "Würth, Franz Caspar" 1947. How Friedrich Würth (Wirth), who moved from Esslingen in Austria to Vienna, was related to the dynasty is hitherto not totally clear. He entered the guild in 1721 and was the father-in-law of Johann Matthäus Donner (1704–1756), the brother of the court sculptor Georg Raffael Donner (1693–1741; see Haupt 2007, p. 367). Thieme and Becker mention Friedrich under his pupil Franz Xaver Würth (see "Würth, Franz Xaver" 1947, p. 295).
59. Thieme and Becker mention that already in 1748 Franz Caspar Würth had delivered to the court a "golden service" [*sic*], which was later given to Albert of Sachsen-Teschen and in the nineteenth century passed by descent into the silver chambers of the dukes of Sachsen-Altenburg; see "Würth, Franz Caspar" 1947. The authors obviously confused the First Sachsen-Teschen Service, assay marked 1748 and 1749 (see fig. 8, pair of oval dishes with covers), with the service made of gold in 1760 (see note 13 above); see also Koeppe 1992, pp. 484–86; and Seelig 2007, pp. 181, 182, nn. 79, 84 (with bibliography). The first monographic text about the Würth dynasty was published in Kamler-Wild 2003, pp. 24–25. For more on the dukes of Sachsen-Altenburg, see Braun 1910, p. 10 (who mentions his correspondence with the castellan of Altenburg Castle); Schoeppl 1917/1992 (for the family's history); and Schulze 1989. See fig. 7 for another part of the service. For the First Sachsen-Teschen Service, see Heitmann 1986, p. 148; Koeppe 1992, ill. p. 450, no. GO 23a, b; and Seelig 2007, p. 182, n. 84. In 1774 Franz Anton Denner (or Derner [1770–1803]; see Koeppe 1992, p. 485) made various additions. The 1774 oval dish illustrated here is numbered "N 11," supporting the fact that the service was substantially enlarged by Duke Albert and Marie Christine; twelve deep soup plates are in a private collection in North Carolina, and one dozen soup plates are in a private collection in Hesse, Germany. Additional plates were made

between 1818 and 1820 by Augustus Kraus (1779–1840) in Nuremberg (Koeppe 1992, p. 486, under no. GO 23a, b). Other examples can be found in *Ein rheinischer Silberschatz* 1980, p. 254, no. 379. The service's elegant Baroque-classical style, based on the sophisticated palatial style called Italian *grandezza*, makes the ensemble functional. The First Sachsen-Teschen Service was likely used on a regular basis for generations and has been maintained in very good condition. After comparing the various inventory numbers of a cross section of its pieces, I find it plausible that the original inventory numerals on the 1748 items were partly erased and replaced by a later numbering system.

60. According to Marga Rauch (1985, pp. 107, 125), Augsburg, Germany, was a center of European goldsmith production from the late sixteenth to the eighteenth century, with "185 goldsmith workshops and only 137 bakeries" in 1615. By 1741 the goldsmith guild counted 260 masters—primarily as a result of the large demand for grand silver services. These numbers gradually declined to 160 in 1788 and to 119 in 1803, a by-product of changing fashions and the rise of other centers such as Vienna and, in the case of the second decline, a result of the French revolutionary wars. Herbert Haupt (2007, p. 50, under *Goldschmiede*, or "goldsmiths") noted that the Viennese guild was even more vulnerable than that of Augsburg to the preferences of changing monarchs, economic crises, and war but that its numbers also rose quickly in periods of ecomomic prosperity. The Viennese masters' ranks grew from 104 in 1728 to an amazing 243 in 1736, then shrank to only 177 workshops in 1781, a number that declined sharply, to 70, in 1792, only to rise again by 1799 to a new height of 288 workshops, which was, however, qualified by the inclusion of *Juweliers* (jewelers). See Latour 1899, p. 423; and Folnesics 1909, p. 288.
61. Koeppe 1992, pp. 484–86; Kräftner 2009, pp. 33–80. For the tureen design, see Braun 1910, pl. XIV, fig. 8.
62. The centerpiece is attributed to Christoph Würth in Latour 1899, ill. p. 421, and Poch-Kalous 1955, p. 248, pl. 69, fig. 112. More recently it has been ascribed to Pieter Jozef Fonson and Jacob Frans van der Donck (Brussels, 1755–70); see De Ren 1987, pp. 62, 63, ill. no. 15, and Baudouin, Colman, and Goethels 1988, pp. 178–79, no. 189.
63. De Ren 1987; for the duke's extensive spending on decorative objects, see Baarsen 2005; and Baarsen and De Ren 2005.
64. Winkler 1996, pp. 130–45.
65. Braun 1910, p. 9, pl. XIV, fig. 4; *Österreich zur Zeit Kaiser Josephs II* 1980, pp. 432–33, no. 533.
66. Braun 1909, p. 15; for the historical context, see Kempf 1909. After the secularization, the lamp and a Viennese chalice were transferred to the treasury of the *Münster* (cathedral) in Freiburg im Breisgau. See Gombert 1965, p. 91, no. 46, fig. 58; and *Österreich zur Zeit Kaiser Josephs II* 1980, pp. 432–33, no. 533.
67. Moser was the first Viennese goldsmith to be celebrated with his own exhibition, accompanied by an excellent catalogue, in 2003 (see *Glanz des Ewigen* 2003).
68. Kamler-Wild 2003, p. 33. In addition to such parade objects, Johann Joseph Würth is known for his sophisticated utilitarian items of high quality and unusual design (see Overzier 1987, p. 120, fig. 189).
69. See Kamler-Wild 2003, p. 62, fig. 34 (sanctuary lamp, 1768, in the church of Maria Radna in Lipova, Romania), and p. 65, fig. 37 (lamp, 1773, in the Cathedral of the Virgin Mary in Győr, Hungary); and Franz Kirchweger in *Glanz des Ewigen* 2003, pp. 135–37, no. 54 (lamp, 1772, in the Church of Saint Ignatius, also in Győr). The quality of the design and craftsmanship of these pieces demonstrates that important masters were able to make outstanding objects if the financial circumstances of the commission were favorable. Most impressive is

the 1773 sanctuary lamp made for the cathedral in Győr (complemented by frescoed walls painted in 1772–74 by Franz Anton Maulbertsch [1724–1796]), which represents a most accomplished and powerful composition.

70. See "Würth, Ignaz Sebastian" 1947, p. 296; and Halama 2003, p. 362. Bayreuth newspaper quoted in Braun 1910, p. 10.

71. See also Braun 1910, p. 10 and pl. xv, figs. 6, 7. Maria Theresa also commissioned from Ignaz Sebastian Würth a reliquary, in the form of a silver head, devoted to Saint Stephen (967–1038), the founder of the Kingdom of Hungary. (Stephen was also the first name of the empress's husband.) Today the reliquary resides in the treasury of the cathedral of Székesfehérvár. I am grateful to Volker Wurster, Bremen, for this reference.

72. The lid's opening accommodates a stirrer for the chocolate. The only decoration is the emperor's monogram, J.II, engraved under the Imperial crown. A further indication that the piece was designed for an important person is its weight—27.4 oz. (625 g) of silver—concentrated into a pot only 6 inches (15 cm) high. See Winkler 1996, p. 38, no. 9; and Huey 2003, p. 19, no. 2.

73. "Würth, Ignaz Sebastian" 1947, p. 296; Seelig 2007, p. 148.

74. Seelig 2007, p. 148.

75. Ibid., p. 145.

76. Ibid., pp. 145–55. I am most grateful to Lorenz Seelig, Munich, for his help and advice during this project. Much of the information about the Hanover set is based on his archival research.

77. Originally belonging to a member of the influential Duncombe family (Earl of Feversham, County of York), the tureen, stand, and ladle later became part of the collection of Lord Polwarth in Edinburgh. Viewed at the Grassi Museum für Angewandt Kunst in Leipzig on October 4, 2009. See Hoyer 2007, p. 161. The pair to the tureen in Leipzig was offered at Christie's, New York, October 17, 1996, lot 185 (without lid).

78. Seelig 2007, pp. 166–69.

79. Quoted in ibid., p. 182, n. 80.

80. Neuwirth 2002, p. 183 (mark nos. P1274–P1279), p. 194 (mark nos. P1490–P1507); *Viennese Gold and Silversmiths* 2005, "Würth, Ignatz Franz Joseph," mark no. 384521, and "Würth, Ignaz Sebastian Joseph," mark no. 294921.

81. Seelig 2007, pp. 148–49. On Valadier, see also González-Palacios 1997.

82. Seelig 2007, pp. 171–72, fig. 38. Ironically, King George III never laid eyes upon what is arguably considered one of the greatest royal silver services of the eighteenth century, large parts of which are preserved in the Rothschild Collection at Waddesdon Manor in England and in the Musée du Louvre.

83. Braun 1910, p. 9. The Würth dynasty of gifted artisans and their important role in shaping the decorative arts within Austria in particular and Europe in general deserve a special monograph. These remarks can only scratch the surface of such a complex project, which would require an interdisciplinary team of scholars. The subject would certainly be a fruitful labor of love.

The Rise of Vienna as a Cultural Center

84. Kaunitz was a count by birth; in 1764, in recognition of his role as a leading statesman of eighteenth-century Europe and a great patron of the arts, he received the title of *Reichsfürst* (loosely translated as "Imperial prince"). Even recent literature on Kaunitz uses the titles "count" and "prince" interchangeably. See Ott 1910; and Poch-Kalous 1955, pp. 248–49.

85. Poch-Kalous 1955, pp. 248–49.

86. Kamler-Wild 2003, pp. 25–26, and p. 71, n. 71 (for the different spelling of the goldsmith's name); and Schulz 2001, p. 359. Domanöck's son, Franz Anton Domanöck (1746–1821), also traveled abroad, to Germany and the Netherlands, before receiving a stipend from Maria Theresa to be trained in Paris (see Latour 1899, p. 425).

87. Franz 2006, pp. 873–74.

88. Bencard 1992, pp. 104–5, no. 76.

89. See Heitmann 1985a; Heitmann 1985b; Heitmann 1985d; and Kamler-Wild 2003, pp. 25–26, and p. 71, n. 71.

90. Poch-Kalous 1955, p. 249; Franz 2006.

91. "Würth, Franz Xaver" 1947.

92. Franz 2006, p. 878. One of Hagenauer's designs for a candlestick depicting Daphne (Franz 2006, p. 875, fig. 7) influenced a silver candlestick realized in 1798 by the workshop of Ignaz Joseph Würth. The candlestick was documented at Gatchina Palace near Saint Petersburg in 1914 (see *Gatchina* 1914/1994, ill. opp. p. 63).

93. Neuwirth 2002, p. 183.

94. Stürmer 1986.

95. "Würth, Ignaz Sebastian" 1947; Neuwirth 2002, p. 183 (mark nos. P1274–P1279); *Viennese Gold and Silversmiths* 2005, "Würth, Ignatz Franz Joseph," mark no. 384521.

96. Neuwirth 2002, p. 183. The family's name is variously spelled "Würth" or "Wirth," and both are often used interchangeably in the literature. Waltraud Neuwirth tried to introduce "Wirth" as the definitive spelling without success, and although some secondary documents from the Viennese guild show the spelling as "Wirth" (see Neuwirth 2004, p. 326, no. 995, p. 327, no. 1014), it was Neuwirth herself in the end who published the master's signature as IGNATZ JOSEPH WÜRTH (see fig. 12, p. 20, and Neuwirth 2004, p. 327) and that of his cousin, Ignaz Sebastian Würth, as SEBASTIAN IGNAZ WÜRTH (Neuwirth 2004, p. 326). I have therefore followed the artisans' own example and used the spelling of "Würth" in this book.

97. This tradition was documented in Bohemia by a gilded-bronze ornament from Prague, now in a Parisian private collection, signed on the back MARTIN: KLINKOSCK.A. 1772: PRAG[A?]. This Martin Klinkosck may possibly be an ancestor of the nineteenth-century Viennese goldsmith family Klinkosch. I am grateful to Alexis Kugel for sending me photographs of this unpublished object (email of November 22, 2008). Court goldsmiths were always exempt from restrictions.

98. Ottomeyer and Pröschel 1986, vol. 1, pp. 102–3, 144–45, 284 (for Auguste); and Perrin 1993, pp. 133, 220–45, 290–92.

99. González-Palacios 1997.

100. Maria Theresa had announced the shipment in a letter of November 1, 1770: "Vous recevrez par ce courrier le présent que la Marie-Anne vous a destiné, et peu de temps après la table de la Marie [Christine], qui a parfaitement réussi." Arneth 1866, p. 19. See also Pierre-Xavier Hans in *Marie-Antoinette* 2008, p. 328, no. 239.

101. Baulez 1978/2007; and Meyer 2002, vol. 1, pp. 216–17, no. 54; the nearly lifesize design of the top, 19¾ × 27¾ in. (50.2 × 70.5 cm); acc. no. 63.547.14.5. The acc. nos. for the related drawings in the Metropolitan Museum are 63.547.14.1–.5. For additional drawings of decorative designs from Duke Albert's collection now in the Metropolitan Museum, see Myers 1991, pp. 195–205, nos. 116–22.

102. The Metropolitan Museum accession number for this drawing is 63.547.14.1. The turning acanthus rosettes are called *soleil* (sun) in eighteenth-century inventories; see Carlier 1993, p. 330.

103. Baulez 1978/2007, p. 249, figs. 11–13 (the table and two designs); Ottomeyer and Pröschel 1986, vol. 1, p. 227, no. 4.1.5;

Pierre-Xavier Hans in *Marie-Antoinette* 2008, p. 328, no. 239. Further designs are mentioned as located at the Albertina in Vienna; see also Schulz 2001, p. 359. The candlestick model in cat. no. 27 shows ram's heads and has a tripod structure.

104. Koschatzky and Krasa 1982, p. 68.

105. Baulez 1978/2007; and Bertrand Rondot in *Marie-Antoinette* 2008, p. 329, no. 240.

106. Baulez 1978/2007, p. 250, fig. 14; Gasc and Mabille 1991, p. 65; Bernhard Rondot mentions it in *Marie-Antoinette* 2008, p. 329, no. 240.

107. Leisching 1912, p. 557; Clare Le Corbeiller in *Liechtenstein* 1985, p. 171, under no. 113.

108. Thieme and Becker mention the table as made by Ignaz Joseph (see "Würth, Ignaz Joseph" 1947), whereas Kamler-Wild 2003, p. 25, refers to Ignaz Sebastian as the table's maker.

109. Winkler 1993, p. 90 (under "1783/84"); Winkler 1996, p. 130.

110. Winkler 1993, p. 92 (under "1793" and "1794").

111. Only few isolated table items, such as a three-light bronze Rococo girandole, and some gilded-bronze fixtures in the Hofburg complex and Schönbrunn Palace (both in Vienna) have survived (Winkler 1993, ill. p. 92). The majority of the utilitarian objects in the Imperial collection are from the nineteenth century.

112. Clare Le Corbeiller in *Liechtenstein* 1985, p. 171, under no. 113.

113. Ibid., p. 169, under no. 113 (inv. nos. 2012–13, 2018–19).

114. They reappeared on the art market in 2005. See Dorotheum, Vienna, sale cat., October 18, 2005, lots 152, 153; and *European Fine Art Fair* 2006, p. 286.

115. Droguet 2004, p. 68, fig. 40.

116. A second candelabrum also combines blue and white Chinese porcelain. The third and fourth candelabra are mounted with polychrome Japanese and Chinese porcelain. They have bases with four zoomorphic feet similar to those on the tureen of 1794 in fig. 57 (page 79 in this catalogue); either the ormolu mounts could be late as 1785 or they were changed in the 1790s. In November 2008 the author was able to make a close inspection of the component elements, which were subsequently cleaned, conserved, and photographed. I am very grateful to director Johann Kräftner for providing that opportunity.

117. Haus,- Hof- und Staatsarchiv, Vienna, Ältere Zeremonial-akten, Karton 83, 1770, IC, 37, fols. 1–6; it is unclear why a "Gräfin Esterhasi" ([Countess Ezterházy] written in a "copia" of the document in the same folder, titled "Eszterházy") received the relatively large amount of 1800 florins. I am most grateful to Claudia Lehner-Jobst, Vienna, for sending me copies of the document (partly cited in Winkler 1993, p. 154, n. 39).

118. See Neuwirth 2004, p. 308, fig. 91.

119. See note 61 above and Koeppe 1992, p. 485 (regarding the repairs).

120. Braun 1910, p. 10, pl. x (shows one oval tureen with artichoke finial). See also Fennimore and Halfpenny 2000, p. 11, no. 2 (as by Johann Sebastian Würth).

121. Braun 1910, p. 10, pl. x, illustrates one example with an oval stand. See also Fennimore and Halfpenny 2000, p. 11, no. 2, who give the combined weight of the two tureens as 21 lbs., 13 oz. (9894 g).

122. Havard 1896, pl. xxxvi; for Henry Havard, see Silverman 1989, pp. 141, 346, n. 35, p. 346, n. 39.

123. The tureen was examined by the author on July 24, 2009. The tureen weighs 23 lbs. 14 oz. (10860 g); the stand, 9 lbs., 4 oz. (4190 g). On the tureen's lid is the maker's mark II/W and hallmark for Vienna with the date of 1775; on the stand is the maker's mark IK and the hallmark for Vienna with the date of 1781, as well as modern French import marks and the collector's mark AR for Anselm [Salomon] Baron von

Rothschild (Vienna [1803–1874]). See *Exposition rétrospective* 1935, p. 11, no. 77 (listed as "soupière en argent ciselé, donnée par Catherine II à Potemkine. XVIIIᵉ siècle. Collection de M. le Baron Robert de Rothschild" [1880–1946]). It is thanks to the immense knowledge of Alexis Kugel, Paris, that access to this object was possible.

124. Mgr. Markéta Jarošová, Curator of Fine Arts, at the Slezské Zemské Muzeum in Opava, stated in an email of August 25, 2009, that the wax relief is no longer held in this museum; see Braun 1906; and Braun 1910, pp. 9–10, pl. xiv, fig. 5.

125. There exists a depiction of Catherine II as Minerva wearing a similar helmet (see Iuna Zek in *Catherine the Great* 1998, p. 547, no. 550). For more on trophy and helmet imagery, see Griseri 1991–92, p. 74, fig. 2; Mingardi 1994, pp. 127–29; and Giuseppe Cirillo in *Petitot* 1997, pp. 331–32, nos. 120–23.

126. Their titles were given in Latin as a reference to their claim as legitimate successors of the ancient Roman Caesars. Kugler 1980, pp. 72–73.

127. Krautauer was the founder of another dynasty of Viennese silversmiths who got his start by taking over the flourishing workshop of the Joseph Stadler mentioned in the 1770 "Specification" for a service for Archduchess Marie Christine. Neuwirth 2002, pp. 12–13, 262 (mark nos. 59, 60, and P2648).

128. The tureen's body and liner are numbered with the Roman numeral ii, signifying that at least one other example existed. Josef Folnesics published the tureen as by Germain and gave a date of about 1760 (Folnesics 1909, p. 254, fig. 165). He discussed in the same volume, under fig. 204, one of the Ignaz Joseph Würth round tureen models without recognizing the close stylistic relation of both. It was Margarethe Poch-Kalous who first mentioned this tureen by Germain as an inspiration for Viennese work, but even she did not question its accepted origin as French (Poch-Kalous 1955, pp. 248, 265, n. 99). The dish and cover were illustrated in Havard 1896, pl. xxxv; see also Fina 1997, pp. 29–30, ill. no. 21.

The tureen (fig. 20) and the dish with cover (present location unknown) mentioned in the text are stylistically connected with the glass cooler (cat. no. 46, p. 78) and two dish covers that Fina illustrates as by Giovanni Battista Boucheron, ca. 1785/90, made in Turin (see Fina 1997, ill. nos. 23a, b). However, those two silver covers were labeled "French, circa 1789" when they came up for sale in 1992 (Christie's, Geneva, sale cat., May 19, 1992, lot 121). One finial (Fina 1997, ill. no. 25) is identical to that seen in figs. 28 and 31 in this catalogue. Further, the ornament and the absence of assay marks indicate that these objects could have belonged to a service made for the Austrian court.

129. *Goldschmiedekunst-Ausstellung* 1889, no. 690. The patron in this case was Baron Samuel von Brukenthal (1721–1803), the only member of the Transylvanian Saxon community to achieve high public office (Chancellor of Transylvania) under the empress Maria Theresa. During his Viennese tenure, the baron began to acquire paintings and other works of art, amassing one of the most important private collections of the time, much of it now in the Brukenthal National Museum in Sibiu, Romania. Krautauer also signed a pair of wine coolers (on the art market in Germany), "IGN KRAUTAUER Inv. et Fec Viennæ 1775."

130. Dennis 1960, vol. 1, p. 353, no. 564.

131. *Goldschmiedekunst-Ausstellung* 1889, no. 690; see also *Maria-Theresia-Ausstellung* 1930, p. 160 (Vitrine ii: Prunktasse *présentoir* [L. 98 cm] 1775, ewer 1775, covered box 1777).

132. *King's Feast* 1991, pp. 181–203, nos. 76–87.

133. Signed "Auguste Fecit A Paris"; Heitmann 1985c, figs. 3a–c; and *Museum für Kunst und Gewerbe* 2000, pp. 77–78.

134. *Kungligt Taffelsilver* 1988, pp. 23, 46, no. 12.

135. Fornari Schianchi 1997, ills. p. 118 (second row); see also Leben 2004, ill. p. 86 (bottom drawing).

136. Regarding the Valadier drawing, see *Friedrich Wilhelm von Erdmannsdorff* 1986, pp. 57, 88, no. 341. See also the so-called Borghese Service of about 1770 in Seelig 2007, p. 149, fig. 3, where the figures on the lid of the tureen are identified as Amphitrite and Triton. According to Ambroise Paré, *Des monstres et prodiges* (1573), tritons and sirens inhabit deep oceans of far distant places; see Paré 1573/1983, pp. 107–8.

The Second Sachsen-Teschen Service Rediscovered

137. Edmund W. Braun in *Alt-Oesterreichischen Goldschmiedearbeiten* 1904, p. 29. For the golden breakfast service and toilet set by Anton Mathias Domanöck for Maria Theresa and Francis I, see Heitmann 1985d, ill. pp. 11, 12, 15; and Huey 2003, pp. 18–19, no. 1.

138. Kamler-Wild 1985, p. 39.

139. Ibid., pp. 39–40.

140. Krog 1985, p. 56. A ladle from the Danish service dated Vienna 1779 and engraved with the monograms CF, GG, and O was sold at Christie's, Geneva, November 15, 1994, lot 82. A pair of four-branch candelabra made by Ignaz Josef Würth in 1779 in Vienna (see *Die Weltkunst* 55, no. 19 [October 1, 1983], p. 2603, advertisement for an auction sale at Arne Bruun Rasmussen, Copenhagen) were once part of the Danish service.

141. Minutier Centrale des Notaires, Archives Nationales, Paris, LXXV-732; I thank Alexis Kugel and Benoît Constensoux, Paris, for providing a scan of the original letter. See also Perrin 1993, pp. 32, 262, n. 109; and Adamczak 2006, p. 181 (Adamczak mentions a date of 1773 for a trip to Vienna).

142. The town mark of Vienna and the dates of 1779 and 1780 are charged on some of the more prominent items and a few covered dishes and plates (see cat. nos. 20, 23, fig. 43).

143. Braun in *Alt-Oesterreichischen Goldschmiedearbeiten* 1904, p. 29; Perrin 1993, pp. 84–85, 214–15.

144. *King's Feast* 1991, pp. 180–87, esp. no. 76. Ignaz Joseph Würth continued using this stand form until at least 1786, the year marked on a Würth tureen and stand in the Stieglitz Collection in Saint Petersburg (*Ancient Silver Objects* 1885, no. 255, pl. 37, called "Tureen in the style of Louis XV," engraved, with Viennese marks of 1786 and II/W). See also Bouilhet 1908, ill. p. 243, for a tureen that is similar in design to the Blome tureen by Auguste today in the Museum für Kunst und Gewerbe in Hamburg (fig. 23); its stand, however, goes back to the form with handles, as seen in cat. no. 17.

145. *King's Feast* 1991, p. 146.

146. Le Corbeiller 1996.

147. *King's Feast* 1991; Perrin 1993.

148. The most telling examples are found in Fina 1997, ill. nos. 26, 27. Fina illustrates putti compositions by Germain, Auguste, and the Italian goldsmith Matteo Promis (doc. 1787–1816); see Fina 2002, p. 58. See also note 128 above.

149. Dolphins have been a traditional goldsmith's motif since antiquity. Renaissance patrons favored the jolly sea dwellers, an allusion to Dionysus, the god of wine and erotic ecstasy, as supports for their drinking vessels. French Rococo dolphins form the spout and feet of gold *chocolatière* and *réchaud* made in 1729 by Henri-Nicolas Cousinet for Marie Leszczyńska's *nécessaire*; the intended owner is referred to as Dauphine of France (see Whitehead 1992, ill. p. 225). For a pair of stands with an intertwined dolphin motif in Italian goldsmiths' work, see Christie's, London, sale cat., November 30–December 1, 2005, lot 317.

150. Ottomeyer and Pröschel 1986, vol. 1, p. 364, no. 5.12.8, ill. p. 365; Fornari Schianchi 1997, ill. p. 119 (top center); Wolfram Koeppe in Koeppe 2008a, pp. 354–55, no. 143; and Bellaigue 2009, vol. 2, pp. 488–91, no. 113 (with bibliography). The taste in French silver is reflected by a tureen ordered by a patron from Naples from Jacques-Charles Mongenot, Paris, 1783–84, with Nereids as feet (Lucy Morton in Partridge Fine Arts 1997, pp. 36–39, no. 18).

151. *Les Grands Orfèvres* 1965, pp. 226–29; Leben 2004, ills. pp. 92, 96 (bottom drawing). For the leaf-scroll motif, see Wolfram Koeppe in Kisluk-Grosheide, Koeppe, and Rieder 2006, p. 22, fig. 10, showing a sixteenth-century chest design with acanthus-spray scrolls embracing bold rosettes yet placed in a strongly symmetrical arrangement reminiscent of the ancient Roman *Ara Pacis* (Altar of Peace). A 1769 drawing by Jean-Charles Delafosse (1734–1789) in the Metropolitan Museum (1973.638) depicts bold scrolls within the frieze of a "Grand Galerie." The same master adapted the motif in a signed drawing for a console table that includes objects in the Greek style, now in the Rothschild Collection at Waddesdon Manor (Leben 2004, ill. p. 128). Robert-Joseph Auguste never adapted this delicate scrollwork but instead preferred a bolder interpretation (see *Les Grands Orfèvres* 1965, pp. 236–37; Tydén-Jordan 1998, ill. p. 609; Seelig 2007, pp. 154, 156, figs. 9, 10, 12). For related gilded bronzes, see Baulez 1996/2007, p. 394, fig. 14; and Baulez 2000/2007, p. 143, fig. 16.

152. Bellaigue 2009, vol. 2, pp. 466–72, no. 108, pp. 514–17, no. 119.

153. Giuseppe Cirillo in *Petitot* 1997, p. 302, nos. 51, 52 (friezes above the door).

154. Not surprisingly, the Germains in Paris produced some of the most intricate examples of this model-casting technique; see Perrin 1993, ills. pp. 59, 65, 139, 191.

155. Valuable advice was given by Barbara Brown, Department of Ichthyology, and Paul Sweet, Department of Ornithology, Division of Vertebrate Zoology, American Museum of Natural History, New York, for which I am very grateful.

156. Ottomeyer 1997; and Ottomeyer 2002, pp. 95–96.

157. See fig. 56 and Braun 1910, pl. 1.

158. Jutta Kappel in Syndram and Scherner 2004, p. 263, no. 141.

159. Acc. no. 1996.1; height 14⅝ in. (37 cm), length of stand 27⅛ in. (68.8 cm), length of tureen 19 in. (48.2 cm), weight 35 lbs. 11.54 oz. (16203 g). See Braun 1910, p. 7, no. 3, pl. 11; Sotheby's, Geneva, sale cat., May 15, 1995, lot 162; and Timothy Schroder in Partridge Fine Arts 1996, pp. 24–25, no. 7. The present location of the second large oval tureen is unknown, but it is documented in Latour 1899, p. 422 (ill.); Braun 1910, p. 7, no. 3; and Galerie Fischer, Lucerne, sale cat., May 6, 1947, lot 33.

160. Gruber 1982, p. 154 (see also p. 127, ill. no. 62, for a still-life painting of 1726–27 depicting an exceptional example).

161. Ibid., p. 157. See also Hernmarck 1977, vol. 2, p. 179, pls. 465, 467. For a set of four sauce tureens and stands made in London in 1772, see Sotheby's, New York, sale cat., October 20, 2009, lot 219.

162. The history-of-food specialist Ivan Day of Penrith, Cumbria, identified the vegetables from photographs. I thank him for his advice. A similar naturalistic application attached on top of a grooved domed lid was made by Antoine-Sébastien Durand in 1764 in Paris (the object was described as a silver fruit box, despite the ornamental shells, in Gruber 1982, p. 268, ill. no. 391).

163. Braun 1910, p. 8, no. 7.

164. Sotheby's, Geneva, sale cat., May 15, 1995, lot 164 (6 lbs., 10 oz. [3005 g]); see also Neidhardt Antiquitäten 1995, pp. 62–64. For the other sauce tureen, see Galerie Fischer, Lucerne, sale cat., June 7 and 8, 1995, lot 101 (6 lbs., 11.58 oz. [3050 g]); sold to Galerie Neuse, Bremen, and then acquired

by the Art Institute of Chicago. See also Zelleke 2002, pp. 48–49, no. 20.

165. I thank Ghenete Zelleke, the Samuel and M. Patricia Grober Curator of European Decorative Arts at the Art Institute of Chicago, for sharing her observations with me (email of November 5, 2009).

166. Gruber 1982, pp. 187–90; Christie's, New York, sale cat., October 18, 1995, lot 198 (Hanover service cruet stand); and Seelig 2007, p. 153, fig. 8, and pp. 151, 157, figs. 5, 15 (the small sauce tureens by Würth could have been used as substitutes for mustard pots in the present service).

167. Gruber 1982, pp. 127–32. Regarding the forms, see Tydén-Jordan 1998, ill. p. 608; the various shapes were single-handedly promoted by François-Thomas Germain through his inventive services, such as one designed for the Portuguese court (Bouilhet 1908, ill. p. 173).

168. *Chambers's Encyclopaedia* 1901, p. 539; Ottomeyer 2002, p. 95.

169. *Les Grands Orfèvres* 1965, ill. p. 42 (from the oeuvre of Claude I Ballin), p. 48 (ewer depicted in a painting), pp. 90–91 (*bassin de toilette* [washing bowl] of 1717–22 by Nicolas Besnier), p. 93, fig. 4 (dish of 1722 by Nicolas Besnier). For the ornament in Boulle marquetry, see Wolfram Koeppe in Kisluk-Grosheide, Koeppe, and Rieder 2006, p. 66, fig. 39.

170. (Introduction to the Art and Science of Ceremonial Manners for Private Persons). See Koeppe 1992, p. 486.

171. One of the round covers is numbered N:21 (cat. no. 20); for the square dish and cover, see Sotheby's, Geneva, sale cat., November 18 and 19, 1996, lot 78 (numbered N:2 and N:4).

172. Galerie Fischer, Lucerne, sale cat., May 6, 1947, pl. 7, lots 46, 48.

173. *Physiologus* 1979 (ed.), pp. 17, 19.

174. Piranesi 1778/1905, pl. 112.

175. Gruber 1982, p. 161; see also *Salz, Macht, Geschichte* 1995.

176. Seelig 2007, p. 157, fig. 16.

177. The last great master of the Würth dynasty was Franz Edler von Würth (active 1797–1831), who received a noble title. His less fortunate son, Eduard Edler von Würth (master 1824, d. 1887), took over the workshop after his father died but went out of business in 1836, thus ending one of the great chapters in the history of the art of the European goldsmith.

178. Gruber 1982, p. 237.

179. Braun 1910, p. 8, no. 14 (mentions thirty-two), pl. VIII, c; Galerie Fischer, Lucerne, sale cat., May 6, 1947, lots 17–29, pls. 1, 5.

180. Having two hundred eighty-eight plates in the service (see cat. no. 36) allowed place settings for between thirty-two and sixty-four to seventy guests. An even number of place settings was customary for events in which such services were used.

181. Whitehead 1992, ill. p. 157; Dion-Tenenbaum et al. 2000; William Rieder in Kisluk-Grosheide, Koeppe, and Rieder 2006, pp. 166–69, no. 69; Wolfram Koeppe in Kisluk-Grosheide, Koeppe, and Rieder 2006, pp. 216–18, no. 91.

182. The painting is called *La Vertueuse Athénienne* (see Jean-Pierre Cuzin and Anne Dion-Tenenbaum in *D'après l'antique* 2000, pp. 342–43, no. 156). For another example in metalwork, see Sotheby's, London, sale cat., December 8, 2009, lot 17.

183. Ottomeyer and Pröschel 1986, vol. 1, p. 230, no. 4.1.12 (bronze candlestick), p. 231, no. 4.1.13 (drawing).

184. Hitherto attributed to Jean-Louis Prieur (1732/36–1795); see Droguet 2004, p. 68, fig. 40. For a pair of superbly finished two-branch Viennese candelabra, see Christie's, London, sale cat., December 8, 1994, lot 50; for an image of snakes coiling around the branches of a candelabrum with pierced shaft by Jean-François Forty, ca. 1775–90, see Bouilhet 1908, ill. p. 257, and Berliner and Egger 1981, vol. 3, no. 1431. Albert and Marie Christine may have seen archaeological examples from Pompei or Herculaneum during their visit to Naples in April 1776 (see Koschatzky and Krasa 1982, pp. 67, 122–23). A

marble clock depicting a *Vestalin* (vestal virgin) with a tripod, height 39 in. (99 cm), was sold from the Sachsen-Teschen Collection in 1933 (Albert Kende and Gilhofer & Ranschburg, Vienna, *Kunstmobiliar . . . aus dem Wiener Palais und den Österreichischen Schlössern des Herrn Erzherzog Friedrich* [duke of Teschen], sale cat., February 8–10, 1933, lot 141 (ill. under "Saal V").

185. Peck 1962.

186. See Parissien 1999, ills. pp. 14–15, 17; and Roberts 2002, pp. 456–57, no. 420, pp. 460–61, no. 424 (watercolors of state dining tables).

187. For the German inscription, see cat. no. 30 in Works in the Exhibition.

188. Béatrix Saule in *Versailles et les tables royales en Europe* 1993, p. 255, no. 14.

189. Galerie Fischer, Lucerne, sale cat., May 6, 1947, lots 200–204, pl. 9, and lots 164, 182, pl. 11 (present location unknown).

190. Galerie Fischer, Lucerne, sale cat., May 6, 1947, lots 164–99, 229–32; see pl. 1 for a decorated *surtout* (present location unknown), which measured 102⅜ in. (260 cm) long by 23 in. (58.5 cm) wide. For the stylistic environment, see Benedik 2008, pp. 183–205.

191. Braun 1910, p. 8, no. 14, pl. VIII, c, and nos. 12, 13, pl. VII, a, b.

192. Hernmarck 1977, vol. 2, pls. 280–84.

193. Galerie Fischer, Lucerne, sale cat., May 6, 1947, lots 125, 126; see also provenance and bibliography for cat. no. 31 in Works in the Exhibition.

194. See the entries by Wolfram Koeppe in "Recent Acquisitions" 2003, p. 26, and McCormick and Ottomeyer et al. 2004, pp. 110–11, no. 51.

195. Braun 1910, p. 7, no. 1, pl. IV.

196. Haslinger 1993, p. 24.

197. Braun 1910, p. 8, nos. 15–20, pl. XIII, figs. 1–3; these numbers may only scratch the surface of the original extent of the service, which also could have included serving pieces from other ensembles.

198. Braun (ibid., p. 8, no. 23) recorded two hundred forty plates (see note 180, above).

199. The service was made to commemorate the marriage of Albert's nephew the Elector Frederick Augustus III of Saxony (reigned 1763–1806) in January 1769; see Arnold 1994, p. 35, and p. 37, fig. 16, p. 44, fig. 24.

200. Arnold 1994, pp. 36, 82, n. 75.

201. Ottomeyer 2002, p. 97.

202. Walker 2002, p. 77, fig. 42; Sallas 2008, p. 17.

203. Joan Sallas has been a continuing inspiration to me and a valuable source of information on this often-neglected aspect of the napkin. I am grateful to him for sharing much of his extensive and unpublished research with me.

204. For a second example, see *Jahresschrift* 1990, p. 24, ill. p. 23.

205. Not only was May 13 the day the treaty was signed, but it was also the birthday of Empress Maria Theresa and Archduchess Marie Christine.

206. Reddaway 1904, p. 336. Maria Theresa also gave away special presents, for example, a semiprecious stone and gilded-bronze table for the marquis de Breteuil, the French envoy to the congress. Made by the Dresden court goldsmith Johann Christian Neuber, the table may have been commissioned through Albert's local connections (see Koeppe 2008b, p. 66, and p. 68, fig. 71).

207. (Practical Lessons in the Newest Art of Table Settings and Meatcutting, Explained with Illustrations). Cited after the edition at the Österreichische Nationalbibliothek, Vienna (32579-B Alt. Mag); see *Art des Tafeldeckens* 1796, pp. 1–4.

208. Gruber 1982, p. 39.

209. See *Albertina* 1969, p. 19, no. 21: "den goldenen Service für weil. Se. kais. Mayst. Francisco allerglorreichsten Gedächtnus."

210. Winkler 1993, p. 102; for the set of Maria Theresa, see Winkler 1996, pp. 30–31, no. 4.

211. Sotheby's, New York, October 21, 1997, lot 61; Christie's, London, June 12, 2006, lot 23.

212. The fish-slicer handles feature the monogram CF under the crown. I am very grateful to Klaus Dahl, Palaces and Properties Agency, Copenhagen, who supplied this information (email of August 28, 2009). See also Krog 1985, p. 61, and Ole Villumsen Krog in *Guld og sølv* 1985, pp. 103–4, nos. 3,04 and 3,05 (regarding the two fish slicers and dessert service with thirty-six sets of utensils).

213. The average lengths were derived by measuring twelve different flatware sets available to the author (from Augsburg, Strasbourg, Frankfurt, Lille, and Toulouse) and may not reflect the complete range of dimensions represented in Europe at the time.

214. Sotheby's, Regensburg, *Die Fürstliche Sammlung Thurn und Taxis*, sale cat., vol. 2, October 12–15, 1993, lot 1201 (dessert cutlery set), and vol. 3, October 16 and 18, lot 2455 (extensive Viennese porcelain service). The twisted and folding band decoration is rather similar to a design in a drawing, owned by the duke and now in the Metropolitan Museum (63.547.14.5), intended for the top of the Domanöck table (fig. 13; see Baulez 1978/2007, p. 249, fig. 12).

 Lorenz Seelig, Munich, helped in many ways in the preparation of this publication. I thank him especially for sharing his correspondence from the archive in Regensburg with me. He suggests that Prince Carl Anselm of Thurn und Taxis may have bought (or commissioned) the porcelain during his 1773 and 1775 stays in Vienna or later; he owned several Viennese gold boxes. Alternatively, the porcelain may have entered the family in the nineteenth century through Prince Paul Anton Esterházy, who married a Princess Maria Theresia of Thurn und Taxis. A third and very probable connection between the Viennese porcelain tableware and the service derives from the 1890 marriage of Prince Albert Maria of Thurn und Taxis (1867–1952) with Archduchess Margarethe Maria of Austria (1870–1955) at Regensburg Palace. Any gifts or special dispatches from the Habsburg relatives could well have been received personally by the bride, in which case they would either have been recorded as personal property or not documented at all. The simple yet sophisticated adornment in the antique manner and the distinguished design of the various porcelain service pieces made them highly sought after in the decades surrounding 1900 (see Seelig 1998, pp. 39–40).

215. Braun 1910, p. 8, mentions that the 1880s restorations and porcelain replacements were made by the firm of Wahliss. (Ernst Wahliss founded a porcelain and faïence factory in 1863 in Turn-Teplitz, Bohemia, Austria [today Trnovany, Czech Republic]). In 1894 the firm of Wahliss bought the A. Stellmacher Imperial and Royal Porcelain Factory, founded in 1859 in Vienna; see Neuwirth 1979. Peter Styra, of the Fürst Thurn und Taxis, Hofbibliothek und Zentralarchiv, Universitätsbibliothek Regensburg, could not find any related references preserved in Regensburg (email correspondence of August 14, 2009, and later conversations). I thank him very much for his time and effort.

216. These pieces were listed in an inventory without value because the presence of the porcelain elements prevented an accurate weighing of the silver; the overall weight of the silver in the service is nearly 624 pounds (283 kg). On November 27, 2009, Claudia Lehner-Jobst of Vienna visited the National Archives of Hungary (Magyar Országos Levéltár) in Budapest and kindly shared her unpublished research with me. The 1766 listing of an older assembled silver service mentions no tureens but does include no fewer than twenty-four *Spielleuchter* (candlesticks for gaming tables; see Lorenz Seelig in Baumstark and Seling 1994, vol. 2, pp. 596–97, no. 178) and six *kleine Leuchter zur Kammer* (portable chamber candlesticks). Only two table salts are recorded, but the presence of triangular, square, and round dishes points to a *service à la française*. (I am very indebted to this special colleague, whose efforts allowed the information presented here to be as comprehensive as possible at this time). For the service, see Magyar Országos Levéltár (National Archives of Hungary), Budapest, P 299, no. 3.

217. The little rectangular plaques with rounded tops and stylized double-eagle motifs that bisect the Golden Fleece collar symbolize the ends of two crossed marshal staffs given to Charles about 1796. The crest therefore must date to after the death of Duke Albert in 1822. It probably represents Charles's official heraldry as it does not include any reference to his wife, Henrietta of Nassau-Weilburg (1797–1829). See Koschatzky and Krasa 1982, pp. 109–10; Benedik 2008, pp. 38–39.

218. Albert's handwritten last will is preserved in the National Archives of Hungary in Budapest.

219. Benedik 2008, pp. 237, 266–67.

220. Albert Kende and Gilhofer & Ranschburg, Vienna, *Kunstmobiliar . . . aus dem Wiener Palais und den Österreichischen Schlössern des Herrn Erzherzog Friedrich* [duke of Teschen], sale cat., February 8–10, 1933.

221. Single pieces either stayed within the family or were separated from the rest before the service was consigned to the Galerie Fischer, Lucerne, by one "Friedrich von Fayer," which could refer to an agent or be a pseudonym (I thank Trude Fischer, Lucerne, for her help and patience in answering my various questions). Princess Marie Christine of Bourbon-Parma, a granddaughter of Archduke Frederick who died on September 1, 2009, in Vienna, retained some parts of the silver service in her collection.

222. Benedik 2008, pp. 38–39; see also Koschatzky and Krasa 1982, pp. 109–10. Despite their dislike for each other, Marie Christine and Leopold had a most interesting correspondence; see Schlitter 1896.

223. See Arneth 1866.

224. "The departure of your sister for the Lowlands will not be until next spring." Ibid., p. 344. For her part, Marie Antoinette treated her sister like any other state visitor during visits to the French court in Versailles. Marie Christine and Albert even stayed at a village inn instead of the palace. Koschatzky and Krasa 1982, pp. 154–55.

225. The empress also paid for a luxurious redecoration of Pressburg castle (Koschatzky and Krasa 1982, p. 98, under September 20 and October 27, 1767). In addition to filling the palace with splendid furnishings (Koschatzky and Krasa 1982, pp. 97–100), Albert and Marie Christine ordered custom-made tapestry sets and the highest-quality fabric from Florence to cover the walls. Further, Maria Theresa's husband, Emperor Francis I, had paid for Joseph's gold wedding service out of his private purse (Winkler 1993, p. 89, under "1760").

226. Winkler 1993, p. 87, under "1743."

227. McGuigan 1966, p. 255.

228. On a similar occasion in 1791, Marie Christine would insist on a single table for herself and her husband. In addition to supplying the Ghent newspaper information, Alain Jacobs and Alexis Kugel shared unpublished research with me. I cannot thank them enough for their generosity.

229. Goetghebuer 1827; A. van Ypersele de Strihou and P. van Ypersele de Strihou 1970; Koschatzky and Krasa 1982, pp. 13–14, 141–46.

230. Kräftner 2009, p. 39. It would be interesting to examine the service's silver alloy chemically and try to trace its origin. It is likely a melange of silver taken from older objects that had

been melted down, but it could also be partly the harvest of Albert's entrepreneurship in mining and other industries.

231. A. van Ypersele de Strihou and P. van Ypersele de Strihou 1970; Christian Benedik 2008, pp. 41–43. Tim Oers, who is writing his Ph.D. dissertation on Schoonenberg Palace, has given me much advice. I thank him for our discussions and for his information about the palace's inaugural festivities.

232. Email correspondences with Tim Oers.

233. The idea of decorative continuity was not new. It had been realized nearly forty-five years earlier, when King Christian VI of Denmark (1699–1746) ordered in 1738–39 from Thomas Germain in Paris a representative silver service as part of the *Gesamtkunstwerk* for Christiansborg Palace (see Völkel 2002; and Ottomeyer and Völkel 2002, p. 227, nos. 146, 147). For Pressburg, see Benedik 2008, p. 37, fig. 32.

234. A. van Ypersele de Strihou and P. van Ypersele de Strihou 1970, ill. p. 23.

235. The pantheon motif was an iconographic stand-in for the Solomonic temple as a symbol of humanity. Albert was very involved in the planning of this concept and the garden room behind as a dialogue between the architecture and the landscape. See Benedik 2008, p. 42, fig. 42; see also fig. 53 in this catalogue, a view of the interior dome at Schoonenberg Palace showing reliefs with the twelve months by Gilles-Lambert Godecharle (1750–1835).

236. Ferdinand Zörrer in *Freimaurer* 1992, p. 438, no. 25/3/2; and Zörrer 1992, p. 431.

237. Abafi 1891, p. 61.

238. Brown 1997, p. 163 (with bibliography).

239. Koschatzky and Krasa 1982, pp. 120–30; Benedik 2008, p. 38. Benedik mentions that on July 4, 1776, the duke received from Durazzo the first one thousand items for the collection.

240. Koschatzky and Krasa 1982, p. 14. For the tapestries, see Bremer-David 1997, pp. 40–53, no. 6.

241. Marie Christine and Albert stayed several times in Bonn with the archduchess's brother, Maximilian Francis, the archbishop-elector of Cologne (1756–1801). Georg Heinrich von Kirn, who is also presumed to have been a Freemason, worked in this region. See Bellaigue 2009, vol. 2, pp. 476–84, nos. 110, 111; and Kei Chan in McCormick and Ottomeyer et al. 2004, pp. 79–80, no. 30. See also Myers 1991, pp. 195–205, nos. 116–22 (for the drawings).

242. Benedik 2008, p. 43. See also Koschatzky and Krasa 1982, p. 180.

243. Claudia Lehner-Jobst, Vienna, research on November 27, 2009, at the National Archives of Hungary. The list is part of the Magyar Országos Levéltár (National Archives of Hungary), Budapest, P 298, 13 d, no. 67.

244. Koschatzky and Krasa 1982, p. 190.

245. Benedik 2008, p. 47, and p. 46, fig. 46. See also Koschatzky 1988.

246. Koschatzky 1988, n.p. (English trans.).

247. Rosenberg 1922–28, vol. 4, nos. 7875, 7876, and other examples of tax marks.

248. Granlund 1999, figs. 8, 9; *Nicolas II Esterházy* 2007, p. 210, nos. 118, 119. See also Krog 1985 regarding the four tureens in Copenhagen, which are still in regular use by the Royal household.

249. Given the fact that one Maria Theresa thaler weighs 28 0668 grams and contains 23 3890 grams of fine silver this was an exorbitant amount displayed on the table; see Works in the Exhibition, p. 90.

250. Braun 1910, p. 7, no. 2, pl. 1. At the time of Braun's publication, the service was sometimes referred to as the Polish Service. So far, no evidence of a connection to Poland has been established, although, as a son of the elector of Saxony and king of Poland, Albert was entitled to be called a royal prince of Poland. Another link could be the close proximity of the duchy of Teschen to Poland; Albert was a major figure (behind the scenes) during the formation of the Peace Treaty of Teschen in 1779, the year the service was begun.

251. The attribution was based on a similar mask seen on portions of Boucheron's Turin service (Griseri 1991–92, figs. 9, 10). However, the swan handles show the Italianate influence that the Würths integrated in their style with such bravura (see fig. 26 and note 128 above).

252. The overall weight of the tureen is 28 lbs. 14.1 oz. (13100 g); it is also incised with various tax marks. From the collection of Princess Marie Christine of Bourbon-Parma, a granddaughter of Archduke Frederick (see note 221 above). Latour 1899, ill. p. 424; Galerie Fischer, Lucerne, sale cat., May 6, 1947, lot 132, pls. 1, 8. For the maker's marks, see Neuwirth 2002, p. 165, no. P967. Special thanks to Johann Kräftner and Michael Schweller, Liechtenstein Museum, Vienna, for their advice and help.

I am grateful to Elisabeth Schmuttermeier for the opportunity to examine a tureen by Johann Georg Hann of 1788 in the Museum für Angewandte Kunst, Vienna (inv. no. GO 1817), on November 20, 2008. See Kamler-Wild 1985, ill. p. 47, and Schmuttermeier in *Guld og sølv* 1985, pp. 115–16, no. 6,01; see further examples in Neuwirth 2002, pp. 37–41. Parts of a silver service of 1789 made by Hann in Vienna were displayed by La Mésangère/Albert Vandervelden at the European Fine Art Fair (TEFAF) in Maastricht, 2009.

Works in the Exhibition

The Habsburg domains were exposed to several periods of warfare and other challenges during the second half of the eighteenth and early nineteenth centuries. Shifting alliances and the recognition of new emerging powers with different monetary systems led to numerous changes related to the goldsmith trade. Practice often varied according to region or country.

The most common units of currency at the time were the thaler, the gulden (or guilder), and the florin (2 guldens/florins = 1 thaler). The most famous Austrian thaler was dated 1780 and named after Maria Theresa; it is one and one-half inches (39.5 mm) in diameter and about a tenth of an inch (2.5 mm) thick, weighs just under one ounce (28 0668 g), and contains about four-fifths of an ounce (23 3890 g) of fine silver. It has a fineness (or silver purity ratio) of 833 per 1000 parts (833/1000).

Large commissions such as the Second Sachsen-Teschen Service were immensely profitable. In the eighteenth century, a weaver or cloth maker earned about 150 thalers per annum; a university professor, who was required to dress appropriately for class and purchase books to maintain his educational standards, was paid approximately 400 thalers per year. In 1779, when work on the service was begun, Wolfgang Amadeus Mozart was working in Salzburg as "court organist and concertmaster," with an annual salary of 450 florins, or 225 thalers. By contrast, the weight of the round tureen (cat. no. 17) without the stand is about 25 pounds, 10 ounces (11620 g), then worth about 414 thalers, representing nearly two years of the young Mozart's salary in Salzburg.

The European goldsmith was traditionally paid in a quantity of silver based on a percentage of the overall weight of the silver purchased for a commission. The average was 15 percent, with a few highly skilled artisans receiving up to 25 percent under special circumstances. After the bulk silver provided by the patron was assayed, or weighed and evaluated for fineness, the agreed percentage of silver payable to the goldsmith was removed before work on the project began. Given that the overall weight of the complete Second Sachsen-Teschen Service was at least 1,500 pounds (680 kg), not including the maker's payment, it is clear that Würth was well compensated.

SILVER ALLOYS, WEIGHTS, AND MARKS

The weight of silver objects in Austria was most often measured by the Viennese mark (1 VM = 280 644 g), which equaled 16 loth (1 loth = 17 540 g), or 64 quentchen (1 quentchen = 4 375 g), or 257 pfennige (1 pfennig = 1 093 g). Among other units of weight mentioned in the text and in use throughout the Holy Roman Empire at this time were the Hanover mark (245 05 g) and the Cologne mark (233 85 g); one loth could vary between 15 6 g and 17 6 g, depending on the region.

In the small sauce tureen (cat. no. 19), therefore, the engraving on the tureen's body, N.1./M.3.13.1.1. (see fig. 64), translates as: sauce tureen number 1, Viennese mark 3 (841 932 g), loth 13 (228 02 g), quentchen 1 (4 375 g), and pfennig 1 (1 093 g), for a total of 1075 42 g, indicating that the weight of the tureen without its stand was about 2 pounds, 4 ounces. The "13" on top of the Viennese hallmark (see figs. 59–61, 63) represents 13 loth, indicating that the silver used has a minimum fineness of 812.5/1000.

Stamped on most pieces of silver was the maker's mark or house mark. We are fortunate in the case of the Second Sachsen-Teschen Service that, after he stopped using his father's mark (fig. 58), Ignaz Joseph Würth developed a mark that consisted of his initials, making his work easy to identify (see figs. 59–63). It is also fortunate that the pieces in this service carry the Viennese hallmark, which not only guarantees the fineness of silver in the object but also includes the date of manufacture, which makes the precise dating of various parts of the service possible. In France the hallmark was often replaced by that of the warden of the local guild, who assayed the objects and guaranteed their silver purity. Because many hallmarks did not include a date, many silver objects are undated. Objects often included charge and import marks as well, indicating the amount of tax charged against the value of the object.

Bibliography: For the relative value of florins to thalers, see Solomon 1996, p. 157; see also Shaw 1895/2005, pp. 204, 375, who notes that a thaler equals two guldens; for the weight and monetary system in most of the Habsburg dominions, see *Konversationslexikon* 1892–93 and Verdenhalven 1993; for more on the economics of eighteenth-century Vienna in comparison with today, see W. J. Baumol and H. Baumol 1994. I thank Elisabeth Schmuttermeier, Museum für Angewandte Kunst/Wiener Werkstätte Archiv, Vienna, for discussing these questions with me.

Comments: In some cases only one or a few examples of a type (e.g., tureen, plate, fork, etc.) are illustrated in the book, whereas several may be displayed in the exhibition. The checklist below encompasses all objects included in the exhibition. Weights are given in avoirdupois pounds and ounces and in grams. The weights given represent overall weights unless otherwise specified.

Fig. 58. Ignaz Joseph Würth's maker's mark (used earlier by his father) for wine coolers, cat. no. 14, 1776. Private collection, Paris

Fig. 59. Viennese hallmark for round-tureen stand, cat. no. 17, 1779. Private collection, Paris

Fig. 60. Viennese hallmark for round dish, cat. no. 33, 1780. Private collection, Paris

Fig. 61. Viennese hallmark for small sauce tureen, cat. no. 19, 1781. Private collection, Paris

Fig. 62. Ignaz Joseph Würth's maker's mark for small sauce tureen, cat. no. 19. Private collection, Paris

Fig. 63. Viennese hallmark for small sauce tureen, cat. no. 19, 1782. Private collection, Paris

Fig. 64. Ignaz Joseph Würth's maker's mark; Viennese hallmark, 1781; and incised weight for small sauce tureen, cat. no. 19, 1781. Private collection, Paris

Fig. 65. Incised weight for verrière, cat. no. 46, ca. 1780. Private collection, France

THE LATE EIGHTEENTH-CENTURY SILVER SERVICE IN EUROPE

Cat. no. 1

Robert-Joseph Auguste (1723[?]–1805). Three-branch candelabrum (one of a pair), Paris, 1767–68. Silver, H. 14¾ in. (37.5 cm), Wt. 5 lb. (2282 9 g). The Metropolitan Museum of Art, New York. Bequest of Catherine D. Wentworth, 1948 48.187.389a, b

Marks: Maker's mark consisting of a crowned fleur-de-lis, 2 *grains de remède*, the initials R J A, and a palm branch; various charge marks; warden's mark for Paris, 1767–68; inscription: AUGUSTE F[AIT] À PARIS (Auguste made it in Paris).

Bibliography: Poullin de Viéville 1785, pp. 169–72; Nocq 1926–31, vol. 4, pp. 217, 236–37; Remington 1938, p. 18, fig. 40; Wenham 1949, p. 202; Brault and Bottineau 1959, p. 103; Dennis 1960, no. 14; Eriksen 1974, pl. 262; Dennis 1960/1994, no. 14; "Auguste: Pair of Candelabra" 2006.

Comments: Three candelabra (of a set of twelve) of the same model, made by Auguste in 1775–76, are at the Royal Palace, Stockholm (Hernmarck 1972, ill. p. 104); for another three-branch model by Auguste, see Seelig 2007, p. 155, fig. 11.

Cat. no. 2

Jacques-Nicolas Roëttiers (1736–1788). Tureen and stand, Paris, 1770–71. From the Orloff Service. Silver, H. of tureen 11 in. (27.9 cm), W. 11¾ in. (29.8 cm), L. 15⅜ in. (39.1 cm); H. of stand 2⅞ in. (7.3 cm), Diam. 18⅜ in. (46.7 cm), Wt. 28 lbs., 14.72 oz. (13120 g). The Metropolitan Museum of Art, New York. Rogers Fund, 1933 33.165.2a–c

Marks: Maker's mark consisting of a fleur-de-lis, 2 *grains de remède*, the intials J N R, a sheaf of wheat; various assay and charge marks for Paris and Saint Petersburg; later French import marks.

Provenance: Gregory Orloff; Catherine the Great; Russian Imperial Collection; Hermitage, Saint Petersburg; Jacques Helft, Paris.

Bibliography: Foelkersam 1907, vol. 1, pp. v, xiv, pl. 31, vol. 2, pp. 67ff.; Nocq 1926–31, vol. 3, pp. 412–13, vol. 4, pp. 237, 238; *French Gold and Silver Plate* 1933, p. 28, no. 38; Avery 1934, pp. 33–34, fig. 1; Remington 1938, p. 18, fig. 67; Bunt 1944, p. 84, no. XI, ill.; *Eighteenth Century Art* 1950, p. 29, no. 185; Remington 1954, p. 88; *French, English and American Silver* 1956, p. 63, no. 38, and p. 21, ill. no. 7; Helft 1957, pp. 29–30; Brault and Bottineau 1959, p. 102; Dennis 1960, no. 296; Le Corbeiller 1969, frontispiece, figs. 5, 6, 8–13; *Masterpieces of Fifty Centuries* 1970, p. 284, no. 323; Eriksen 1974, p. 367, pl. 263; Le Corbeiller 1977, p. 396, fig. 2; Le Corbeiller, Kuodriaveca, and Lopato 1993; Clare Le Corbeiller in *Versailles et les tables royales en Europe* 1993, p. 318, no. 208; Dennis 1960/1994, no. 296; "Roettiers: Tureen with stand from the Orloff Service" 2006; Koeppe 2009, pp. 230–31, fig. 9.9.

Comments: A *pot-à-oille* (tureen) and *plateau* (tray) also from the Orloff Service were sold from the collection of Jaime Ortiz-Patiño at Sotheby's, New York, May 21, 1992, lot 118; a pair of wine coolers was auctioned at Christie's, New York, April 19, 2002, lot 74.

Cat. no. 3

Gottlieb Menzel (1676–1757). Two plates, Augsburg, 1730. From the Double-Gilded Service. Gilded silver, Diam. of each 9¾ in. (24.8 cm). Wt. 1 lb., 7.7 oz. (670.7 g), 1 lb., 7.4 oz. (661.1 g). The Metropolitan Museum of Art, New York. Gift of Mr. and Mrs. Charles Wrightsman, 1976 1976.155.40, 41

Marks: Maker's mark GM (Seling 1980, vol. 3, no. 2022); Augsburg hallmark (pinecone, see Seling 1980, vol. 3, p. 24, no. 195); incised on the reverse: No. 223/Ao. 1730 and No. 224/Ao. 1730; engraved on the border: the arms of Poland and Saxony in pretense.

Bibliography: Watson and Dauterman 1970, pp. 236–37, no. 58; see cat. no. 4, notes 39–41, for bibliography on the Double-Gilded

Service of Augustus the Strong of Saxony; see also Sotheby's, Zurich, sale cat., December 9–11, 1997, pp. 187–89.

Comments: These plates are part of an extension of the 1718 service made in Augsburg about 1730. The incised numbers indicate the approximate quantity of items (including 224 or more plates) that were part of this first grand German parade service made for Duke Albert's grandfather Augustus the Strong.

Cat. no. 4

Attributed to Gottlieb Menzel (1676–1757). Caddinet, Augsburg, 1718. From the Double-Gilded Service. Gilded silver, 9¾ × 8¼ in. (24.8 × 21 cm), Wt. 2 lbs., 3.84 oz. (1014 3 g). The Metropolitan Museum of Art, New York. The Lesley and Emma Sheafer Collection, Bequest of Emma A. Sheafer, 1973 1974.356.775

Marks: None; incised on the reverse: No. 4./Ao. 1718; engraved in the center of the tray: the arms of Poland and Saxony in pretense.

Bibliography: Seelig 1995, p. 375, fig. 5; Koeppe 1996, p. 186, fig. 8, p. 188, n. 25; Cassidy-Geiger 2002, p. 141, fig. 17; see notes 39–41 for literature about the Double-Gilded Service of Augustus the Strong of Saxony.

Comments: Caddinet (or *cadenas*) no. 4 was part of a set of six matching examples. The caddinets were reserved for the sovereign and his immediate family. A manual for setting a banquet at Dresden Palace on September 3, 1719, instructs: "On the table is [to be placed] in front . . . of the king and the . . . queen the so-called Cadenat . . . in which are salt, pepper, and other [spices] in diverse compartments" (quoted in Weber 1985, p. 40). The three lidded compartments once housed shallow bowls containing salt and pepper that flanked a rectangular box for nutmeg (and grater) or other spices. The tray held the private royal cutlery and a specially folded napkin that covered bread rolls (see Sallas 2008, pp. 16, 18), hence the items' name *BrodtTeller* (bread tray) in contemporary inventories (Seelig 1995, p. 375). The difference in quality of execution between the tray and the lids suggests that the latter may have been repaired or may even be eighteenth-century replacements.

THE RISE OF VIENNA AS A CULTURAL CENTER

Cat. no. 5

Design for elevation of a table, Austria, ca. 1770. Pen and brown and black ink, black and red chalk, and graphite, 34¼ × 26⅛ in. (87 × 66.5 cm). The Metropolitan Museum of Art, New York. Gift of Raphael Esmerian, 1963 63.547.14.4

Provenance: Duke Albert of Sachsen-Teschen; Prince Charles de Ligne (1735–1814); Armand Sigwalt (1875–1952); sale, H. Gilhofer & H. Ranschburg, Lucerne, November 28 and 29, 1934 (see p. 47 of the sale catalogue; part of a large group of drawings originally owned by Duke Albert of Sachsen-Teschen [see also cat. nos. 7, 8, 30, 45]); Raphael Esmerian.

Bibliography: Baulez 1978/2007, p. 249, fig. 11.

Comments: This is one design from a group of four "table elevations" and one drawing showing the "top view" for the small table made in Vienna by (or by a designer for) Anton Mathias Domanöck before or during 1770 (see fig. 13). It was folded in the middle. Various shades of yellow and orange indicate both matte and burnished gilded-metal surfaces. The artist's sketchy method points to a design proposal and not a record of an existing object; for an example of the latter, see cat. no. 45.

Cat. no. 6

Ignaz Joseph Würth (1742–1792). Pair of vases, Vienna, 1780. Petrified wood (Hungary), gilded bronze, H. 15¾ in. (40 cm). Petit Trianon, Musée national des châteaux de Versailles et de Trianon Inv. T 517 C

Marks: none; inscribed Jos[EPH].WÜRTH FEC[IT].Vienna 1780 (Joseph Würth made [them], Vienna, 1780).

Provenance: Bequest of the Holy Roman Empress Maria Theresa to King Louis XVI of France.

Bibliography: Baulez 1978/2007, p. 251, fig. 16; Bertrand Rondot in *Marie-Antoinette* 2008, p. 329, no. 240.

Comments: For more on the medium of petrified wood, see Koeppe 2008a, pp. 322–23, no. 128 (entry by Annamaria Giusti), and p. 362, no. 146 (entry by Jutta Kappel); and Koeppe 2008b, p. 65.

Cat. no. 7

Design for an urn (potpourri), Austria?, ca. 1770–85. Pen and brown ink, graphite, 14¾ × 9⅜ in. (37.3 × 23.7 cm). The Metropolitan Museum of Art, New York. Gift of Raphael Esmerian, 1963 63.547.9

Marks: Inscribed No. 3 (sequenced with drawings including cat. no. 8) in pen; written in graphite to the right of the base of the urn: JÜNFTZ[?] FECIT or JÜNFTGER FECIT (Jünftger[?] made it).

Provenance: Duke Albert of Sachsen-Teschen; Prince Charles de Ligne (1735–1814); Armand Sigwalt (1875–1952); sale, H. Gilhofer & H. Ranschburg, Lucerne, November 28 and 29, 1934 (see p. 47 of the sale cat.; part of a large group of drawings originally owned by Duke Albert of Sachsen-Teschen [see also cat. nos. 5, 8, 30, 45]); Raphael Esmerian.

Comments: This drawing and a second urn design (cat. no. 8) were associated with green Sèvres porcelain mounted in gilded bronze (file notes by James Parker); however, a recent discovery links the drawings directly to a garniture of five vases made at the Fürstenberg Porcelain Manufactory about 1768, now in the Metropolitan Museum's collection (accession nos. 94.4.351–55; see Caroline Hannah in McCormick and Ottomeyer et al. 2004, pp. 70–71, no. 25). The paint-decorated porcelain bodies are embellished with gilded-porcelain areas in imitation of ormolu mounts. Two of the three models (cat. nos. 7, 8) differ only in minute details from the present designs. Similar vases may have existed in a Viennese collection at the time; alternatively, both the Fürstenberg porcelain vases and the drawings go back to an as yet unidentified (Austrian?) primary source. James Parker noted that related green Sèvres vases (ca. 1767–70) with ormolu mounts can be found in Waddesdon Manor (see Eriksen 1968, pp. 236–37, no. 81). Two high Sèvres porcelain vases with similar ormolu masks are also in the Metropolitan Museum's collection (accession nos. 1978.12.4, 5).

Cat. no. 8

Design for an urn (potpourri), Austria?, ca. 1770–85. Pen and brown ink, graphite, 14⅝ × 9⅝ in. (37.1 × 24.3 cm). The Metropolitan Museum of Art, New York. Gift of Raphael Esmerian, 1963 63.547.10

Marks: Inscribed No. 4 (sequenced with drawings including cat. no. 7) in pen; written in graphite at the lower right: RICHTER FE[CIT] or RICHTER F[E]C[IT] (Richter made it); delicate penciling indicates the glaze of the porcelain and the pierced lid.

Provenance: Duke Albert of Sachsen-Teschen; Prince Charles de Ligne (1735–1814); Armand Sigwalt (1875–1952); sale, H. Gilhofer & H. Ranschburg, Lucerne, November 28 and 29, 1934 (see p. 47 of the sale cat.; part of a large group of drawings originally owned by Duke Albert of Sachsen-Teschen [see cat. nos. 5, 7, 30, 45]); Raphael Esmerian.

Comments: This design's massive canted base with stepped, molded foot is of unusually high proportions. It corresponds, as does the drawing in cat. no. 7, to a Fürstenberg porcelain set, but the drawn bases are not harmonious with the porcelain examples, and the bow-tie decoration, whimsically lopsided in the drawing, is symmetrical in the porcelain version. The mounts in figs. 14–17, pp. 23–25, were influenced by related inventions, which were disseminated by traveling artisans or patrons ordering from local workshops.

Cat. no. 9

Jacques-Nicolas Roëttiers (1736–1788). Tureen with cover, Paris, 1775–76. Silver, H. 11 3/4 in. (29.8 cm), L. 16 in. (40.6 cm), Wt. 16 lbs., 13.44 oz. (7640 g). The Metropolitan Museum of Art, New York. Gift of Mrs. Reginald McVitty and Estate of Janet C. Livingston, 1976 1976.357.1a–e

Marks: Maker's mark consisting of a fleur-de-lis, 2 *grains de remède*, the initials J N R, and a sheaf of wheat; various assay and charge marks for Paris, 1774–80.

Bibliography: Reynolds 1914, p. 1301 (for the Livingston coat of arms); Le Corbeiller 1969, p. 294, fig. 7; Le Corbeiller 1977, p. 396, figs. 3, 4; Sutton 1977, p. 45, no. 29, fig. 29; Clare Le Corbeiller in *Treasures from the Metropolitan Museum* 1989, p. 122, no. 66; Whitehead 1992, p. 234; Adams 2003, p. 273, ill. p. 274.

Comments: The technical quality and finishing detail of this service by Roëttiers are much higher than those of the Orloff Service. The latter incorporated large quantities of different objects and was created under time pressure; thus, it was either not possible or not required by the patron that each object be exquisitely finished with the same devotion to detail seen in the present tureen. The tureen is part of a table service said by family tradition to have been acquired by Robert R. Livingston (1746–1813), first chancellor of New York State, from Gouverneur Morris (1752–1816), with whom he and John Jay drafted the New York State Constitution in 1777–78. For other pieces from the service now at the Metropolitan Museum, see three covered dishes (1973.318a–c, 1976.206a–c, 1977.175a–c); a tureen (1986.320a–c); and a ladle (cat. no. 39).

Cat. no. 10

Ignaz Krautauer (master 1771; d. 1787). Ewer, Vienna, 1775. Silver, H. 18⅞ in. (48.1 cm), Diam. of base 6¾ in. (17.2 cm), Wt. 9 lbs., 3.2 oz. (4173 g). The Metropolitan Museum of Art, New York. Anonymous Gift, 2009 2009.414.1

Marks: Maker's mark JK in ligature (see Neuwirth 2002, pp. 12–13, mark no. 59, and p. 262); Viennese hallmark, 1775; full signature incised on the base (see p. 30).

Provenance: Collection of Baron Samuel von Brukenthal (1721–1803); Collection of Baroness Rosenfeld-Brukenthal, Schloss Dorf a. d. Enns, Austria (for the first owner, see Kroner 2003; and *Bruegel, Memling, Van Eyck* 2009); Private collection, Paris.

Bibliography: *Goldschmiedekunst-Ausstellung* 1889, no. 690; *Maria-Theresia-Ausstellung* 1930, p. 160 (under Vitrine II).

Comments: The ewer is from the same set as the box with cover and oval tray (cat. nos. 11, 13). Foot inscription with signature shows a similar—but quite bold—disposition as the signature of the candelabrum by Auguste (cat. no. 1).

Cat. no. 11

Ignaz Krautauer (master 1771; d. 1787). Box with cover, Vienna, 1777. Silver, H. 7⅞ in. (20.1 cm), Diam. 6⅝ in. (16.8 cm), Wt. approx. 4 lbs. (1790 g). The Metropolitan Museum of Art, New York. Anonymous Gift, 2009 2009.414.2a, b

Marks: Maker's mark JK in ligature (see Neuwirth 2002, pp. 12–13, mark no. 59, and p. 262); Viennese hallmark, 1777 (on the underside).

Provenance: Collection of Baron Samuel von Brukenthal (1721–1803); Collection of Baroness Rosenfeld-Brukenthal, Schloss Dorf a. d. Enns, Austria (for the first owner, see Kroner 2003; and *Bruegel, Memling, Van Eyck* 2009); Private collection, Paris.

Bibliography: *Goldschmiedekunst-Ausstellung* 1889, no. 690; *Maria-Theresia-Ausstellung* 1930, p. 160 (under Vitrine II).

Comments: The box and cover are from the same set as the ewer and oval tray (cat. nos. 10, 13). The Neoclassical box was created two years after the ewer, which was made in the Transitional style, thus recording the ornamental progress of this innovative Viennese workshop. Compare, for example, the domed and channeled lid of this box with the leaves of the domed lid form in the small sauce tureen, cat. no. 19, by Würth.

Cat. no. 12

Barthélemy Samson (master ca. 1760, d. 1782). Ewer, Toulouse, 1771. Silver, H. 10¾ in. (27.3 cm), Wt. 2 lbs., 8.32 oz. (1143 g). The Metropolitan Museum of Art, New York. Bequest of William Mitchell, 1921 22.32.2

Marks: Maker's mark consisting of B between 2 *grains de remède*, the initials SAM/SON, and a rose below; various charge and warden's marks for Toulouse, 1768–74; later recharge and control marks.

Bibliography: "Accessions" 1922, p. 91; *Eighteenth Century Art* 1950, p. 29, no. 184; Dennis 1960, no. 564; Helft 1968, p. 393, no. 1152, pl. LXXV, a; Dennis 1960/1994, no. 564.

Cat. no. 13

Ignaz Krautauer (master 1771; d. 1787). Monumental oval tray, Vienna, 1777. Silver, 38⅝ × 21⅝ in. (98 × 55 cm), Wt. 16 lbs., 10 oz. (7543 g). Private collection, France

Marks: Maker's mark JK in ligature (see Neuwirth 2002, pp. 12–13, mark no. 59, and p. 262); Viennese hallmark, 1777.

Provenance: Collection of Baron Samuel von Brukenthal (1721–1803); Collection of Baroness Rosenfeld-Brukenthal, Schloss Dorf a. d. Enns, Austria (for the first owner, see Kroner 2003; and *Bruegel, Memling, Van Eyck* 2009).

Bibliography: *Goldschmiedekunst-Ausstellung* 1889, no. 690; *Maria-Theresia-Ausstellung* 1930, p. 160 (under Vitrine II).

Comments: This tray is from the same set as the ewer and box with cover (cat. nos. 10, 11). An important example of Austrian silver of the Transitional style, it features a progressively classical oval outline with grooved border in combination with highly stylized elements of preceding idioms (compare these handles with those of a Rococo *écuelle*, or salver dish, from Strasbourg in Gruber 1982, p. 151, ill. no. 200; for a Toulouse example with similar handles formed by looping and reeded bands intertwined with laurel motifs, see "Landes: Covered Bowl and Stand" 2006). See also notes 127, 129, 131.

Cat. no. 14

Ignaz Joseph Würth (1742–1792). Two wine coolers, Vienna, 1776. Silver, H. 10⅝ in. (27.1 cm), Diam. of opening 8⅝ in. (21.8 cm), Diam. of base 5¾ in. (14.6 cm), Wt. 10 lbs., 11.36 oz. (4860 g); H. 10¾ in. (27.2 cm), Diam. of opening 8½ in. (21.6 cm), Diam. of base 5⅞ in. (14.8 cm), Wt. 11 lbs., 7 oz. (5190 g). Private collection, Paris

Marks: Maker's mark II/W in shaped frame (see figs. 25, 58; Ignaz Joseph is likely still using the mark of his father, Johann Joseph Würth [active 1733–57]; see Neuwirth 2002, p. 183, similar to mark no. P1271); Viennese hallmark, 1776.

Comments: These early works, which display a strong Italian influence, are by the same goldsmith who made the Second

Sachsen-Teschen Service. The sculptural details are highly accomplished, and the surface finish—see, for example, the scaling on the dolphins or the chiseling and punching on the figural tails, evoking a peltlike appearance—reflect the hand of a great master leading a skillful team of artisans in his workshop who were likely specialized in the various aspects of technical virtuosity needed to create silver objects of such a high quality.

THE SECOND SACHSEN-TESCHEN SERVICE

Ignaz Joseph Würth (1742–1792). Second Sachsen-Teschen Service [a portion], Vienna, ca. 1779–82. Private collection, Paris

Provenance: Duke Albert Casimir of Sachsen-Teschen and Archduchess Marie Christine of Austria; Duke Charles of Teschen (adopted heir of Albert and Marie Christine); Duke Albrecht of Teschen (son of Charles); Duke Frederick of Teschen (nephew of Albrecht); Duke Albrecht II of Teschen (son of Frederick); Baron Paul Waldbott-Bassenheim (nephew of Albrecht II); Galerie Fischer, Lucerne, 1947; see also p. 70 of this volume.

Comments: The information above applies to all of the objects in this section unless otherwise noted or amplified.

Cat. no. 15

Oval tureen with stand, Vienna, 1780–81. Silver, H. overall 14⅝ in. (37 cm), L. of stand 26½ in. (66.8 cm), Wt. 27 lbs., 2 oz. (12300 g) Private collection, Paris

Marks: Maker's mark II/W in oval (see Neuwirth 2002, p. 183, mark no. P1274); Viennese hallmarks, 1780 (on stand), 1781 (on body); early nineteenth-century Austrian control marks and later French import marks; incised N:3.

Provenance: Sale, Galerie Fischer, Lucerne, May 6, 1947, lot 35 (pl. 3).

Bibliography: Braun 1910, p. 7, no. 4 (Braun confuses the type with the sauce tureen model [fig. 40] that he illustrates on pl. VI, c); *Albertina* 1969, p. 19, under no. 21.1.

Comments: Of two known examples of a larger variation of this model, one is in the Sterling and Francine Clark Art Institute, Williamstown, Mass. The location of the second large tureen is unknown.

Cat. no. 16

Oval tureen with stand, Vienna, 1780–81. Silver, H. overall 14⅝ in. (37 cm), L. of stand 27½ in. (70 cm), Wt. 27 lbs., 6.88 oz. (12440 g). Private collection, Paris

Marks: Maker's mark II/W in oval (see Neuwirth 2002, p. 183, mark no. P1274); Viennese hallmarks, 1780 (on stand and liner), 1781 (on body); early nineteenth-century Austrian control marks and later French import marks; incised N:4.

Provenance: Sale, Galerie Fischer, Lucerne, May 6, 1947, lot 36.

Bibliography: Braun 1910, p. 7, no. 4 (Braun confuses the type with the sauce tureen model [fig. 40] that he illustrates on pl. VI, c); *Albertina* 1969, p. 19, under no. 21.1.

Comments: See cat. no. 15, above.

Cat. no. 17

Round tureen with stand, Vienna, ca. 1779–81. Silver, H. overall 16½ in. (42 cm), L. of stand 26⅜ in. (67 cm), Wt. of tureen 25 lbs., 10 oz. (11620 g), Wt. of stand 12 lbs., 12.6 oz. (5800 g). Private collection, Paris

Marks: Maker's mark II/W in oval (see Neuwirth 2002, p. 183, mark no. P1274); Viennese hallmarks, 1779 (on stand), 1781 (on body and liner); early nineteenth-century Austrian control marks; incised N:2, each part numbered II; see also fig. 59.

Provenance: Sale, Sotheby's, Geneva, May 15, 1996, lot 163.

Bibliography: Braun 1910, p. 7, no. 2; *Albertina* 1969, p. 19, no. 21.1 (lists one round example; likely a mistake, as no round tureen was on display).

Comments: The master's extraordinary talent is documented by an earlier round tureen with stand, without any applied decoration but of superior quality and execution, made in 1769 (possibly still in his mother's workshop). Its specifications are H. 7⅞ in. (20 cm), Diam. of stand 13¼ in. (33.5 cm), Wt. 8 lbs., 2.24 oz. (3695 g) (art market, Germany). Würth and his family would later cater more specifically to the taste of their patrons. The collection of the Princes of Esterházy in Eisenstadt preserves parts of a silver service from the workshop of Ignaz Sebastian Würth, and possibly Ignaz Joseph Würth, from 1791–92. The tureens' massive bodies and the candelabra's shafts recall the intertwined dolphins of the present compositions, albeit much less successfully adapted to changing tastes just before the turn of the century (and shortly before the death of Ignaz Joseph Würth in 1792; see Ingrid Haslinger in *Die Fürsten Esterházy* 1995, pp. 339–40, no. XIX/7, 8; and *Nicolas II Esterházy* 2007, p. 210, nos. 118, 119).

Cat. no. 18

Original octagonal leather case for round tureen, cat. no. 17. Late 18th century. Leather and protective iron strips, various metal hooks, handles, and locks, red lacquer seals, wood core, interior fabric lining, 17¼ × 19 × 14 in. (44 × 48 × 35.5 cm). Private collection, Paris

Mark: Numbered 10/35 3/4 (on bottom of case).

Comments: It appears that two seal imprints (see fig. 38) are layered on top of each other and that the heat of a later third addition (today largely lost) distorted the contours of the first two. István Heller (Munich and Budapest) translated the readable Hungarian abbreviations as [?]KIR[?]FENSE[?]. The original legend may have read CSÁSZÁRI ÉS KIRÁLYI FENSÉG (imperial and royal majesty), pointing possibly to an owner's seal; however, it was applied either during the Austrian Empire (1804–67) or even after the establishment of the Austro-Hungarian (*k. und k.*, or *kaiserlich und königlich*) Monarchy in 1867.

Cat. no. 19

Two small sauce tureens with stands, Vienna, 1781–82. Silver, gilded liners, H. (N:1, illustrated in book) 5½ in. (14 cm), L. 11¼ in. (28.5 cm), Wt. 4 lbs., 11.52 oz. (2140 g); H. (N:2) 5½ in. (14 cm), L. 11¼ in. (28.5 cm), Wt. 4 lbs., 8.32 oz. (2050 g). Private collection, Paris

Marks: Maker's marks II/W in oval (see Neuwirth 2002, p. 183, mark no. P1274); Viennese hallmarks, 1781 (on stands), 1782 (on bodies); early nineteenth-century Austrian control marks and later French import marks; incised N:1 and I , N:2 and II, respectively; see also figs. 61–64.

Provenance: Sale, Galerie Fischer, Lucerne, May 6, 1947, lots 44, 45.

Bibliography: Braun 1910, p. 8, no. 8, pl. V, a; *Albertina* 1969, p. 19, under no. 21.1.

Cat. no. 20

Round dish with cover, Vienna, 1781. Silver, H. 8½ in. (21 cm), Diam. of cover 11¼ in. (28.5 cm), Diam. of dish 12¾ in. (32.5 cm), Wt. of cover 5 lbs. (2290 g), Wt. of dish 2 lbs., 6.4 oz. (1090 g). Private collection, Paris

Marks: Maker's mark II/W in oval (see Neuwirth 2002, p. 183, mark no. P1274); Viennese hallmarks, 1781 (on dish and cover); incised N:10 (dish) and N:21 (cover).

Provenance: Sale, Galerie Fischer, Lucerne, May 6, 1947, lot 119 (pl. 6) (dish incorrectly described as N:19).

Bibliography: Braun 1910, p. 8, under no. 9; *Albertina* 1969, p. 19, no. 21.3 (one cover and dish, numbers not specified).

Comments: From a set of approximately twenty-four round covers. Galerie Fischer 1947, p. 13, included only eight round covers with dishes (lots 113–20). Braun 1910 also mentioned only eight (see pl. VI, a); however, because Galerie Fischer lot 120 gives an inventory number N:23 for this type of object, it is possible that twenty-four or more round covers and dishes existed originally.

Cat. no. 21

Round dish with cover, Vienna, 1781. Silver, H. 7⅞ in. (20 cm), Diam. of cover 11¼ in. (28.5 cm), Diam. of dish 12¾ in. (32.5 cm), Wt. of cover 2 lbs., 5.76 oz. (1070 g), Wt. of dish 5 lbs., 6.72 oz. (2460 g). Private collection, Paris

Marks: Maker's mark II/W in oval (see Neuwirth 2002, p. 183, mark no. P1274); Viennese hallmarks, 1781 (on dish and cover); incised N:5 (dish) and N:14 (cover).

Provenance: Sale, Galerie Fischer, Lucerne, May 6, 1947, lot 115 (only N:5 [dish] is listed in the catalogue).

Bibliography: *Albertina* 1969, p. 19, no. 21.3 (one cover and dish, numbers not specified).

Comments: See cat. no. 20, above.

Cat. no. 22

Triangular dish with cover, Vienna, 1781. Silver, H. 7⅞ in. (20 cm), Diam. of cover 11⅛ in. (28.4 cm), Diam. of dish approx. 12¼ in. (31 cm), Wt. of cover 5 lbs., 13.12 oz. (2640 g), Wt. of dish 1 lb., 14.4 oz. (860 g). Private collection, Paris

Marks: Maker's mark II/W in oval (see Neuwirth 2002, p. 183, mark no. P1274); Viennese hallmarks, 1781 (on dish and cover); incised N:4 (dish) and N:4 (cover).

Provenance: Sale, Galerie Fischer, Lucerne, May 6, 1947, lot 59 (pl. 2) (incorrectly listed as N:1).

Bibliography: Braun 1910, p. 8, under no. 10.

Cat. no. 23

Triangular dish with cover, Vienna, 1780–81. Silver, H. 7⅞ in. (20 cm), Diam. of cover 11⅛ in. (28.4 cm), Diam. of dish approx. 12¼ in. (31 cm), Wt. of cover 5 lbs., 5 oz. (2410 g), Wt. of dish 1 lb., 11.84 oz. (790 g). Private collection, Paris

Marks: Maker's mark II/W in oval (see Neuwirth 2002, p. 183, mark no. P1274); Viennese hallmarks, 1781 (on dish and cover); incised N:1 (dish) and N:1 (cover).

Provenance: Sale, Galerie Fischer, Lucerne, May 6, 1947, lot 62.

Bibliography: Braun 1910, p. 8, under no. 10.

Cat. no. 24

Three small ewers, Vienna, 1782. Silver, H. (N:1) 13½ in. (34.4 cm), Diam. of base 3¼ in. (8.2 cm), Wt. 2 lbs., 14.56 oz. (1320 g); H. (N:3, illustrated in book) 13¾ in. (34.8 cm), Diam. of base 3⅛ in. (8.1 cm), Wt. 2 lbs., 14.24 oz. (1310 g); H. (N:6) 13¾ in. (34.8 cm), base 3⅛ in. (8.1 cm), Wt. 2 lbs., 14.88 oz. (1330 g). Private collection, Paris

Marks: Engraved N:1, N:3, N:6.

Provenance: Sale, Galerie Fischer, Lucerne, May 6, 1947, lots 48, 50, 53.

Bibliography: Braun 1910, p. 8, under no. 6, pl. VIII, a.

Comments: Two adaptations of the Würth ewer model were made by Johann Georg Hann (master 1780, d. 1812), Vienna, 1804, with gilding added later (see Christie's, New York, sale cat., October 24, 2002, lot 169).

Cat. no. 25

Eight single salts, some with glass liners, Vienna, 1782 (4), 1852 (4). Silver, H. approx. 2 in. (5.2 cm), L. 4 in. (10 cm), Wt. range (without glass) 8.16–9.12 oz. (230–260 g). Private collection, Paris

Marks: Maker's mark II/W in oval (see Neuwirth 2002, p. 183, mark no. P1274) for salts incised N:2, N:3, N:9, and N:11; Viennese hallmark, 1782, for N:2, N:3, N:9, and N:11; maker's mark MAYERHOFER & KLINKOSCH 1852 for four unnumbered salts.

Provenance: Sale, Galerie Fischer, Lucerne, May 6, 1947, lots 2, 3 (1782), 150–54 (1852).

Comments: Four of the salts exhibited were part of the original service and made in 1782; four others were made in 1852 by Mayerhofer & Klinkosch, Vienna.

Cat. no. 26

Six double salts, Vienna, 1782. Silver, H. approx. 3⅛ in. (7.9 cm), L. 6 in. (15.2 cm), Wt. range (without glass) 14.88–17.28 oz. (420–490 g). Private collection, Paris

Marks: Engraved N:1–N:6.

Provenance: Sale, Galerie Fischer, Lucerne, May 6, 1947, lots 9–14 (pl. 4); sale, Ader Picard Tajan, Hotel George V, Paris, June 23, 1976, lot 63 (N:1, N:2, N:3 only).

Cat. no. 27

Twenty-four single candlesticks, Vienna, 1781. Silver, H. approx. 12¼ in. (31 cm), Diam. of bases approx. 5¼ in. (13.4 cm), Wt. range 3 lbs., 8.8 oz.–3 lbs., 12.64 oz. (1610–1720 g). Private collection, Paris, and Private collection, Vienna (N:7, N:8)

Marks: Maker's mark II/W in oval (see Neuwirth 2002, p. 183, mark no. P1274); Viennese hallmark, 1781; incised numbers run (with omissions) from no. N:2 to N:32.

Provenance: Sale, Galerie Fischer, Lucerne, May 6, 1947, lots 17–29 (lot 19, N:7, N:8); sale, Ader Picard Tajan, Hotel George V, Paris, June 23, 1976, lot 65 (N:7, N:8); sale, Christie's, New York, April 11, 1995, lot 119 (N:7, N:8; sale cat. does not give incised numbers).

Bibliography: Braun 1910, p. 8, under no. 14; *Albertina* 1969, p. 19, no. 21.2 (two examples).

Cat. no. 28

Two two-branch candelabra, Vienna, 1781. Silver, H. approx. 22⅞ in. (58 cm), Diam. of bases 6⅞ in. (17.5 cm), Wt. (N:1) 11 lbs., 13.76 oz. (5380 g); Wt. (N:2, illustrated in book) 11 lbs., 12.64 oz. (5350 g). Private collection, Paris

Marks: Maker's mark II/W in oval (see Neuwirth 2002, p. 183, mark no. P1274); Viennese hallmark, 1781.

Provenance: Sale, Galerie Fischer, Lucerne, May 6, 1947, lot 54 (two of ten offered as lots 54–58).

Bibliography: Braun 1910, p. 8, under no. 13, pl. VII, b.

Cat. no. 29

Four six-light candelabra, Vienna, 1781. Silver, H. approx. 27⅛ in. (69 cm), Diam. of bases (without the feet) approx. 6⅞ in. (17.5 cm), Dist. between the feet 8¼ × 8¼ × 8¼ in. (21 × 21 × 21 cm), Wt. range 20 lbs.–20 lbs., 8.8 oz. (9070–9320 g). Private collection, Paris

Marks: Maker's mark II/W in oval (see Neuwirth 2002, p. 183, mark no. P1274); Viennese hallmark, 1781; incised on bases N:9 through N:12.

Provenance: Sale, Galerie Fischer, Lucerne, May 6, 1947, lot 58 (N:11, N:12).

Comments: The small shell-ornamented feet were likely added in 1852 (see p. 58 of this volume). The six-light candelabra were not mentioned in Braun 1910. For a discussion of the tripod stands in cat. nos. 27, 28, and 29, see note 103 in this volume.

Cat. no. 30

Design for a candelabrum with eleven branches, Austria, ca. 1770–80. Pen and black ink, graphite, 10⅝ × 16½ in. (27.1 × 41.7 cm). The Metropolitan Museum of Art, New York. Gift of Raphael Esmerian, 1963 63.547.15.9

Inscription: PLAN ... TISCH ODER CANDELABRA ARMLEUCHTER ... / N.3 DAS DIESER LEUCHTER MARG VOR DIE WAND ZU STELLEN KÖNNT/ SO IST AUF EINER SEITE DER ÄUßERE ARM AUSGELASSEN/6 ZOLL ... 1, ... 2, ... 3 (plan ... [of a parade] ... table or candelabrum or candleholder with branches/N:3 That this candelabra could be placed in front of the wall [or the end of a table?]/one of the outer [arms] is omitted below the indication of the measurement/6 zoll ... 1, ... 2, ... 3); also a handwritten indication of about 33½ in. (85.1 cm) for the span of the candelabra branches (assuming one zoll equals about one inch [2.54 cm]).

Provenance: Duke Albert of Sachsen-Teschen; Prince Charles de Ligne (1735–1814); Armand Sigwalt (1875–1952); sale, H. Gilhofer & H. Ranschburg, Lucerne, November 28 and 29, 1934 (see p. 47 of the sale cat.; part of a large group of drawings originally owned by Duke Albert of Sachsen-Teschen [see also cat. nos. 5, 7, 8, 45]); Raphael Esmerian.

Comments: This highly experimental design focuses only on the functional requirements of a large candleholder, omitting any suggestion of additional ornament. It reflects the visionary exploration of the Viennese academy and affiliated goldsmiths of the late eighteenth century (see pp. 19–20 of this volume) and appears to anticipate the modern era in early twentieth-century Vienna. Compare the placement of two four-branch candelabra on a table at a banquet for Louis XIV in 1702 (see *Versailles et les tables royales en Europe* 1993, p. 255, no. 14); for a related candelabrum used as a table centerpiece, see DeJean 2005, p. 121, fig. 5.2.

Cat. no. 31

Pair of wine coolers, Vienna, 1781. Silver, H. 11⅜ in. (28.9 cm), Diam. of upper rims approx. 9½ in. (24.1 cm), Diam. of bases 6⅜ in. (16.2 cm), Wt. (N:5) 13 lbs., 3.68 oz. (6003 13 g), Wt. (N:7) 13 lbs. (5939 07 g). The Metropolitan Museum of Art, New York. Purchase, Anna-Maria and Stephen Kellen Foundation Gift, 2002 2002.265.1a, b, 2a, b

Marks: Maker's mark II/W in oval (see Neuwirth 2002, p. 183, mark no. P1274); Viennese hallmark, 1781; early nineteenth-century Austrian control marks and later French import marks; incised inside on the bodies and outside on the silver liners V (.1a, b) and VII (.2a, b); weights incised under the base N:5. M.21.6.1. and N:7. M.21.2.2. The weights of each cooler as determined by a modern scale (N:5 = 6000 g; N:7 = 5940 g) are almost identical to the weights indicated by the scratch marks above. See also p. 90 of this volume for a reading of scratch marks.

Provenance: Sale, Galerie Fischer, Lucerne, May 6, 1947, lots 125, 126; sale, Ader Picard Tajan, Hotel George V, Paris, June 23, 1976, lot 69; sale, Christie's, New York, April 11, 1995, lot 120; private collection; sale, Sotheby's, New York, April 18 and 19, 2002, lot 47 (sold to Galerie Neuse, Bremen).

Bibliography: Wolfram Koeppe in "Recent Acquisitions" 2003, p. 26; Koeppe in McCormick and Ottomeyer et al. 2004, pp. 110–11, no. 51; "Würth: Pair of Wine Coolers" 2008; Wardropper 2009, pp. 54–55.

Comments: Braun 1910, p. 7, no. 1, mentions "eight champagne coolers"; the Metropolitan Museum's pair is probably identical to those

seen in *Fine European Silver*, Christie's, Geneva, sale cat., November 17, 1980, lot 111, and identified as "a pair of fine Austrian vase-shaped wine-coolers," 1781. Wine cooler N:6 is not accounted for and was not part of the 1947 Galerie Fischer sale; one other example is in a private collection, Brussels (I am grateful to Alexis Kugel, Paris, for this information).

Cat. no. 31a (not illustrated in this volume)

Pair of wine coolers, Vienna, 1781. Silver, H. of each 11⅜ in. (29 cm), Diam. of upper rims 9¾ in. (24.8 cm), Diam. of bases 6⅜ in. (16.3 cm), Wt. (N:4) 13 lbs., 4 oz. (6010 g), Wt. (N:8) 13 lbs., 9.6 oz. (6170 g). Private collection, Paris

Marks: Maker's mark II/W in oval (see Neuwirth 2002, p. 183, mark no. P1274); Viennese hallmark, 1781; early nineteenth-century Austrian control marks and later French import marks; engraved inside on the bodies and outside on the silver liners IV and VIII; engraved N:4 and N:8 (the latter also numbered VIII).

Provenance: Sale, Galerie Fischer, Lucerne, May 6, 1947, lots 124, 127.

Bibliography: *Albertina* 1969, p. 19, no. 21.4 (one cooler, number not specified).

Comments: See cat. no. 31, above.

Cat. no. 32

Medium round serving dish, Vienna, 1781. Silver, Diam. 12¾ in. (32.5 cm), Wt. 2 lbs., 4.48 oz. (1080 g). Private collection, Paris

Marks: Engraved with the arms of Archduke Charles of Austria, duke of Teschen: Per pale; dexter, a lion rampant; sinister, three eagles displayed on a bend; over the division, a pale of Austria (see note 117; I am grateful to Timothy Wilson for discussing this with me); maker's mark II/W in oval (see Neuwirth 2002, p. 183, mark no. P1274); Viennese hallmark, 1781; incised N:12.

Provenance: Sale, Galerie Fischer, Lucerne, May 6, 1947, lot 98.

Comments: The diameter of this dish is the same as that of those under the round covers (cat. nos. 20, 21); thus, this model could have been used as a separate serving dish size or a dish for a matching cover. The incised inventory numbers for this dish size reach N:18 (see Galerie Fischer, Lucerne, sale cat., May 6, 1947, lot 102).

Cat. no. 33

Two round dishes, Vienna, 1780. Silver, Diam. 11⅞ in. (30.3 cm), Wt. (N:10) 1 lb., 11.2 oz. (770 g), Wt. (N:14) 1 lb., 10.88 oz. (760 g). Private collection, Paris

Marks: Engraved with the arms of Archduke Charles of Austria: see cat. no. 32; maker's mark II/W in oval (see Neuwirth 2002, p. 183, mark no. P1274); Viennese hallmark, 1780; incised N:10 and N:14.

Provenance: Galerie Fischer, Lucerne, sale cat., May 6, 1947, lots 108, 110.

Comments: The incised inventory numbers of this type reach N:16 (see Galerie Fischer, Lucerne, sale cat., May 6, 1947, lot 112).

Cat. no. 34

Large oval serving platter, Vienna, 1780. Silver, 23¾ × 16½ in. (60.4 × 41.8 cm), Wt. 5 lbs., 9.6 oz. (2540 g). Private collection, Paris

Marks: Engraved with the arms of Archduke Charles of Austria: see cat. no. 32; maker's mark II/W in oval (see Neuwirth 2002, p. 183, mark no. P1274); Viennese hallmark, 1780; incised N:3.

Provenance: Sale, Galerie Fischer, Lucerne, May 6, 1947, lot 78.

Comments: The incised inventory numbers N:3 and N:4 (the latter relating to lot 79 of the Galerie Fischer, Lucerne, sale cat., May 6, 1947) point to the existence of a set of at least four similar platters; a smaller oval version is documented as one of eight examples in its size (see Galerie Fischer, Lucerne, sale cat., May 6, 1947, lots 82–87; one of these is incised N:7, which implies a missing N:8, which would have been its mate).

Cat. no. 35

Large round serving platter, Vienna, 1781. Silver, Diam. 16½ in. (41.8 cm), Wt. 4 lbs., 2.72 oz. (1890 g). Private collection, Paris

Marks: Engraved with the arms of Archduke Charles of Austria: see cat. no. 32; maker's mark II/W in oval (see Neuwirth 2002, p. 183, mark no. P1274); Viennese hallmark, 1780; incised N:4.

Provenance: Galerie Fischer, Lucerne, sale cat., May 6, 1947, lot 91.

Comments: The incised inventory number N:4 indicates a set of at least four platters of this size.

Cat. no. 36

Sixty dinner plates, Vienna, 1781–82. Silver, Diam. approx. 10–10⅛ in. (25.5–25.6 cm), Wt. per dozen ave. 14 lbs., 12.32 oz. (6700 g). Private collection, Paris

Marks: Engraved with the arms of Archduke Charles of Austria: see cat. no. 32; maker's mark II/W in oval (see Neuwirth 2002, p. 183, mark no. P1274); Viennese hallmark, 1781–82.

Provenance: Sale, Galerie Fischer, Lucerne, May 6, 1947, lots 66–75 (116 plates, most sold by the dozen; lot 75 contained only eight plates, one numbered 287); Swiss art market (eighteen plates, each with a diameter of 10 inches [25.5 cm] and a 1781 Viennese hallmark [see *Weltkunst*, November 15, 1984, p. 3471]; sale, Sotheby's, Geneva, November 15, 1993, lot 84 (six plates, nos. 98, 186, 210, 227, 259, 282, are part of the current private collection in Paris).

Bibliography: Braun 1910, p. 8, no. 23 (mentions 240 plates).

Comments: Two plates may have been in the sale at Galerie Fischer, Lucerne, June 7 and 8, 1995, lot 99 (not illustrated in the sale cat.).

Cat. no. 37

Napkin designs in the forms of various animals (for example, no. 1 depicts a double-headed eagle and no. 18 the lion of Saint Mark), Italy, 1639. Engraving, 5¾ × 8⅛ in. (14.6 × 20.8 cm) From *Li tre trattati* (The Three Treatises) by Mattia Giegher (Padua: Paolo Frambotto, 1639), plate 5. The Metropolitan Museum of Art, New York. Harris Brisbane Dick Fund, 1940 40.84

Bibliography: Walker 2002, p. 77, fig. 42; Sallas 2008, p. 17.

Cat. no. 38

Ladle, Vienna, 1780. Silver, L. 14⅜ in. (36.4 cm), Wt. 13.92 oz. (396 g). Private collection, Paris

Marks: Maker's mark II/W in oval (see Neuwirth 2002, p. 183, mark no. P1274); Viennese hallmark, 1780.

Provenance: Sotheby's, New York, October 21, 1997, lot 61; Christie's, London, June 12, 2006, lot 23.

Bibliography: Braun 1910, p. 8, under no. 24 (one of six).

Comments: Other than the wine coolers and the soup ladle with rounded bowl (see fig. 47e), this is the only item of the service that displays the lion symbol (on the back of the handle). A similar ladle (Vienna, 1779, from the Danish service), incised with the crowned monograms CF, GG, and O, was sold at Christie's, Geneva, November 15, 1994, lot 82.

Cat. no. 39

Jacques-Nicolas Roëttiers (1736–1788). Ladle, Paris, 1775–76. Silver, L. 14⅞ in. (37.9 cm), Wt. 13.27 oz. (376 3 g). The Metropolitan Museum of Art, New York. Gift of Mrs. Reginald McVitty and Estate of Janet C. Livingston, 1976 1976.357.2

Marks: Maker's mark consisting of a fleur-de-lis, 2 *grains de remède*, the initials J N R, and a sheaf of wheat; various assay and charge marks for Paris, 1774–80.

Bibliography: Le Corbeiller 1977, pp. 396, 398–99, figs. 5, 6.

Comments: This ladle is part of the same service as the tureen with cover, cat. no. 9.

Cat. no. 40

Three original cases for flatware (cat. nos. 41, 42, 43). Leather, various metal hooks, handles, and locks, wood core, interior suede lining, (cat. no. 41) 5½ × 11½ × 11 in. (14 × 29 × 28 cm), (cat. no. 42) 5 × 15 × 10½ in (13 × 38 × 27 cm), (cat. no. 43) 3½ × 22½ × 10¼ in. (9 × 57 × 26 cm). Private collection, Paris

Comments: These cases show residues of red lacquer seals similar to those on the round leather case, cat. no. 18.

Cat. no. 41

Flatware, Vienna, 1781. Leather case (see cat. no. 40, above); 24 forks: gilded silver, porcelain handles, L. 8¼ in. (21 cm); 24 knives: gilded silver, porcelain handles, L. 8⅝–8¾ in. (22–22.2 cm); 24 spoons: gilded silver, with undulating-band decoration, L. 7¾–7⅞ in. (19.7–19.9 cm). Private collection, Paris

Marks: Maker's mark II/W in oval (see Neuwirth 2002, p. 183, mark no. P1274); Viennese hallmark, 1781.

Provenance: Sale, Galerie Fischer, Lucerne, May 6, 1947, lot 128.

Bibliography: Braun 1910, p. 8, pl. IX, g, h, i (see also fig. 47 in this volume).

Cat. no. 42

Flatware, Vienna, 1781. Leather case (see cat. no. 40, above); 25 forks: gilded silver, porcelain handles, L. 8¼ in. (21 cm); 25 knives: gilded silver, porcelain handles, L. 8⅝–8¾ in. (22–22.2 cm); 25 spoons: gilded silver, with rosettes, L. 7½ in. (19 cm). Private collection, Paris

Marks: Maker's mark II/W in oval (see Neuwirth 2002, p. 183, mark no. P1274); Viennese hallmark, 1781.

Provenance: Sale, Galerie Fischer, Lucerne, May 6, 1947, lot 129.

Bibliography: Braun 1910, p. 8.

Comments: The porcelain service sold from the Thurn and Taxis Collection (fig. 50) included matching flatware offered as a separate lot. See Sotheby's, Regensburg, *Die Fürstliche Sammlung Thurn und Taxis*, sale cat., vol. 2, October 12–15, 1993, lot 1201 (dessert cutlery set).

Cat. no. 43

Mayerhofer & Klinkosch. Flatware, Vienna, 1852. Leather case (see cat. no. 40, above); 25 forks: silver, porcelain handles, L. 8¼ in. (21 cm); 24 knives: silver, porcelain handles, L. 8⅜ in. (21.2 cm); 25 spoons: silver, L. 7 in. (17.7 cm). Private collection, Paris

Marks: Maker's mark MAYERHOFER & KLINKOSCH (see Neuwirth 2002, p. 215); Viennese hallmark, 1852.

Provenance: Sale, Galerie Fischer, Lucerne, May 6, 1947, lot 215.

Cat. no. 44

Table-setting plan for the inauguration of Joseph II as count of Flanders, with Marie Christine and Albert, joint governors of the Austrian Netherlands, presiding. Ghent, July 1781. Drawing, 25¼ × 36⅝ in. (64 × 93 cm). Private collection, France

Provenance: Noble family, Belgium.

Comments: This is one of a group of six drawings, including another table plan for the joint governors and four designs for contemporary triumphal arches and festive illuminations.

Cat. no. 45

Georg Heinrich von Kirn (1736–1793). Design for a porcelain gilded-bronze-mounted ewer, Germany, ca. 1790. Pen and black and brown ink, graphite, watercolor, framing lines in pen and black ink, sheet size 19⅞ × 14⅛ in. (50.5 × 35.9 cm). The Metropolitan Museum of Art, New York. Gift of Raphael Esmerian, 1963 63.547.3

Marks: Pen inscription: KIRN CAD: D'ARTILL: DELIN:/KIRN CAD[ET] D'ARTILL[ERIE] DELIN[EAVIT] (he drew [this]).

Provenance: Duke Albert of Sachsen-Teschen; Prince Charles de Ligne (1735–1814); Armand Sigwalt (1875–1952); sale, H. Gilhofer & H. Ranschburg, Lucerne, November 28 and 29, 1934 (see p. 47 of the sale cat.; part of a large group of drawings originally owned by Duke Albert of Sachsen-Teschen [see also cat. nos. 5, 7, 8, 30]); Raphael Esmerian.

Bibliography: Kei Chan in McCormick and Ottomeyer et al. 2004, pp. 79–80, no. 30; Bellaigue 2009, vol. 2, pp. 479, 480, fig. 110.1.

Comments: Accompanied by a front and back view in The Metropolitan Museum of Art (see *Design for an Urn*, ca. 1770–90; Gift of Raphael Esmerian, 1963 [63.547.1, signed in pen and brown ink at lower right: KIRN CAD: D'ARTILL: DELIN:; in pen and red ink at lower right: 4; on verso in graphite: GEORGE HEINRICH]; and *Design for a Gilt Bronze Urn*, ca. 1770–90; Gift of Raphael Esmerian, 1963 [63.547.2, signed in pen and brown ink at lower right: KIRN CAD: D'ARTILL: DELIN:; in pen and red ink at lower right: 5]). All are fully finished works documenting existing objects. Given that Kirn was working in the Rhine River region (see "Kirn" 1927), the drawings may have been made during one of Albert's stays in Bonn (1790 or after) with his brother-in-law Maximilian, the elector and archbishop of Cologne (Koschatzky and Krasa 1982, pp. 173–77). It is possible that Albert carried the objects depicted in the drawings with him, and/or that the drawings record a gift in gratitude to the elector, who gave Albert and Marie Christine refuge after their evacuation from Brussels.

Cat. no. 46

Verrière (glass cooler), attributed to Ignaz Joseph Würth, Vienna, ca. 1780. Silver, with silver liner, H. 10 in. (25.3 cm), L. overall 18¼ in. (46.4 cm), D. 10⅝ in. (27.1 cm), L. of base 9¾ in. (24.9 cm), D. 6⅝ in. (16.8 cm), Wt. 13 lbs., 11.52 oz. (6224 47g). Private collection, France

Marks: Incised on base N.2.M.22.2.3.2. (see fig. 65). The weights of the verrière as determined by a modern scale (6223 38 g) is almost identical to the weight indicated by the scratch marks. See also p. 90 of this volume for a reading of scratch marks.

Comments: The new attribution for the cooler above links it to the Second Sachsen-Teschen Service or a closely related Viennese service of about 1780. A former attribution to the Turin goldsmith Giovanni Battista Boucheron (1742–1815) was based on the bacchantic mask (see Boucheron's service for the Russian imperial family, Griseri 1991–92, figs. 9, 10). However, the ornamental friezes and swan handles (the latter influenced by Luigi Valadier and Ennemond Alexandre Petitot; see figs. 26, 27) were influential to Würth's work. Also, the weight inscription (see Marks, above, and fig. 65) corresponds closely to the formula of a Viennese workshop, most likely that of Würth.

Bibliography

Abafi 1891
Ludwig Abafi [Lajos Aigner]. *Geschichte der Freimaurerei in Österreich-Ungarn.* Vol. 2. Budapest, 1891.

"Accessions" 1922
"Accessions and Notes: Bequest of William Mitchell." *The Metropolitan Museum of Art Bulletin* 17, no. 4 (April 1922), pp. 91–92.

Adamczak 2006
Alicia Adamczak. "Germain, François-Thomas." In *Allgemeines Künstlerlexikon: Die bildenden Künstler aller Zeiten und Völken*, vol. 52, pp. 180–84. Leipzig, 2006.

Adams 2003
William Howard Adams. *Gouverneur Morris: An Independent Life.* New Haven, 2003.

Albertina 1969
200 Jahre Albertina: Herzog Albert von Sachsen-Teschen und seine Kunstsammlung. Exh. cat. Graphische Sammlung Albertina, Vienna, May 12–September 28, 1969. Vienna, 1969.

Alt-Oesterreichischen Goldschmiedearbeiten 1904
Katalog der Ausstellung von Alt-Oesterreichischen Goldschmiedearbeiten. Foreword by Edmund Wilhelm Braun. Exh. cat. Kaiser Franz Josef-Museum für Kunst und Gewerbe, Troppau, September 1–October 1, 1904. Troppau, 1904.

Ancient Silver Objects 1885
Catalogue of the Temporary Exhibition of Ancient (XVIII Century) Silver Objects from the Museum of the Institute of Drawing of Baron Stieglitz. [In Russian.] Saint Petersburg, 1885.

Arneth 1866
Alfred Ritter von Arneth, ed. *Maria Theresia und Marie Antoinette: Ihr Briefwechsel.* 2nd ed. Leipzig, 1866.

Arnold 1994
Ulli Arnold. *Dresdner Hofsilber des 18. Jahrhunderts.* Kulturstiftung der Länder, Patrimonia 74. Grünes Gewölbe, Staatliche Kunstsammlungen Dresden. Dresden, 1994.

Art des Tafeldeckens 1796
Praktischer Unterricht in der neuesten Art des Tafeldeckens und Trenschirens, mit Figuren erläutert. Vienna, 1796.

"Auguste: Pair of Candelabra" 2006
"Marked by Robert-Joseph Auguste: Pair of Candelabra (48.187.389ab,.390ab)." In *Heilbrunn Timeline of Art History.* The Metropolitan Museum of Art. New York, 2000–. http://www.metmuseum.org/toah/hd/fsilv/ho_48.187.389ab,.390ab.htm [October 2006].

Avery 1934
C. Louise Avery. "French Silver." *The Metropolitan Museum of Art Bulletin* 29, no. 2 (February 1934), pp. 32–36.

Baarsen 2005
Reinier Baarsen. "Charles of Lorrain's Audience Chamber in Brussels." *Burlington Magazine* 147 (July 2005), pp. 464–73.

Baarsen and De Ren 2005
Reinier Baarsen and Leo De Ren. "'Ébénisterie' at the Court of Charles of Lorraine." *Burlington Magazine* 147 (February 2005), pp. 91–99.

Baudouin, Colman, and Goethals 1988
Piet Baudouin, Pierre Colman, and Dorsan Goethals. *Edelsmeedkunst in Belgie: Profaan zilver, XVI^de–XVII^de–XVIII^de euw.* Tielt, 1988. [French ed., *Orfèvrerie en Belgique, XVI^e–XVII^e–XVIII^e siècles.* Paris, 1988.]

Baulez 1978/2007
Christian Baulez. "Notes sur quelques meubles et objects d'art des appartements intérieurs de Louis XVI et de Marie-Antoinette." *La Revue du Louvre et des Musées de France* 28, nos. 5–6 (1978), pp. 359–73; reprinted in *Versailles: Deux Siècles d'histoire de l'art; études et chroniques de Christian Baulez*, pp. 241–54. Versailles, 2007.

Baulez 1996/2007
Christian Baulez. "David Roentgen et François Rémond: Une Collaboration majeure dans l'histoire du mobilier européen." *L'Estampille/L'Objet d'art*, no. 305 (1996), pp. 96–118; reprinted in *Versailles: Deux Siècles d'histoire de l'art; études et chroniques de Christian Baulez*, pp. 385–402. Versailles, 2007.

Baulez 2000/2007
Christian Baulez. "La Bibliothèque de Louis XVI à Versailles et son remeublement." *La Revue du Louvre et des Musées de France* 50, no. 2 (2000), pp. 59–76; reprinted in *Versailles: Deux Siècles d'histoire de l'art; études et chroniques de Christian Baulez*, pp. 131–50. Versailles, 2007.

W. J. Baumol and H. Baumol 1994
William J. Baumol and Hilda Baumol. "On the Economics of Musical Composition in Mozart's Vienna." *Journal of Cultural Economics* 18 (1994), pp. 171–98.

Baumstark and Seling 1994
Reinhold Baumstark and Helmut Seling, eds. *Silber und Gold: Augsburger Goldschmiedekunst für die Höfe Europas.* Exh. cat. by Lorenz Seelig, with contributions by Ulli Arnold et al. 2 vols. Bayerisches Nationalmuseum, Munich, February 23– May 29, 1994. Munich, 1994.

Bellaigue 2009
Geoffrey de Bellaigue. *French Porcelain in the Collection of Her Majesty the Queen.* 3 vols. London, 2009.

Bencard 1992
Mogens Bencard. *Silver Furniture.* Translated by Martha Gaber Abrahamsen. Copenhagen, 1992.

Benedik 2008
Christian Benedik. *The Albertina: The Palais and the Habsburg State Rooms.* Vienna, 2008.

Berliner and Egger 1981
Rudolf Berliner and Gerhart Egger. *Ornamentale Vorlageblätter des 15. bis 18. Jahrhunderts.* 3 vols. 2nd ed. Munich, 1981. [Originally published Leipzig, 1926.]

Betthausen 2002
Peter Betthausen. "Winckelmann, Anton von Maron und Wien." In Hagen 2002, pp. 79–84.

Biermann 1894
G. Biermann. *Geschichte des Herzogthums Teschen.* 2nd ed. Teschen, 1894.

Boehn 1921
Max von Boehn. *Rokoko: Frankreich im XVIII. Jahrhundert.* Berlin, 1921.

Bouilhet 1908
Henri Bouilhet. *L'Orfèvrerie française aux XVIII^e et XIX^e siècles.* Vol. 1, *L'Orfèvrerie française aux XVIII^e siècle (1700–1789).* Paris, 1908.

Brault and Bottineau 1959
Solange Brault and Yves Bottineau. *L'Orfèvrerie française du XVIII^e siècle.* Paris, 1959.

Braun 1906
Edmund Wilhelm Braun. "Wachs-bossierung eines Wiener Goldschmiedes aus der Mitte des XVIII. Jahrhunderts." *Kunst und Kunsthandwerk* 9 (1906), p. 90.

Braun 1909
Edmund Wilhelm Braun. "Der Freiburger Münsterschatz. 1. Zwei Wiener Gold-schmiedearbeiten aus dem Jahre 1770." *Freiburger Münsterblätter* 5 (1909), pp. 15–22.

Braun 1910
Edmund Wilhelm Braun. *Das Tafelsilber des Herzogs Albert von Sachsen-Teschen: Ein Beitrag zur Geschichte der Wiener-Goldschmiedekunst in der Louis Seize-Zeit.* Vienna, 1910.

Bremer-David 1997
Charissa Bremer-David. *French Tapestries and Textiles in the J. Paul Getty Museum.* Los Angeles, 1997.

Brown 1997
Bruce Alan Brown. "*I cacciatori amanti*: The Portrait of Count Giacomo Durazzo and His Wife by Martin van Meytens the Younger." *Metropolitan Museum Journal* 32 (1997), pp. 161–74.

Bruegel, Memling, Van Eyck 2009
Bruegel, Memling, Van Eyck . . . : La Collection Brukenthal. Exh. cat. Musée Jacquemart-André, Paris, September 11, 2009–January 11, 2010. Brussels, 2009.

Bunt 1944
Cyril G. E. Bunt. "Eighteenth-Century French Silver." *Connoisseur* 113 (June 1944), pp. 80–85.

Carlier 1993
Yves Carlier. "Le Service d'orfèvrerie de George III d'Angleterre." In *Versailles et les tables royales en Europe* 1993, pp. 330–33.

Cassidy-Geiger 2002
Maureen Cassidy-Geiger. "Meissen Porcelain for Sophie Dorothea of Prussia and the Exchange of Visits between the Kings of Poland and Prussia in 1728." *Metropolitan Museum Journal* 37 (2002), pp. 138–66.

Cassidy-Geiger 2007a
Maureen Cassidy-Geiger. "Ein neues silbern Französisches Tafel Service: Linking the Penthièvre-Orléans Service to Dresden." *Silver Studies: The Journal of the Silver Society*, no. 22 (2007), pp. 123–52.

Cassidy-Geiger 2007b
Maureen Cassidy-Geiger. "Sugar and Silver into Porcelain: The *Conditorei* and Court Dining in Dresden under Augustus III." *Silver Studies: The Journal of the Silver Society*, no. 22 (2007), pp. 152–54.

Catherine the Great 1998
Catherine the Great and Gustav III. Exh. cat. Nationalmuseum, Stockholm, October 9, 1998–February 28, 1999. Stockholm and Saint Petersburg, 1998.

Chambers's Encyclopaedia 1901
Chambers's Encyclopaedia: A Dictionary of Universal Knowledge. New ed. London and Philadelphia, 1901.

D'après l'antique 2000
D'après l'antique. Exh. cat. Musée du Louvre, Paris, October 16, 2000–January 15, 2001. Paris, 2000.

DeJean 2005
Joan DeJean. *The Essence of Style: How the French Invented High Fashion, Fine Food, Chic Cafés, Style, Sophistication, and Glamour.* New York, 2005.

Dennis 1960
Faith Dennis. *Three Centuries of French Domestic Silver: Its Makers and Its Marks.* 2 vols. New York, 1960.

Dennis 1960/1994
Faith Dennis. *Three Centuries of French Domestic Silver: Its Makers and Its Marks/Trois Siècles d'orfèvrerie française.* 2 vols. New York, 1960. 2nd ed., San Francisco, 1994.

De Ren 1987
Leo De Ren. "Charles-Alexandre de Lorraine: Collectionneur et amateur d'art." In *Charles-Alexandre de Lorraine: Gouverneur général des Pays-Bas autrichiens*, pp. 50–73. Exh. cat. Palais de Charles de Lorraine, Bibliothèque Royale Albert Iᵉʳ, Brussels, September 18–December 16, 1987. Brussels, 1987.

Dion-Tenenbaum et al. 2000
Anne Dion-Tenenbaum et al. "L'Athénienne." In *D'après l'antique* 2000, pp. 336–53.

Droguet 2004
Anne Droguet. *Les Styles Transition et Louis XVI.* Paris, 2004.

Eighteenth Century Art 1950
The Eighteenth Century Art of France and England / L'Art en France et en Angleterre au dix-huitième siècle. Exh. cat. Montreal Museum of Fine Arts, April 27–May 31, 1950. Montreal, 1950.

Ennès 1995
Pierre Ennès. "L'Art de la table à la Renaissance." In *Le Dressoir du prince: Services d'apparat à la Renaissance*, pp. 11–19. Exh. cat. Musée National de la Renaissance, Château d'Ecouen, October 18, 1995–February 19, 1996. Ecouen, 1995.

Eriksen 1968
Svend Eriksen. *Sèvres Porcelain.* The James A. Rothschild Collection at Waddesdon Manor. Fribourg, 1968.

Eriksen 1974
Svend Eriksen. *Early Neo-Classicism in France: The Creation of the Louis Seize Style in Architectural Decoration, Furniture and Ormolu, Gold and Silver, and Sèvres Porcelain in the Mid-Eighteenth Century.* Translated and edited by Peter Thornton. London, 1974.

European Fine Art Fair 2006
The European Fine Art Fair, Maastricht 06. Exh. cat. Maastricht Exhibition and Congress Centre, Maastricht, The Netherlands, March 10–19, 2006. Organized by the European Fine Art Foundation. Helvoirt, 2006.

Exposition rétrospective 1935
Exposition rétrospective: L'Orfèvrerie et le bijou d'autrefois. Preface by Camille Gronkowski. Exh. cat. Galerie Mellerio, Paris, March 19–April 10, 1935. Paris, 1935.

Fennimore and Halfpenny 2000
Donald L. Fennimore and Patricia A. Halfpenny. *The Campbell Collection of Soup Tureens at Winterthur.* Henry Francis Du Pont Winterthur Museum, Winterthur, Delaware. Winterthur, 2000.

Fina 1997
Gianfranco Fina. *Maestri argentieri ed argenterie alla corte di Carlo Emanuele III e Vittorio Amedeo III, 1730–1796.* Turin, 1997.

Fina 2002
Gianfranco Fina. *L'argenteria torinese del Settecento.* Turin, 2002.

Foelkersam 1907
Baron de Foelkersam (Armin Evgenievich), ed. *Inventaire de l'argenterie conservée dans les garde-meubles des palais impériaux: Palais d'Hiver, Palais Anitchkov et Château de Gatchino.* [In Russian.] 2 vols. Saint Petersburg, 1907.

Folnesics 1909
Josef Folnesics. "Das Kunstgewerbe in der Louis-XVI- und Empirezeit." In *Illustrierte Geschichte des Kunstgewerbes*, vol. 2, *Das Kunstgewerbe in Barock, Rokoko, Louis-XVI, Empire und neuester Zeit, im Gebiete des Islams und in Ostasien*, pp. 225–406. Berlin, 1909.

Fornari Schianchi 1997
Lucia Fornari Schianchi. "Petitot fra progetto e decorazione." In *Petitot* 1997, pp. 107–20.

Franz 2006
Rainald Franz. "Die Ornamentvorlagen des Johann Baptist Hagenauer." *Barockberichte*, nos. 44–45 (2006), pp. 871–80.

Freimauer 1992
Freimauer: Solange die Welt besteht. Historisches Museum der Stadt Wien, September 18, 1992–January 10, 1993. Sonderausstellung des Historischen Museums der Stadt Wien 165. Vienna, 1992.

French, English and American Silver 1956
French, English and American Silver. Exh. cat. Minneapolis Institute of Arts, June 9–July 15, 1956. Minneapolis, 1956.

French Gold and Silver Plate 1933
Exhibition of Old French Gold and Silver Plate (XVIth to XVIIIth Century). Exh. cat. Arnold Seligmann, Rey et Co., New York, December 1933. Organized by Jacques Helft. Paris, 1933.

Friedrich Wilhelm von Erdmannsdorff 1986
Friedrich Wilhelm von Erdmannsdorff, 1736–1800: Sammlung der Zeichnungen. Exh. cat. Graphische Sammlung, Schloss Georgium, Staatliche Galerie Dessau, May 9–July 31, 1986. Dessau, 1986.

Die Fürsten Esterházy 1995
Die Fürsten Esterházy: Magnaten, Diplomaten & Mäzene. Exh. cat. Schloss Esterházy, Eisenstadt, April 28–October 31, 1995. Burgenländische Forschungen, suppl., 16. Eisenstadt, 1995.

Gaehtgens, Syndram, and Saule 2006
Thomas W. Gaehtgens, Dirk Syndram, and Béatrix Saule, eds. *Splendeurs de la cour de Saxe: Dresde à Versailles.* Exh. cat. Musée National des Châteaux de Versailles et de Trianon, January 23–April 23, 2006. Paris, 2006.

Galerie Fischer 1947
Tafelsilber aus einem fürstlichen Hause. Sale cat. Galerie Fischer, Lucerne, May 6, 1947.

Gasc and Mabille 1991
Nadine Gasc and Gérard Mabille. *The Nissim de Camondo Museum.* Musées et monuments de France. Paris, 1991.

Gatchina 1914/1994
Gatchina, imperatorskii dvorets: Tret'e stoletie istorii (Gatchina, Imperial Palace: Three Hundred Years of History). Saint Petersburg, 1994. ["Gatchina pri Pavle Petroviche, Tsesareviche i imperatore" (Gatchina under Pavel Petrovich, Tsar and Emperor), pp. 11–361, reprinted from *Starye gody* (Saint Petersburg), 1914.]

Glanz des Ewigen 2003
Glanz des Ewigen: Der Wiener Goldschmied Joseph Moser, 1715–1801. Edited by Johann Kronbichler and Wilfried Siepel. Exh. cat. Diözesanmuseum, St. Pölten, May 6–October 5, 2003; and Kunsthistorisches Museum, Vienna, October 22, 2003–January 19, 2004. Milan and Vienna, 2003.

Goetghebuer 1827
P. J. Goetghebuer. *Choix des monumens, édifices et maisons les plus remarquables du royaume des Pays-Bas.* Ghent, 1827.

Goethe 1811/1994
Johann Wolfgang Goethe. *From My Life: Poetry and Truth.* Pts. 1–3. [1811.] Translated by Robert R. Heitner. Edited by Thomas P. Saine and Jeffrey L. Sammons. Goethe's Collected Works 4. Princeton, 1994.

Goldschmiedekunst-Ausstellung 1889
Katalog der grossen Goldschmiedekunst-Ausstellung im Palais Schwarzenberg. Exh. cat. Palais Schwarzenberg, Vienna, 1889. Vienna, 1889.

Gombert 1965
Hermann Gombert. *Der Freiburger Münsterschatz.* Freiburg im Breisgau, 1965.

González-Palacios 1997
Alvar González-Palacios, ed. *L'oro di Valadier: Un genio nella Roma del Settecento.* Exh. cat. Villa Medici, Rome, January 29–April 8, 1997. Rome, 1997.

Les Grands Orfèvres 1965
Les Grands Orfèvres de Louis XIII à Charles X. Preface by Jacques Helft. Collection Connaissance des arts "Grandes artisans d'autrefois." Paris, 1965. [English ed., *French Master Goldsmiths and Silversmiths from the Seventeenth to the Nineteenth Century.* New York, 1966.]

Granlund 1999
Lis Granlund. "An Exquisite Inheritance from Brazil to Sweden." In *Mesas reais europeias: Encomendas e ofertas / Royal and Princely Tables of Europe: Commissions and Gifts / Tables royales en Europe: Commandes et cadeaux,* pp. 202–15. Acts of an international colloquium, "Imported Objects for the Royal and Princely Tables in Europe: Commands and Gifts," held in Lisbon, December 1996. Lisbon, 1999.

Griseri 1991–92
Angela Griseri. "Nuovi documenti: Giovan Battista Boucheron e la sua bottega." *Antologia di belle arti,* n.s., nos. 39–42 (1991–92), pp. 73–79.

Gruber 1982
Alain Gruber. *Silverware.* Translated by David Smith. New York, 1982.

Guld og sølv 1985
Guld og sølv fra Wien og København / Gold und Silber aus Wien und Kopenhagen. Exh. cat. Christiansborg Slot, Copenhagen, October 9–November 3, 1985. Copenhagen, 1985.

Hagen 2002
Bettina Hagen. *Antike in Wien: Die Akademie und der Klassizismus um 1800.* With a contribution by Peter Betthausen. Exh. cat. Akademie der Bildenden Künste, Vienna, November 27, 2002–March 9, 2003; and Winckelmann-Gesellschaft, Stendal, May 11–July 27, 2003. Mainz am Rhein, 2002.

Halama 2003
Diether Halama. "Biographies of Viennese Gold- and Silversmiths." In Huey 2003, pp. 386–93.

Hanke 2006
Rene Hanke. *Brühl und das Renversement des Alliances: Die antipreussische Aussen-politik des Dresdener Hofes, 1744–1756.* Historia Profana et Ecclesiastica 15. Berlin, 2006.

Hantschmann 2009
Katharina Hantschmann. "The Art of Dining." In *Fired by Passion: Vienna Baroque Porcelain of Claudius Innocentius Du Paquier,* edited by Meredith Chilton, vol. 2, pp. 764–847. Stuttgart, 2009.

Haslinger 1993
Ingrid Haslinger. *Küche und Tafelkultur am kaiserlichen Hofe zu Wien: Zur Geschichte von Hofküche, Hofzuckerbäckerei und Hofsilber- und Tafelkammer.* With a contribution by Hubert Chryspolitus Winkler. Bern, 1993.

Haslinger 1997
Ingrid Haslinger. *Ehemalige Hofsilber & Tafelkammer: Der kaiserliche Haushalt.* Publikationsreihe der Museen des Mobiliendepots 2. Vienna, 1997.

Haslinger 2002
Ingrid Haslinger. "Der Kaiser speist en public: Die Geschichte der öffentlichen Tafel bei den Habsburgern vom 16. bis ins 20. Jahrhundert." In Ottomeyer and Völkel 2002, pp. 48–57.

Haupt 2007
Herbert Haupt. *Das hof- und hofbefreite Handwerk im barocken Wien, 1620 bis 1770: Ein Handbuch.* Forschungen und Beiträge zur Wiener Stadtgeschichte 46. Innsbruck, 2007.

Havard 1896
Henry Havard. *Histoire l'orfèvrerie française.* Paris, 1896.

Heitmann 1985a
Bernhard Heitmann. "Goldgarnituren: Ihr Hintergrund und ihre Funktion"/ "Guldgarniturer: Deres Baggrund og Funktion." In *Guld og sølv* 1985, pp. 23–34.

Heitmann 1985b
Bernhard Heitmann. "Die Goldtoilette der dänischen Königinnen"/"De dansk Dronningers Guldtoilette." In *Guld og sølv* 1985, pp. 17–22.

Heitmann 1985c
Bernhard Heitmann. "Silberne Terrinen." *Die Weltkunst* 55, no. 17 (September 1, 1985), pp. 2330–32.

Heitmann 1985d
Bernhard Heitmann. "Die Wiener Goldgarnitur"/"Wiener Guldgarnituret." In *Guld og sølv* 1985, pp. 11–16.

Heitmann 1986
Bernhard Heitmann. *Europäisches Kunsthandwerk, 1500–1800: Vermächtnis F.K.A./G.A.E. Huelsmann.* Exh. cat. Kunsthalle Bielefeld, November 9, 1986–January 4, 1987. Bielefeld, 1986.

Helbig 1917
Georg Adolf Wilhelm von Helbig. *Russische Günstlinge.* Edited by Max Bauer. Munich, 1917.

Helft 1957
Jacques Helft. *Treasure Hunt: Memoirs of an Antique Dealer.* London, 1957.

Helft 1968
Jacques Helft. *Le Poinçon des provinces françaises.* Paris, 1968.

Hennings 1966
Fred Hennings. *Das Josephinische Wien.* Munich, 1966.

Hernmarck 1972
Carl Hernmarck. "Great French Silver Services in the Neo-Classical Style." *Connoisseur* 181 (October 1972), pp. 104–10.

Hernmarck 1977
Carl Hernmarck. *The Art of the European Silversmith, 1430–1830.* 2 vols. London, 1977.

Hoos 1991
Hildegard Hoos. "Zur Geschichte der Tafelkultur im Kaiserreich." In *Die kaiserliche Tafel* 1991, pp. 15–59.

Hoyer 2007
Eva Maria Hoyer. *Grassi Museum für Angewandte Kunst, Leipzig: Ständige Ausstellung, Antike bis Historismus.* Leipzig, 2007.

Huey 2003
Michael Huey, ed. *Viennese Silver: Modern Design, 1780–1918.* Exh. cat. Neue Galerie, New York, October 17, 2003–February 15, 2004; and Kunsthistorisches Museum, Vienna, November 11, 2004–March 13, 2005. Ostfildern-Ruit, 2003.

Jahresschrift 1990
Jahresschrift 1990. Edited by Wolfgang Henning. Damast- und Heimatmuseum, Gross-Schönau. Zittau, 1990.

Die kaiserliche Tafel 1991
Die kaiserliche Tafel: Ehemalige Hofsilver- und Tafelkammer Wien. Exh. cat. Museum für Kunsthandwerk, Frankfurt am Main, August 7–October 17, 1991. Frankfurt am Main, 1991.

Kamler-Wild 1985
Barbara [Kamler]-Wild. "Profane Gold- und Silberschmiedekunst des 18. Jahrhunderts in Wien"/"Guld- og Sølvsmedekunst i Wien i det 18. Århundrede." In *Guld og sølv* 1985, pp. 35–50.

Kamler-Wild 2003
Barbara Kamler-Wild. "Joseph Moser und die Wiener Goldschmiedekunst im 18. Jahrhunderts." In *Glanz des Ewigen* 2003, pp. 13–75.

Keller 1995
Katrin Keller. "August der Starke auf Reisen: Umstände und Folgen seiner Kavalierstour der Jahre 1687 bis 1689." In *August der Starke und seine Zeit: Beiträge des Kolloquiums vom 16./17. September 1994 auf der Festung Königstein,* pp. 23–34. Verein für sächsische Landesgeschichte. Saxonia 1. Dresden, 1995.

Kempf 1909
Friedrich Kempf. "Neue Nachrichten über die zwei Wiener Goldschmiedearbeiten aus dem Jahre 1770 im Freiburger Münster." *Freiburger Münsterblätter* 5 (1909), pp. 68–70.

King's Feast 1991
A King's Feast: The Goldsmith's Art and Royal Banqueting in the Eighteenth Century. Exh. cat. Kensington Palace, London, June 5–September 29, 1991. Copenhagen, 1991.

"Kirn" 1927
"Kirn, Georg Heinrich von." In Ulrich Thieme and Felix Becker, *Allgemeines Lexikon der bildenden Künstler, von der Antike bis zur Gegenwart,* vol. 20, edited by Hans Vollmer, pp. 374–75. Leipzig, 1927.

Kisluk-Grosheide, Koeppe, and Rieder 2006
Daniëlle O. Kisluk-Grosheide, Wolfram Koeppe, and William Rieder. *European Furniture in The Metropolitan Museum of Art: Highlights of the Collection.* New York, 2006.

Koeppe 1992
Wolfram Koeppe. *Die Lemmers-Danforth-Sammlung Wetzlar: Europäische Wohnkultur aus Renaissance und Barock.* Heidelberg, 1992.

Koeppe 1993
Wolfram Koeppe. "Blickfang sächsischer Bankette: Tafelleuchter und Girandolen." *Kunst und Antiquitäten,* 1993, no. 3, pp. 48–52.

Koeppe 1996
Wolfram Koeppe. "Möbel und Schaustücke." In *Liselotte von der Pfalz: Madame am Hofe des Sonnenkönigs,* edited by Sigrun Paas, pp. 179–88. Exh. cat. Heidelberger Schloss, September 9, 1996–January 26, 1997. Heidelberg, 1996.

Koeppe 2003
Wolfram Koeppe. "Saint Petersburg." In *Heilbrunn Timeline of Art History.* The Metropolitan Museum of Art. New York, 2000–. http://www.metmuseum.org/toah/hd/stpt/hd_stpt.htm [October 2003].

Koeppe 2008a
Wolfram Koeppe, ed. *Art of the Royal Court: Treasures in Pietre Dure from the Palaces of Europe.* Exh. cat. by Wolfram Koeppe and Annamaria Giusti, with contributions by Cristina Acidini et al. The Metropolitan Museum of Art, New York, July 1–September 21, 2008. New York, 2008.

Koeppe 2008b
Wolfram Koeppe. "Pietre Dure North of the Alps." In Koeppe 2008a, pp. 55–69.

Koeppe 2009
Wolfram Koeppe. "Gone with the Wind: The Selling of Furniture by David Roentgen and Other Decorative Arts." In *Treasures into Tractors: The Selling of Russia's Cultural Heritage, 1918–1938,* edited by Anne Odom and Wendy R. Salmond, pp. 215–35. Washington, D.C., 2009. [Also published as *Canadian-American Slavic Studies* 43, nos. 1–4 (2009).]

Koeppe and Knothe 2008
Wolfram Koeppe and Florian Knothe. "An Enduring Seductiveness: The Reclaiming of Pietre Dure in the Eighteenth Century." In Koeppe 2008a, pp. 85–93.

***En Konges Taffel* 1988**
En Konges Taffel: Guldsmedekunst og Borddaekning i det 18. Århundrede. Exh. cat. Christian VII's Palace, Amalienborg, Copenhagen, May 28–September 18, 1988. Copenhagen, 1988.

***Konversationslexikon* 1892–93**
Kleines Konversationslexikon. 3 vols. Leipzig, 1892–93.

Koschatzky 1988
Walter Koschatzky. "Die Albertina in Wien"/"The Albertina in Vienna." In *Albert Herzog von Sachsen-Teschen, 1738–1822, zum 250. Geburtstag.* Exh. cat. Graphische Sammlung Albertina, Vienna, July 13–September 4, 1988. Vienna, 1988.

Koschatzky and Krasa 1982
Walter Koschatzky and Selma Krasa. *Herzog Albert von Sachsen-Teschen, 1738–1822: Reichsfeldmarschall und Kunstmäzen.* Veröffentlichungen der Albertina 18. Vienna, 1982.

Kräftner 2009
Johann Kräftner. "The Triumph of Baroque Vienna." In *Fired by Passion: Vienna Baroque Porcelain of Claudius Innocentius Du Paquier,* edited by Meredith Chilton, vol. 1, pp. 34–141. Stuttgart, 2009.

Kraus and Müller 1993
Wolfgang Kraus and Peter Müller. *The Palaces of Vienna.* New York, 1993.

Krog 1985
Ole Villumsen Krog. "Das Klassizistische Wiener Tafelsilber in der Königlichen Silberkammer"/"Det Wienerklassicistiske Bordsølv i det Kongelige Sølvkammer." In *Guld og sølv* 1985, pp. 51–65.

Kroner 2003
Michael Kroner. *Samuel von Brukenthal: Staatsmann, Sammler, Mäzen und Museumsgründer. 200 Jahre seit seinem Tode.* Nuremberg, 2003.

Kugler 1980
Georg Kugler. *Schönbrunn.* Vienna, 1980. [Commentaries in German, English, French, and Italian.]

***Kungligt Taffelsilver* 1988**
Kungligt Taffelsilver från 1700-talet. Skattkammaren, Stockholms Slott. Stockholm, 1988.

"Landes: Covered Bowl and Stand" 2006
"Marked by Louis Landes: Covered Bowl and Stand (48.187.7ab,.8)." In *Heilbrunn Timeline of Art History.* The Metropolitan Museum of Art. New York, 2000–. http://www.metmuseum.org/toah/hd/fsilv/ho_48.187.7ab,.8.htm [October 2006].

Latour 1899
Vincenz Graf Latour. "Altes Wiener Silber." In *Kunst und Kunsthandwerk* 2 (1899), pp. 417–29.

Leben 2004
Ulrich Leben. *Object Design in the Age of Enlightenment: The History of the Royal Free Drawing School in Paris.* Los Angeles, 2004.

Le Corbeiller 1969
Clare Le Corbeiller. "Grace and Favor." *The Metropolitan Museum of Art Bulletin,* n.s., 27, no. 6 (February 1969), pp. 289–98.

Le Corbeiller 1977
Clare Le Corbeiller. "Craftsmanship and Elegance in Eighteenth-Century French Silver." *Apollo* 106 (November 1977), pp. 396–401.

Le Corbeiller 1996
Clare Le Corbeiller. "Robert-Joseph Auguste: Silversmith—and Sculptor?" *Metropolitan Museum Journal* 31 (1996), pp. 211–18.

Le Corbeiller, Kuodriaveca, and Lopato 1993
Clare Le Corbeiller, Angela Kuodriaveca, and Marina Lopato. "Le Service Orloff." In *Versailles et les tables royales en Europe* 1993, pp. 315–18.

Leisching 1912
Eduard Leisching. "Theresianischer und Josefinischer Stil." *Kunst und Kunsthandwerk* 15 (1912), pp. 493–563.

***Liechtenstein* 1985**
Liechtenstein, the Princely Collections: The Collections of the Prince of Liechtenstein. Exh. cat. The Metropolitan Museum of Art, New York, October 26, 1985–May 1, 1986. New York, 1985.

Löffler 1910
Klemens Löffler. "Maria Theresa." In *The Catholic Encyclopedia,* vol. 9, pp. 662–65. New York, 1910.

Lopato 1998
Marina Lopato. "Catherine II's Collection of French Silver." In *Catherine the Great* 1998, pp. 579–82, 633.

Lopato 2001
Marina Lopato. "Neues über die Gouvernement-Service Zarin Katharinas II. von Russland." In *Studien zur europäischen Goldschmiedekunst des 14. bis 20. Jahrhunderts: Festschrift für Helmut Seling zum 80. Geburtstag am 12. Februar 2001,* edited for the Bayerisches Nationalmuseum by Renate Eikelmann, Annette Schommers, and Lorenz Seelig, pp. 307–12. Munich, 2001.

Mabille 1988
Gérard Mabille. "French Banqueting Customs in the Eighteenth Century." In *En Konges Taffel* 1988, pp. 255–58.

Mahan 1932/2007
J. Alexander Mahan. *Maria Theresa of Austria.* N.p., 2007. [Originally published New York, 1932.]

"Maria Theresa" 1911
"Maria Theresa." In *Encyclopaedia Britannica,* 11th ed., vol. 17, pp. 708–9. Cambridge, 1911.

***Maria-Theresia-Ausstellung* 1930**
Katalog der Maria-Theresia-Ausstellung. Exh. cat. Schönbrunn, Vienna, May–October 1930. Verein der Museumsfreunde in Wien. Vienna, 1930.

***Marie-Antoinette* 2008**
Marie-Antoinette. Exh. cat. Galeries Nationales du Grand Palais, Paris, March 15–June 30, 2008. Paris, 2008.

***Masterpieces of Fifty Centuries* 1970**
Masterpieces of Fifty Centuries. Introduction by Kenneth Clark. Exh. cat. The Metropolitan Museum of Art, New York, November 14, 1970–June 1, 1971. New York, 1970.

McCormick and Ottomeyer et al. 2004
Heather Jane McCormick and Hans Ottomeyer et al. *Vasemania: Neoclassical Form and Ornament in Europe. Selections from The Metropolitan Museum of Art.* Edited by Stephanie Walker. Exh. cat. Bard Graduate Center for Studies in the Decorative Arts, Design, and Culture, New York, July 22–October 17, 2004. New York, 2004.

McGuigan 1966
Dorothy Gies McGuigan. *The Habsburgs.* London, 1966.

Mengs 1762/1995
Anton Raphael Mengs. "Gedanken über die Schönheit und über den Geschmack in der Malerei." In *Frühklassizismus, Position und Opposition: Winckelmann, Mengs, Heinse,* edited by Helmut Pfotenhauer, Markus Bernauer, and Norbert Miller, pp. 195–249. Bibliothek der Kunstliteratur 2. Frankfurt am Main, 1995.

Meyer 2002
Daniel Meyer. *Versailles: Furniture of the Royal Palace, Seventeenth and Eighteenth Centuries.* 2 vols. Dijon, 2002.

Mingardi 1997
Corrado Mingardi. "Idee petitotiane ed esperienze bodoniane." In *Petitot 1997*, pp. 121–43.

Munger 2003
Jeffrey Munger. "French Silver in the Seventeenth and Eighteenth Centuries." In *Heilbrunn Timeline of Art History*. The Metropolitan Museum of Art. New York, 2000–. http://www.metmuseum.org/toah/hd/fsilv/hd_fsilv.htm [October 2003].

Museum für Kunst und Gewerbe 2000
Museum für Kunst und Gewerbe Hamburg. Munich, 2000.

Myers 1991
Mary L. Myers. *French Architectural and Ornamental Drawings of the Eighteenth Century.* Exh. cat. The Metropolitan Museum of Art, New York, December 10, 1991–March 15, 1992. New York, 1991.

Neidhardt Antiquitäten 1995
Neidhardt Antiquitäten. [Dealer's cat.] No. 21. Munich, n.d. [1995].

Neuwirth 1979
Waltraud Neuwirth. *Wiener Porzellan: Original, Kopie, Verfälschung, Fälschung.* Vienna, 1979.

Neuwirth 2002
Waltraud Neuwirth. *Wiener Silber: Namens- und Firmenpunzen, 1781–1866 / Viennese Silver: Makers' and Company Marks, 1781–1866.* Vienna, 2002.

Neuwirth 2004
Waltraud Neuwirth. *Wiener Silber: Punzierung, 1524–1780.* Vienna, 2004.

Nicolas II Esterházy 2007
Nicolas II Esterházy, 1765–1833, un prince hongrois collectioneur: Une Histoire du goût en Europe aux XVIII^e–XIX^e siècles. Exh. cat. Musée National du Château de Compiègne, September 21, 2007– January 7, 2008. Paris, 2007.

Nocq 1926–31
Henry Nocq. *Le Poinçon de Paris: Répertoire des maîtres-orfèvres de la juridiction de Paris depuis le Moyen-Âge jusqu'à la fin du XVIII^e siècle.* 5 vols. Paris, 1926–31.

Österreich zur Zeit Kaiser Josephs II 1980
Österreich zur Zeit Kaiser Josephs II: Mitregent Kaiserin Maria Theresias, Kaiser u. Landesfürst. Exh. cat. Stift Melk, March 29–November 2, 1980. Vienna, 1980.

Ott 1910
Michael Ott. "Kaunitz, Wenzel Anton." In *The Catholic Encyclopedia*, vol. 8, pp. 611–12. New York, 1910.

Ottomeyer 1997
Hans Ottomeyer. "*Olla podriga* und *pot d'oille*: Leitfossilien europäischer Tafelkultur." In *Essen und kulturelle Identität: Europäische Perspektiven*, edited by Hans Jürgen Teuteberg, Gerhard Neumann, and Alois Wierlacher, pp. 164–75. Kulturthema Essen 2. Papers of the 2nd Internationales Kolloquium zur Kulturwissenschaft des Essens, held in Wissenschaftszentrum Schloss Thurnau, March 21–24, 1994. Berlin, 1997.

Ottomeyer 2002
Hans Ottomeyer. "*Service à la francaise* und *service à la russe*: Die Entwicklung der Tafel zwischen dem 18. und 19. Jahrhundert." In Ottomeyer and Völkel 2002, pp. 94–101.

Ottomeyer and Pröschel 1986
Hans Ottomeyer and Peter Pröschel. *Vergoldete Bronzen: Bronzearbeiten des Spätbarock und Klassizismus.* With contributions by Jean-Dominique Augarde et al. 2 vols. Munich, 1986.

Ottomeyer and Völkel 2002
Hans Ottomeyer and Michaela Völkel, eds. *Die öffentliche Tafel: Tafelzeremoniell in Europa, 1300–1900.* Exh. cat. Kronprinzenpalais, Berlin, November 29, 2002– March 11, 2003. Organized by the Deutsches Historisches Museum, Berlin. Wolfratshausen, 2002.

Overzier 1987
Claus Overzier. *Deutsches Silber: Formen und Typen, 1550–1850.* Munich, 1987.

Paré 1573/1983
Ambroise Paré. On *Monsters and Marvels.* [Translation of *Des monstres et prodiges* (1573)]. Translated and edited by Janis L. Pallister. Chicago, 1983.

Parissien 1999
Steven Parissien. "The Regency." In *Magnificent Regency Silver and Silver-Gilt: The Collection of Alan and Simone Hartman*, sale cat., Christie's, New York, October 20, 1999, pp. 13–19.

Partridge Fine Arts 1996
Partridge Fine Arts. *Recent Acquisitions, 1996.* Compiled by Lucy Morton. London, 1996.

Partridge Fine Arts 1997
Partridge Fine Arts. *Silver at Partridge: Recent Acquisitions, October 1997.* London, 1997.

Peck 1962
Harry Thurston Peck. "Aesculapius or Asclēpius." In *Harper's Dictionary of Classical Literature and Antiquities*, edited by Harry Thurston Peck, p. 37. [2nd ed.] New York, 1962. [Reprint of 1897 ed.]

Perrin 1993
Christiane Perrin. *François Thomas Germain: Orfèvre des rois.* Saint-Rémy-en-l'Eau, 1993.

Petitot 1997
Petitot: Un artista del Settecento europeo a Parma. Exh. cat. Parma, April 6–June 29, 1997. Le Mostre della Fondazione 6. Fondazione Cassa di Risparmio di Parma. Parma, 1997.

Physiologus 1979 (ed.)
Physiologus. Translated by Michael J. Curley. Austin, Tex., 1979.

Piranesi 1778/1905
Giovanni Battista Piranesi. *Coupes, vases, candélabres, sarcophages, trépieds, lampes & ornements divers.* Paris, 1905. [Originally published as *Vasi, candelabri, cippi, sarcofagi, tripodi, lucerne ed ornamenti antichi.* Rome, 1778.]

Plaisirs et manières de table 1992
Plaisirs et manières de table aux XIV^e et XV^e siècles. Exh. cat. Musée des Augustins, Toulouse, April 23–June 29, 1992. Toulouse, 1992.

Poch-Kalous 1955
Margarethe Poch-Kalous. "Das Wiener Kunsthandwerk seit dem Zeitalter der Renaissance." In *Geschichte der bildenden Kunst in Wien*, pp. 225–66. Geschichte der Stadt Wien, n.s., 7, no. 2. Vienna, 1955.

Poullin de Viéville 1785
Nicolas-Louis-Justin Poullin de Viéville. *Code de l'orfèvrerie: ou, Recueil et abrégé chronologiques des principaux reglements concernant les droits de marque & de contrôle sur les ouvrages d'or & d'argent.* Paris, 1785.

Rattner and Danzer 2005
Josef Rattner and Gerhard Danzer. *Reifsein ist alles: Erfahrungen und Erkenntnisse beim Alt- und Älterwerden.* Würzburg, 2005.

Rauch 1985
Marga Rauch. *Handwerk in Augsburg: Chronik einer grossen Leistung.* Bad Wörishofen, 1985.

"Recent Acquisitions" 2003
"Recent Acquisitions: A Selection, 2002–2003." *The Metropolitan Museum of Art Bulletin*, n.s., 61, no. 2 (Fall 2003).

Reddaway 1904
William Fiddian Reddaway. *Frederick the Great and the Rise of Prussia.* Heroes of the Nations. New York, 1904.

Remington 1938
Preston Remington. *Three Centuries of French Domestic Silver.* Exh. cat. The Metropolitan Museum of Art, New York, May 18–September 18, 1938. New York, 1938.

Remington 1954
Preston Remington. "The Galleries of European Decorative Art and Period Rooms, Chiefly XVII and XVIII Century." *The Metropolitan Museum of Art Bulletin,* n.s., 13, no. 3 (November 1954), pp. 65–135.

Reynolds 1914
Cuyler Reynolds. *Genealogical and Family History of Southern New York and the Hudson River Valley: A Record of the Achievements of Her People in the Making of a Commonwealth and the Building of a Nation.* 3 vols. New York, 1914.

Ein rheinischer Silberschatz 1980
Ein rheinischer Silberschatz: Schmuck und Gerät aus Privatbesitz. Exh. cat. Kunstgewerbemuseum der Stadt Köln, May 24–July 27, 1980. Cologne, 1980.

Roberts 2002
Jane Roberts, ed. *Royal Treasures: A Golden Jubilee Celebration.* Exh. cat. The Queen's Gallery, Buckingham Palace, London, May 22, 2002–January 12, 2003. London, 2002.

"Roettiers: Tureen with stand from the Orloff Service" 2006
"Jacques-Nicolas Roettiers: Tureen with stand from the Orloff Service (33.165.2a–c)." In *Heilbrunn Timeline of Art History.* The Metropolitan Museum of Art. New York, 2000–. http://www.metmuseum.org/toah/hd/stpt/ho_33.165.2a-c.htm [October 2006].

Rosenberg 1922–28
Marc Rosenberg. *Der Goldschmiede Merkzeichen.* 3rd ed. 4 vols. Frankfurt am Main, 1922–28.

Sallas 2008
Joan Sallas. *Ursprung und Entwicklung des Serviettenbrechens: Katalog zur Ausstellung Tischlein deck dich.* Exh. cat. Salzburger Barockmuseum, July 2–October 26, 2008. Freiburg im Breisgau and Salzburg, 2008.

Salz, Macht, Geschichte 1995
Salz, Macht, Geschichte: Katalog. Edited by Manfred Treml, Rainhard Riepertinger, and Evamaria Brockhoff. Exh. cat. Haus der Bayerischen Geschichte, Augsburg, 1995. Veröffentlichungen zur Bayerischen Geschichte und Kultur 30. Augsburg, 1995.

Sargentson 1996
Carolyn Sargentson. *Merchants and Luxury Markets: The Marchands Merciers of Eighteenth Century Paris.* London, 1996.

Schlitter 1896
Hanns Schlitter. *Briefe der Erzherzogin Marie Christine, Statthalterin der Niederlande, an Leopold II.* Vienna, 1896.

Schoeppl 1917
Heinrich Ferdinand Schoeppl. *Die Herzöge von Sachsen-Altenburg ehem. von Hildburghausen.* Bozen, 1917. [Reprint ed. (facsimile), Altenburg, 1992.]

Schulz 2001
Karl Schulz. "Domanöck (Domanek), Anton Mathias (Anton Mathias Joseph)." In *Allgemeines Künstlerlexikon: Die bildenden Künstler aller Zeiten und Völken,* vol. 28, pp. 359–60. Leipzig, 2001.

Schulze 1989
Kurt Schulze. *Das Altenburger Schloss.* 5th ed. Baudenkmale 3. Leipzig, 1989.

Seelig 1994a
Lorenz Seelig. "Die Kunst der Augsburger Goldschmiede im Dienst höfischer Repräsentation." In Baumstark and Seling 1994, vol. 1, pp. 32–56.

Seelig 1994b
Lorenz Seelig. "'Silberzimmer' und 'Grünes Gewölbe': Augsburger Goldschmiedekunst am Dresdner Hof Augusts des Starken." In Baumstark and Seling 1994, vol. 2, pp. 472–73. Munich, 1994.

Seelig 1995
Lorenz Seelig. "Das Dresdner Vermeil-Service." *Die Weltkunst* 65 (February 15, 1995), pp. 373–75.

Seelig 1998
Lorenz Seelig. "Die Fürsten von Thurn und Taxis als Sammler und Auftraggeber." In *Thurn und Taxis Museum, Regensburg: Höfische Kunst und Kultur,* edited by Reinhold Baumstark, pp. 28–47. Bayerisches Nationalmuseum. Munich, 1998.

Seelig 2002
Lorenz Seelig. "Der schöne Schatz: Tafel-silber als Staatsvermögen. Bestellung, Lieferung und Einschmelzung süddeutscher Tafelservice des 18. Jahrhunderts." In Ottomeyer and Völkel 2002, pp. 102–11.

Seelig 2007
Lorenz Seelig. "Das Silberservice König Georgs III. von Robert-Joseph Auguste und Frantz Peter Bundsen: Zur Gold-schmiedekunst des frühen Klassizismus in Paris, London und Hannover." *Münchner Jahrbuch der bildenden Kunst,* 3rd ser., 58 (2007), pp. 141–207.

Seling 1980
Helmut Seling. *Die Kunst der Augsburger Goldschmiede, 1529–1868: Meister, Marken, Werke.* 3 vols. Munich, 1980. [See also suppl. to vol. 3 (1994) and rev. ed. of vol. 3 (2007).]

Semple 2005
Clara Semple. *A Silver Legend: The Story of the Maria Theresia Thaler.* Manchester, 2005.

Shaw 1895/2005
Willian Arthur Shaw. *The History of Currency, 1252 to 1894: Being an Account of the Gold and Silver Monies and Monetary Standards of Europe and America, Together with an Examination of the Effects of Currency and Exchange Phenomena on Commercial and National Progress and Well-Being.* New York, 1895. Reprint ed., 2005.

Silverman 1989
Debora L. Silverman. *Art Nouveau in Fin-de-Siècle France: Politics, Psychology, and Style.* Studies on the History of Society and Culture 7. Berkeley, 1989.

Solomon 1996
Maynard Solomon. *Mozart: A Life.* New York, 1996.

Stahl 2002
Patricia Stahl. "Im grossen Saal des Römers ward gespeiset in höchstem Grade prächtig: Zur Geschichte der kaiserlichen Krönungsbankette in Frankfurt am Main." In Ottomeyer and Völkel 2002, pp. 58–71.

Stürmer 1986
Michael Stürmer. *Herbst des alten Hand-werks: Meister, Gesellen und Obrigkeit im 18. Jahrhundert.* Munich, 1986.

Sutton 1977
Denys Sutton. *Paris—New York: A Continuing Romance.* Exh. cat. Wildenstein & Company, New York, November 3–December 17, 1977. New York, 1977.

Syndram 1999
Dirk Syndram. *Die Schatzkammer Augusts des Starken: Von der Pretiosensammlung zum Grünen Gewölbe.* Leipzig, 1999.

Syndram and Scherner 2004
Dirk Syndram and Antje Scherner, eds. *Princely Splendor: The Dresden Court, 1580–1620.* Exh. cat. Museum für Kunst und Gewerbe, Hamburg, June 10–September 26, 2004; The Metropolitan Museum of Art, New York, October 26, 2004–January 30, 2005; and Fondazione Memmo, Palazzo Ruspoli, Rome, March 1–April 29, 2005. Milan, Dresden, and New York, 2004.

Tolley 2001
Thomas Tolley. *Painting the Cannon's Roar: Music, the Visual Arts and the Rise of an Attentive Public in the Age of Haydn, c. 1750 to c. 1810.* Burlington, Vt., 2001.

Treasures from the Metropolitan Museum 1989
Treasures from The Metropolitan Museum of Art: French Art from the Middle Ages to the Twentieth Century. Exh. cat. Yokohama Museum of Art, March 25–June 4, 1989. [Tokyo], 1989.

Tydén-Jordan 1998
Astrid Tydén-Jordan. "'Worthy of the King's Grand Couvert': The Silver Service Made by Robert-Joseph Auguste for Ambassador Creutz." In *Catherine the Great* 1998, pp. 605–9, 633.

Verdenhalven 1993
Fritz Verdenhalven. *Alte Mess- und Währungssysteme aus dem deutschen Sprachgebiet: Was familien- und Lokalgeschichtsforscher suchen.* 2nd ed. Neustadt an der Aisch, 1993.

Versailles et les tables royales en Europe 1993
Versailles et les tables royales en Europe, XVIIème–XIXème siècles. Exh. cat. Musée National des Châteaux de Versailles et de Trianon, November 3, 1993–February 27, 1994. Paris, 1993.

Viennese Gold and Silversmiths 2005
Wiener Gold- und Silberschmiede von 1781 bis 1921 und ihre Punzen/Viennese Gold and Silversmiths from 1781 to 1921 and Their Marks. CD-ROM. Edited by Peter Noever. Accompanied by booklet written by Elisabeth Schmuttermeier. Vienna, 2005.

Völkel 2002
Michaela Völkel. "Das Silberservice für Christian VI. von Dänemark." In Ottomeyer and Völkel 2002, p. 226.

Walker 2002
Stefanie Walker. "Dining in Papal Rome: *Un onore ideale e una fatica corporale.*" In Ottomeyer and Völkel 2002, pp. 72–83.

Wardropper 2009
Ian Wardropper. "ESDA in the Philippe de Montebello Years." In *Philippe de Montebello and The Metropolitan Museum of Art, 1977–2008,* pp. 48–55. The Metropolitan Museum of Art. New York, 2009.

Watson and Dauterman 1970
Francis J. B. Watson and Carl Christian Dauterman. *The Wrightsman Collection.* Vol. 3, *Furniture, Gold Boxes; Porcelain Boxes, Silver.* New York, 1970.

Weber 1985
Ingrid Szeiklies Weber. *Planetenfeste August des Starken: Zur Hochzeit des Kronprinzen, 1719.* Munich, 1985.

Wenham 1949
Edward Wenham. "French Silver: Its Influence in England." *Antique Collector* 20, no. 6 (November–December 1949), pp. 201–7.

Whitehead 1992
John Whitehead. *The French Interior in the Eighteenth Century.* London, 1992.

Winkler 1993
Hubert Chryspolitus Winkler. "Chronologische geschichte der ehemaligen Hofsilber- und Tafelkammer." In Haslinger 1993, pp. 86–137, 152–64.

Winkler 1996
Hubert Chryspolitus Winkler. *Ehemalige Hofsilber & Tafelkammer: Silber, Bronzen, Porzellan, Glas.* With contributions by Ilsebill Barta-Fliedl, Ingrid Haslinger, and Maria-Luise Jesch. Publikationsreihe der Museen des Mobiliendepots 1. Vienna, 1996.

Wolf 1863
Adam Wolf. *Marie Christine, Erzherzogin von Oesterreich.* 2 vols. in 1. Vienna, 1863.

Wraxall 1806
Nathaniel William Wraxall. *Memoirs of the Courts of Berlin, Dresden, Warsaw, and Vienna, in the Years 1777, 1778, and 1779.* 2 vols. 3rd ed. London, 1806.

"Würth, Franz Caspar" 1947
"Würth (Wirth), Franz Caspar." In Ulrich Thieme and Felix Becker, *Allgemeines Lexikon der bildenden Künstler, von der Antike bis zur Gegenwart,* vol. 36, edited by Hans Vollmer, p. 295. Leipzig, 1947.

"Würth, Franz Xaver" 1947
"Würth (Wirth, Würt), Franz Xaver." In Ulrich Thieme and Felix Becker, *Allgemeines Lexikon der bildenden Künstler, von der Antike bis zur Gegenwart,* vol. 36, edited by Hans Vollmer, pp. 295–96. Leipzig, 1947.

"Würth, Ignaz Joseph" 1947
"Würth (Wirth), Ignaz Joseph." In Ulrich Thieme and Felix Becker, *Allgemeines Lexikon der bildenden Künstler, von der Antike bis zur Gegenwart,* vol. 36, edited by Hans Vollmer, p. 296. Leipzig, 1947.

"Würth, Ignaz Sebastian" 1947
"Würth, Ignaz Sebastian von." In Ulrich Thieme and Felix Becker, *Allgemeines Lexikon der bildenden Künstler, von der Antike bis zur Gegenwart,* vol. 36, edited by Hans Vollmer, pp. 296–97. Leipzig, 1947.

"Würth: Pair of Wine Coolers" 2008
"Ignaz Josef Würth: Pair of Wine Coolers (2002.265.1a,b,.2a)." In *Heilbrunn Timeline of Art History.* The Metropolitan Museum of Art. New York, 2000–. http://www.metmuseum.org/toah/hd/neoc_1/ho_2002.265.1a,b,.2a.htm [October 2008].

A. van Ypersele de Strihou and P. van Ypersele de Strihou 1970
Anne van Ypersele de Strihou and Paul van Ypersele de Strihou. *Laeken: Résidence impériale et royale.* Brussels, 1970.

Zelleke 2002
Ghenete Zelleke. "An Embarrassment of Riches: Fifteen Years of European Decorative Arts." *Museum Studies* (Art Institute of Chicago) 28, no. 2 (2002), pp. 22–89, 92–96. [Issue titled *Gifts beyond Measure: The Antiquarian Society and European Decorative Arts, 1987–2002.*]

Zischka, Ottomeyer, and Bäumler 1993
Ulrike Zischka, Hans Ottomeyer, and Susanne Bäumler, eds. *Die Anständige Lust: Von Esskultur und Tafelsitten.* Exh. cat. Stadtmuseum, Munich, February 2–May 31, 1993. Munich, 1993.

Zörrer 1992
Ferdinand Zörrer. "Die Geschichte der österreichischen Freimaurerei." In *Freimauer* 1992, pp. 431–36.

Index

Page numbers in *italic* type refer to illustrations.

coronation banquet, of Joseph II (fig. 2), 4–5, 5, 82n.13
Corradini, Antonio (1668–1752), 16
Cousinet, Henri-Nicolas, 86n.149
crayfish motifs, 38, 42, 45; detail, 43
Credenze zur Parade (parade buffets), 4–5, 7
Crimpelle, Charles, 55

Deffand, Marie de Vichy-Chamrond, marquise du (1697–1780), 6
Delafosse, Jean-Charles (1734–1789), 21, 86n.151
Denmark, 7
 chandelier by Domanöck presented to king of, 19
 royal silver of
 tureens by Auguste, 39
 Würth service of 1779, 37, 86n.140; fish slicers, 65, 87n.212; gilded-silver dessert spoons, forks, and knives, 68–70; tureens (fig. 28), 37, 37, 40; details, 42
 see also Copenhagen
Denner, Franz Anton, oval dish from First Sachsen-Teschen Service (fig. 8), 14
Dessau, court in, 17
DeWailly, Charles (1730–1798), 72, 75
dinner plates (*assiettes*):
 from Double-Gilded Service (cat. no. 3), 10, 11, 82n.40
 machine production of blanks for, 60
 from Second Sachsen-Teschen Service (cat. no. 36), 60, 61, 79, 87n.180
dishes (*plats*):
 with cloches, or covers, 86–87n.167
 from Second Sachsen-Teschen Service (cat. nos. 20–23, fig. 43), 49–52, 50–52
 serving, from Second Sachsen-Teschen Service (cat. nos. 32–35), 60, 61
 see also dinner plates; oval dishes; round dishes
dolphin motifs, 28, 33, 35, 35, 86n.149
Domanöck, Anton Mathias (1713–1779), 19, 20, 86n.137
 pedestal table with inlaid top (fig. 13), 20–21, 21, 22, 88n.214
Domanöck, Franz Anton (1746–1821), 20, 84n.86
Donck, Jacob Frans vander, 83n.62
Donner, Georg Raffael (1693–1741), 83n.58
Donner, Johann Matthäus (1704–1756), 83n.58
Double-Gilded Service (cat. nos. 3, 4), 10, 11, 82nn.40, 42
Dresden, 60
 Royal Palace in, 9–10
Durand, Antoine-Sébastien, 86n.162
Durazzo, Count Giacomo (1717–1794), 76

egoists (objects intended for one person), 16
Elizabeth Charlotte of the Palatinate, duchess of Orléans (1652–1722), 6
Elizabeth Petrovna, tsarina of Russia (1709–1762), 8, 39
Empire period, 79

England and English decorative arts, 7, 39, 46–47, 54
 see also London
Enlightenment, 3, 20, 75
Erdmannsdorff, Friedrich Wilhelm von (1736–1800), 17
Esterházy, Countess, 85.n117
Esterházy, Prince Paul Anton, 88n.214
ewers:
 by Krautauer (cat. no. 10), 28–31, 30; detail, 33
 by Samson (cat. no. 12), 28, 32
 from Second Sachsen-Teschen Service (cat. no. 24), 52–54, 53

Falconet, Étienne-Maurice (1716–1791), 9
Fayer, Friedrich von, 88n.221
finials, 24
 with naturalistic still-life compositions, 31, 31, 38–40, 42–45, 49, 50–52, 86n.162; details, 43, 44
 with statuettes (fig. 31), 40, 42
First Sachsen-Teschen Service (figs. 7, 8), 13–14, 14, 26, 28, 70, 83nn.57, 59, 88n.216
Fischer von Erlach, Joseph Emanuel (1693–1742), 16
fish slicers, from Ignaz Joseph Würth's 1779 Danish ensemble, 65, 87n.212
flatware and serving pieces:
 dessert set in Ignaz Joseph Würth's 1779 Danish ensemble, 68–70
 ladle by Roëttiers (cat. no. 39), 63, 64
 by Mayerhofer & Klinkosch (cat. no. 43), 68, 68
 from Second Sachsen-Teschen Service (cat. nos. 38, 41, 42), 63–70, 64, 66, 67; detail, 68; documented by Braun (fig. 47), 64, 65, 79; original leather cases for nos. 41, 42 (cat. no. 40), 65; porcelain service in same pattern as porcelain handles in (fig. 50), 69, 70, 88nn.214, 215
Föbell, Johann Philipp (master 1733–51), cover for oval dish from First Sachsen-Teschen Service (fig. 8), 13, 14
Fonson, Pieter Jozef, 83n.62
France and French decorative arts, 3–4, 6–9, 14, 17, 31, 42, 54, 73, 150n.86
 ewer by Samson (cat. no. 12), 28, 32
 flamboyant dining and entertaining *en public* in, 6–7, 10
 revolutionary wars in, 5, 9, 23, 76, 83n.60
 Russian patronage and, 7–9
 service à la française (fig. 3), 6, 7, 40, 49
 Viennese artisans trained in, 37
 see also Paris
Francis I, Holy Roman Emperor (formerly Duke Francis Stephen of Lorraine; 1708–1765), 4, 10, 19, 63, 82n.9, 88n.225
 Rococo centerpiece made for, 14–15, 83n.62
Francis II, Holy Roman Emperor (1768–1835), 23

Frankfurt, coronation banquet of Joseph II in (fig. 2), 4–5, 5, 82n.13
Franz Joseph I, prince of Liechtenstein (1726–1781), 24
Frederick II, called the Great, king of Prussia (1712–1786), 3, 75
Frederick Augustus II, elector of Saxony, king of Poland (as Augustus III) (1696–1763), 9, 10, 82n.42
Frederick Augustus III, elector of Saxony (reigned 1763–1806), 87n.199
Frederick Christian, elector of Saxony, 10
Frederick Maria (1856–1936), archduke of Austria, duke of Teschen, 70
Freemasonry, 75–76
French language, as lingua franca for Continental elite, 7
French Revolution, 9, 76
 see also France—revolutionary wars in
frises des rinceaux, 26, 42
fruit and dessert stands (*tambours*), 58
Füger, Heinrich Friedrich, *Maria Theresa of Austria with Her Children* (fig. 1), 4

Galle, Claude (1759–1815), 42
George II, king of Great Britain, 17
George III, king of Great Britain (1738–1820), 17, 38, 84n.82
Germain, François-Thomas (1726–1791), 8, 17, 20, 39, 40, 82n.27, 86nn.154, 167
 tureen attributed to (fig. 19), 26, 28, 128n.85
 Viennese sojourn of, 37–38
Germain, Thomas (1673–1748), 20, 39, 82n.27, 86n.154, 88n.233
Germany and German decorative arts, 3, 7
 silver service for court at Hanover, 16–17, 20, 38, 84n.82
 tureen by Müller and Marggraff (fig. 24), 31–32, 34
 see also Augsburg and Frankfurt
Ghent, inauguration of Joseph II as count of Flanders in (cat. no. 44), 71, 72
Giegher, Mattia, *Li tre trattati* (The Three Treatises), 62
Girtler von Kleeborn, Joseph Ritter, 76
glass cooler (verrière), attributed to Ignaz Joseph Würth (cat. no. 46), 78, 79, 85n.128
Goethe, Johann Wolfgang von (1749–1832), *Dichtung und Wahrheit*, 4
"golden service," use of term, 63
"Goldschmiedekunst-Ausstellung im Palais Schwarzenberg" (Goldsmith Exhibition at Palais Schwarzenberg, Vienna; 1889), 28–31
gold services, 7
 at coronation banquet of Joseph II, 4–5, 82n.13, 83n.59
 by Domanöck, 19
 flatware of Albert and Marie Christine and their adopted son, Charles of Austria, 63
 made in commemoration of marriage of Joseph II to Isabella of Parma, 4–6, 82n.15
goût grec, 31, 42

silver wedding ensemble of (First
Sachsen-Teschen Service; figs. 7, 8),
13–14, *14*, 26, 28, 70, 83nn.57, 59,
88n.216
table silver by Ignaz Joseph Würth for,
35, 37–71, 73–74, 77–79; *see also*
Second Sachsen-Teschen Service
Marie Christine of Bourbon-Parma,
princess, 88n.221, 89n.252
Maron, Anton von (1733–1808), 16, 17
Maulbertsch, Franz Anton (1724–1796),
84n.69
Maximilian III Joseph, elector of Bavaria, 10
Maximilian Francis, archbishop-elector of
Cologne (1756–1801), 89n.241
Mayerhofer & Klinkosch, 54, 58
flatware (cat. no. 43), 68, *68*
Medieval period, salts in, 54
melting down of gold and silver objects
and table ensembles, 5–6, 23, 82n.42
Mengs, Anton Raphael (1728–1779), 3, 16
Menzel, Gottlieb, Double-Gilded Service
(cat. nos. 3, 4), 10, *11*, 82nn.40, 42
Meytens, Martin van (1695–1770), 82n.15
*Coronation Banquet of Joseph II in
Frankfurt* (fig. 2), 4–5, *5*; detail, *2*
Minerva, depictions of Catherine the
Great as, 28, 85n.125
Miscellanea Saxonica, 60
models, casting from, 42, 86n.154
Moll, Balthasar Ferdinand (1717–1785), 16
Montoyer, Louis Joseph (ca. 1747/49–1811),
72, 76–77
Monument to Just War, 28
Moser, Friedrich Karl von (1723–1798), 7
Moser, Joseph (1715–1801), 15–16, 20,
83n.67
Mozart, Wolfgang Amadeus (1756–1791),
3, 75, 90
Müller, Johann Bernhard, tureen (fig. 24),
31–32, *34*
Mundzeug, use of term, 63

napkins, 60–63
commemorative, showing allegory of
Peace Treaty of Teschen (fig. 46),
62, *63*
designs for, from Giegher's *Li tre trattati*
(The Three Treatises) (cat. no. 37),
60, *62*
naturalism, 21, 39
finials with still-life compositions, 31, *31*,
38–40, *42–45*, 49, *50–52*, 86n.162;
details, *43*, *44*
Neoclassicism, 3, 8, 15, 16, 17, 20–21, 22,
39, 52, 60, 73–74, 79
Viennese, development of, 19, 26–35
Neuber, Johann Christian, 87

Orloff, Count Gregory (1734–1783), 9
silver service presented to (cat. no. 2),
8, *9*
Ostend (Dutch East India) Trading
Company, 24
oval dishes:
from First Sachsen-Teschen Service
(fig. 8), *14*, 83n.59

from Second Sachsen-Teschen Service
(cat. no. 34), 60, *61*
oval tray, monumental, by Krautauer (cat.
no. 13), 31, *33*

Pajou, Augustin (1730–1809), 72
Pálffy von Erdöd, Prince Karl Hieronymus
(1735–1816), 25
pantheon motif, at Schoonenberg Palace,
75, 89n.235
parade buffets (*Credenze zur Parade*),
4–5, 7
Paris, 4, 7, 17, 19, 20, 21, 76
Orloff Service by Roëttiers (cat. no. 2),
8, *9*
three-branch candelabrum by Auguste
(cat. no. 1), 7
tureen by Auguste (fig. 23), 28, 31, *34*,
86n.144
tureens by Roëttiers (cat. nos. 2, 9), *8*,
28, *29*
Parisian Service (Russian state service), 8
Peace Treaty of Teschen (1779), 62,
87n.205, 89n.250
commemorative napkin showing alle-
gory of (fig. 46), 62, *63*
pearl-string motifs, 24, *24*, *38–40*, 42, 47,
48, 54
Petitot, Ennemond Alexandre (1727–1801),
Series of Vases (fig. 27), 35, *35*
petrified wood:
pedestal table with top made of (fig. 13),
20–21, *21*
vases made of (cat. no. 6), 21–23, *22*
Physiologus, 52–53
Piranesi, Giovanni Battista (1720–1778),
53–54
*Dessin d'un morceau d'un antique
édifice* (fig. 44), *52*, 54
Polish Service, 89n.250
porcelain embellishments, 14
flatware with
by Mayerhofer & Klinkosch (cat.
no. 43), 68, *68*
from Second Sachsen-Teschen Service
(cat. nos. 41–43, fig. 47), *64*, *66*,
67, 68, 79; detail, *68*; porcelain
service in same pattern as
(fig. 50), 69, 70, 88nn.214, 215
porcelain service, in Princely Collection of
Thurn und Taxis (fig. 50), 69, 70,
88nn.214, 215
porcelains with gilded cast-bronze
mounts, 23–26
candelabra, 85n.116
monumental, with Chinese blue and
white porcelain (fig. 17), *25*, 25–26
three-branch (fig. 16), 24–25, *25*, 56
vases
with Arita jars from Japan's Edo
period (fig. 14), *23*, 24
with Chinese celadon (fig. 15), 24, *24*
Powell, Thomas, tureen with stand and
ladle (fig. 11), *16*, 17, 84n.77
Prague, Cathedral of Saint Vitus, mauso-
leum of Saint Johannes von Nepomuk,
16, 20

*Praktischer Unterricht in der neuesten Art des
Tafeldeckens und Trenchirens, mit
Figuren erläutert*, 62–63
Pressburg (today Bratislava, Slovakia),
palace in, 71, 72, 76, 88n.225
Prieur, Jean Louis (ca. 1732/36–1795), 25,
87n.184
Prussia, Seven Years' War and, 10
putto motifs, 32, *34*, 37, 40; detail, *42*

ram's-head motifs:
pedestal table with, 21, *21*
in Second Sachsen-Teschen candlesticks
and candelabra, 56, *56*, 57, 85n.103
tureen handles by Auguste, 31, *34*
Raphael, 3
Rémond, François (ca. 1747–1812), 22
Renaissance, 54, 86n.149
Rococo, 3, 6, 8, 14–15, 16, 17, 21, 28, 39, 42,
86n.149
Roëttiers, Jacques-Nicolas (1736–1788), 40
ladle (cat. no. 39), 63, *64*
Orloff Service (cat. no. 2), *8*, *9*
tureen with cover (cat. no. 9), 28, *29*
Rohr, Julius Bernhard von, *Einleitung zur
Ceremoniel-Wissenschaft der Privat-
Personen*, 52
Rome, 16, 17, 20, 35, 54
rosettes, 21, *38–40*, 39, *52*, 54, 74, 86n.151
round dishes:
with covers, from Second Sachsen-
Teschen Service (cat. nos. 20, 21),
49–52, *50*
from First Sachsen-Teschen Service
(fig. 7), *14*, 83n.57
Russian Empire, 7–9, 28, 39, 62
guberniias services of, 7, 71
preservation of historic silver from, 9,
82n.34
see also Saint Petersburg

Saint Petersburg:
silver services for court at, 7–9
Stroganoff Collection
gilded-bronze candelabra attributed to
Würth, 56
three-branch candelabra attributed to
Prieur, 25
salts, from Second Sachsen-Teschen
Service (cat. nos. 25, 26), 54, *54*
Samson, Barthélemy, ewer (cat. no. 12), 28,
32
sauce tureens:
from Second Sachsen-Teschen Service
(cat. no. 19, figs. 39, 40), *46*, 46–48,
47; details, *48*, *49*
traditional sauceboat compared to,
46–47
Saxony, 9–10
Servis vor die hohe Herrschaft (Service for
the High Lords) in, 60
Schrödel, 60
Schule für Fabrikanten (School for
Manufacturers), 19
scroll feet, 21, *57*, 58
sea-creature motifs:
dolphins, 28, *33*, 35, *35*, 86n.149

Photograph Credits